THE HOLY SHROUD

THE HOLY SHROUD

A Brilliant Hoax in the Time of the Black Death

GARY VIKAN

SCIENTIFIC ADDENDUM FROM
ROBERT MORTON AND REBECCA HOPPE

PEGASUS BOOKS
NEW YORK LONDON

THE HOLY SHROUD

Pegasus Books Ltd.
148 W 37th Street, 13th Floor
New York, NY 10018

First Pegasus Books edition May 2020

Interior design by Maria Fernandez

Library of Congress Cataloging-in-Publication Data is available.

ISBN: 978-1-64313-432-1

10 9 8 7 6 5 4 3 2 1

Printed in the United States of America
Distributed by Simon & Schuster
www.pegasusbooks.us

For Bob Morton and Rebecca Hoppe,
who figured it out;

Andrea Nicolotti,
who gave the Shroud the scholarship it deserves;

and

Alain and Monique Hourseau,
who bring the 14th century to life.

CONTENTS

INTRODUCTION

On Sunday, April 19, 2015, two weeks after Easter, the Holy Shroud went on display for sixty-seven days in the Cathedral of St. John the Baptist in Turin, Italy. This was its fifth showing in thirty-seven years; the first, in the fall of 1978, drew 3.5 million pilgrims in just five weeks. The 2010 viewing, which lasted six weeks, attracted more than 2 million. Pope Benedict XVI was among the pilgrims in attendance on May 2, 2010, when he described what he saw as an "icon" that once "wrapped the remains of a crucified man in full correspondence with what the Gospels tell us of Jesus." The pope could gaze at his leisure, whereas ordinary visitors, numbering close to fifty thousand a day, had to catch a brief glimpse from out in the crowd of the shroud's shadowy body image of a battered naked man, about six feet tall and weighing perhaps 175 pounds, with shoulder-length hair, a mustache and beard, and arms extended with his hands covering his genitals.

The "Man of the Shroud," as he is called by those who study him, is imprinted front and back in pale sepia tones on a rectangular piece of fine herringbone-woven linen just over fourteen feet long and just

under four feet wide. Close examination reveals what appear to be graphic wounds of whipping on the figure's back, arms, and legs; small rivulets of what looks to be blood flow from what appear to be tiny puncture wounds on the figure's forehead; similar blood flows down the arms from what appears to be a large wound in the figure's right side, as well as from a similar major wound in the upper right hand, which overlays the left wrist.

For millions of believers worldwide, to gaze upon the face of the Man of the Shroud is to gaze upon the face of the Son of God—as if it were an ancient photo, captured just minutes after Jesus came down from the cross. But where believers see their Savior, I see the greatest deception in the history of Christianity. And, at the same time, I see the work of an artistic genius.

From the moment of my first encounter with the shroud in 1981, I knew it could not be the burial cloth of Jesus. Of course, many inside and outside the church shared my skepticism. But unlike the others, I could not simply accept it as a fake and move on. Instead, I set my sights on exposing once and for all the truth behind the Shroud of Turin. As it turned out, my quest, with many interruptions and multiple detours, would last a quarter of a century and take me on a circuitous journey from Turin to Jerusalem, Constantinople, Rome, Avignon, the green country of northeast Oklahoma, and the desert hills north of Santa Fe—then, finally, to the hamlet of Lirey in northeast France, where, in the mid-14th century, the shroud's story began.

The amazing cast of characters I encountered along the way includes an audacious pope in Avignon who wanted to make France the center of the Catholic Church; an ill-fated French king, dubbed "the Good," who was captured in battle; the most illustrious knight of the Middle Ages, who died saving a king's life; the knight's aspiring widow, who likely had a hand in the Holy Shroud hoax; bands of Catholic fanatics who publicly whipped themselves nearly to death; a pair of angry bishops with a shared

gift for conspiracy theories; a quirky scientist from Oklahoma with an unmeasurable IQ; and an amateur historian and irrepressible tour guide in Lirey, who in period costume takes on the persona of the shroud's first owner. The backdrop against which the shroud's story unfolds is a grim mélange of the most devastating plague in human history and a brutal war between France and England that lasted more than a century. Though I suppose it should have been obvious from the beginning: A creation as astounding and enduring as the Shroud of Turin could only have been realized in an extraordinary age and with epic players.

I began my quest nearly forty years ago with the blind optimism and puffed-up ego of a recent PhD graduate, but in truth, there were many false starts and dead ends along the way. In following my shroud journey, readers will get to know an admittedly arrogant Byzantine academic who pushed against the ivory tower of traditional art history to dig into a subject of tabloid fascination, even when it meant that his boss at Harvard's prestigious Dumbarton Oaks research center banished him to the basement for his first shroud television interview. More than once my own hubris got in the way, and it was dumb luck alone that opened an unanticipated path forward. What I could not have guessed when I started, though, was that I would eventually discover a basic, counterintuitive truth about the shroud; namely, that most people don't want its mysteries to be solved. Mysteries, after all, are the stuff of television shows and novels.

I naively believed that my arguments of the early eighties, which I based on the history of relics, the evolving iconography of Christ's Passion story, and the documents relating to the shroud's first appearance in the historical record—coupled with its carbon-14 dating in 1988 to between the years 1260 and 1390—would put the authenticity question to rest. But they did not. Successive public displays of the shroud in 1998, 2000, 2010, and 2015 each drew millions of pilgrims and the endorsement of the reigning pope.

After a quarter of a century of struggling to solve the mystery of the shroud, I knew one thing for certain: My quest would never be over until I figured out how the image of the Man of the Shroud was created. But how could I, when dozens of very smart scientists had struggled with that question over decades and had failed to come up with the answer? In 2006, when I had all but given up hope, I met, by chance, an extraordinary Philips Petroleum material chemist from rural Bartlesville, Oklahoma, who, with his daughter, made the breakthrough I desperately needed. They discovered that the Man of the Shroud was made by a simple but messy printing technique using everyday materials well known to scribes and artists—and with a living human subject. After that stunning discovery, I moved on into territory rarely explored in books about the Shroud of Turin: When was the shroud made, why, and by whom? And who was behind the hoax?

My perspective is that of an art historian, and my focus is specifically on the four decades in the second half of the 14th century (1350–1390) when the Holy Shroud was made and then created its initial public stir. My story is a personal journey of discovery as I have played the Holy Shroud detective. And the guiding spirit on my journey has been William of Occam, who died in Munich in 1347, just a few years before the shroud was first shown to pilgrims. The story of the Shroud of Turin, for those who take its authenticity for granted and absorb each new bit of shroud "evidence" with their deep-seated confirmation bias, is the story of piling complexity upon complexity, with every seeming dead end in the chain of logic calling for yet another contrived explanatory wrinkle. Inspired by William of Occam and his "razor"—his law of succinctness—I have taken the opposite path: The arms of the Man of the Shroud are impossibly long not because Jesus had Marfan syndrome, but because the artist manipulated the figure's arms in the printing process to cover his genitals.

The shroud's next public showing is scheduled for 2025, but if this book finds its audience, that display may never take place. The Catholic Church may finally acknowledge publicly what it has known privately for more than six hundred years: that the Shroud of Turin is *certainly not* the burial cloth of Jesus. And more than that, the church may at last do what a crusading 14th-century bishop begged it to do in order to halt the idolatry it inspires: renounce the shroud as one enormous hoax, and tuck it away forever.

TIMELINE

TIMELINE

1352	King John II appoints Geoffroi de Charny a knight of the Order of the Star
Early 1353	Building of the Lirey Collegiate Church
June 1353	Founding of the Lirey Collegiate Church
October 1353	King John II confirms the foundation of the Lirey Collegiate Church and grants land rents
1353–1370	Henri de Poitiers is bishop of Troyes
1354–1358	Robert de Caillac is dean of the Lirey Collegiate Church
Early 1354	Pope Innocent VI confirms the foundation of the Lirey Collegiate Church
June 1355	King John II appoints Geoffroi de Charny the bearer of the *Oriflamme*
Summer 1355	First mass pilgrimage to Lirey
1355	Likely date of the Cluny Museum shroud pilgrim badge and the Lirey badge casting mold
Later 1355	Bishop Henri de Poitiers initiates action to halt the exhibition of the Lirey Shroud
1355–1389	The Lirey Shroud is hidden away outside the Diocese of Troyes
May 20, 1356	Bishop Henri de Poitiers confirms the foundation of the Lirey Collegiate Church
September 19, 1356	Death of Geoffroi de Charny at the Battle of Poitiers
1361	Jeanne de Vergy marries Aymon de Genève
1369	Aymon de Genève dies
1377–1395	Pierre d'Arcis is bishop of Troyes
1378–1417	The Great Schism
1380–1422	Reign of King Charles VI
1386	Geoffroi II de Charny marries Marguerite de Poitiers, niece of Bishop Henri de Poitiers
1387	Geoffrey Chaucer's *Canterbury Tales*
Spring 1389	The Pope's legate in France grants permission to Geoffroi II de Charny to place the shroud in the Lirey church
Summer 1389	Second mass pilgrimage to Lirey

TIMELINE

July 28, 1389	Pope Clement VII's bull to Geoffroi II de Charny, confirming his legate's permission and allowing exhibition of the shroud for veneration
August 4, 1389	King Charles VI's letter to his bailiff in Troyes, commanding him to seize the Lirey Shroud
August 15, 1389	King Charles VI's bailiff tries and fails to seize the Lirey Shroud
September 5, 1389	It is announced that King Charles VI is now in "verbal" possession of the Lirey Shroud
Later 1389	Bishop Pierre d'Arcis writes his memorandum to the pope
January 6, 1390	Pope Clement VII's issues a bull on the Lirey Shroud
June 1, 1390	Pope Clement VII's revises his January bull on the Lirey Shroud; the Lirey textile must be identified as a figure or representation and must not be afforded during its exhibition the solemn honors due a relic
1394	Death of Pope Clement VII
1395	Death of Pierre d'Arcis
1398	Death of Geoffroi II de Charny

THE HOLY SHROUD

1

Hooked

I met the Shroud of Turin for the first time on the side of the road in
Washington, DC, on a sunny morning in March 1981. I was thirty-
five years old and the father of two girls; my wife, Elana, was
teaching French in a private school, and we lived in a row house on the
north edge of the city. In those days, I loved to walk to work, and that
meant four miles, from just south of the Maryland line to Dumbarton
Oaks, at the top of Georgetown. I had earned my PhD in art history from
Princeton a few years earlier and now had my first paying job, with the
lofty title Associate for Byzantine Art Studies. I was a scholar, pure and
simple, at that most luxurious enclave for Byzantine studies, Harvard's
Dumbarton Oaks Research Library and Collection.

I took different routes south and west toward DO (as we insiders
call Dumbarton Oaks), always on the lookout for "the street that time
forgot." Mostly, this meant meandering through the elegant neighbor-
hoods north of the National Cathedral, with the goal of passing yet

again—and almost always alone—through its lovely boxwood garden. This morning, though, perhaps because I was starting late, I chose the direct and prosaic Wisconsin Avenue route. I wasn't long into my journey when I spied it there on the ground, partially stuck in the remnants of a snowbank: a crumpled copy of that week's *National Enquirer* that happened to fall open to a page with an advertisement featuring a picture of the Shroud of Turin. I was immediately intrigued.

The idea was simple: You send $12 to an address in Richmond, Virginia, and someone there will send you a two-and-a-half-foot linen replica of the Shroud of Turin. This, the Holy Shroud Miracle Cloth, will, in the words of the ad, "bring you everything in life you desire and so rightly deserve." Drape the Holy Shroud Miracle Cloth over your bed or fold it up in your wallet and "the same miraculous forces that brought about the creation of the Shroud (will) go to work for you," bringing you "remarkable cures, good luck, love, money, robust health and happiness," not to mention success "at bingo, the races, card games, the casino and other games of chance." All of this is guaranteed or your money back, even though there is no claim that the Holy Shroud Miracle Cloth had ever touched the real shroud, had ever been to Turin, or, for that matter, had been blessed by anyone with church credentials.

Of course, I immediately ordered my own Holy Shroud Miracle Cloth and, a few years later, while in Richmond to see an exhibition of icons, I went to the address listed in that *National Enquirer* advertisement. I wanted to discover the secret to the Miracle Cloth's potency. What I found was a simple, green one-story frame house, the sort transported on flatbed trucks; it was tucked in behind a car dealership on the north edge of town. A small cardboard plaque set in a slot on its front door identified it as "The House of Power." Unfortunately, I arrived too early for a visit with the staff; office hours were 2:00 P.M. to 2:00 A.M.

The initial reason that *National Enquirer* ad caught my attention was that I was then finishing research for a small exhibition called *Sacred*

Souvenirs: Byzantine Pilgrimage Art that would open at DO the following year. I recognized immediately that the Holy Shroud fit perfectly into what I already had learned from my study of Christian relics. So I assumed that it could not be genuine, any more than the True Cross, the Crown of Thorns, the Holy Nails, or the Holy Foreskin are genuine.

I've always been interested in relics. Maybe that's because I was brought up as a Lutheran in a tiny town in Minnesota. We had neither saints nor relics in our version of Christianity at Hope Lutheran Church. And like nearly everyone else in this mostly Norwegian American community of 1,500, I was suspicious of the few local Catholics, who, I was told, worshipped painted statues. Our Hope Lutheran Jesus in stained glass had light brown hair, pale skin, and blue eyes, just like my father. And he was still bloodless, in the hours just before his arrest, earnestly praying against a large rock in the Garden of Gethsemane.

I encountered Christian relics for the first time at age twenty. It was the summer after my graduation with an art history degree from Carleton College, and three of us rented a blue Citroen 2CV, the anemic French version of the German Beetle, for a grand European road trip. We drove twelve thousand miles, from Paris to Naples to Berlin to Amsterdam, camping all the way and drinking vast quantities of beer. This was my first trip to Europe, and suddenly, my art history books had come to life. I was delirious.

We mapped our path south and west through France, along the medieval pilgrimage route that led from Paris to Poitiers to Toulouse and, ultimately, on to the famous pilgrimage shrine of Santiago de Compostela in northwest Spain. We headed back east and north just after Barcelona, though, toward Aix-en-Provence, because I wanted to drive our little Citroen up Mont Sante-Victoire, that otherwise undistinguished mini-mountain that my favorite artist Paul Cezanne made famous in his

paintings. Our last overnight before crossing the Pyrenees into Spain was in Toulouse, and it was there, in its magnificent Romanesque basilica of St. Sernin, that I first felt the power of relics.

I slowly made my way counterclockwise around that great church, and in every one of its many side chapels, I found teeth, bone chips, or scraps of cloth protected behind dirty glass disks set in elaborate gilded reliquaries. And everywhere, before each reliquary, were rows of votive candles. I was pretty much alone, save for a few old women wearing scarves and dressed in black, kneeling and crossing themselves. My two Carleton friends did not share my newfound fascination with relics, and almost immediately walked out of that dark church into the sunlight of a beautiful June day.

I was absolutely enthralled, which made no sense, given that seven years earlier, at the age of thirteen, I had converted from Lutheranism to unstated atheism. I saw no reason to upset my parents, so I kept my mouth shut. But by that age, the idea of a long-haired man in a robe and sandals rising from the dead suddenly seemed ridiculous to me. So no, I didn't think those relics could perform miracles, as I assumed the women in black did. But still, I felt that I was in the presence of something powerful.

It was around noon when I arrived at the midpoint of my little pilgrimage around the basilica. I was just behind the altar, and I saw steps going down to the crypt, where I assumed I would find at least a few bits of Saint Sernin himself. I recall a landing a few steps down, and stairs going down from there to both the left and right. I have a clear image of that landing in my head: There was a single relic in a little gold box. The label simply read: *Vraie croix*. Given its extraordinary treasure, I was surprised that this golden box with the True Cross was not protected behind thick glass, and that there was no guard around to keep it safe. I remember a hinged lid and a little latch at the front center, with no sign of a lock.

I looked around, as a shoplifter might, and I saw no one. So slowly, I reached forward. And the second that my extended right hand came to rest on that little golden latch, there was an enormous blast from the pipe organ in the balcony above the front door. It was a deep and powerful single cord that suddenly shattered the dead silence of the church. For the first time I understood what it meant to have your hair stand on end.

◆

The other reason that strange ad in the discarded tabloid captured my attention was that just then, in March 1981, my current DO exhibition, *Questions of Authenticity Among the Arts of Byzantium,* was at the mid-point of its four-month run and getting lots of attention. It was a tiny show—just three wall cases in the corridor leading toward the legendary warm and woody Music Room, with its enormous French Renaissance fireplace and its spectacular 16th-century marble arches imported from Italy. It was in the Music Room that Nadia Boulanger premiered Igor Stravinsky's *Dumbarton Oaks Concerto* in 1938, and where, six years later, the Great Powers, at the conclusion of the Dumbarton Oaks Conference, announced the formation of the United Nations. This scandalous little show in those hallowed halls got the kind of media attention that, for the staid Dumbarton Oaks, was both highly unusual and thoroughly unwanted. In the eyes of the keepers of DO's spiritual flame, I was hanging out dirty laundry. For me, though, it was a career milestone and a triumph.

I am fascinated by relics and their power over people, but I'm even more intrigued by forgeries, and I've made a secondary career out of detecting them. I discovered my gift for sussing out fakes in 1968 during my first graduate seminar with the professor who would later become my thesis advisor, the formidable German émigré Kurt Weitzmann. For the first paper in his legendary seminar on medieval

ivories, KW (as we called him behind his back) assigned a single work of art to each student, and as often as not, it was a fake. My assigned piece was supposedly a 10th-century Byzantine ivory jewelry box; it was then on display at the Cloisters in New York in an exhibition called *Medieval Art from Private Collections.*

For me, this was a case of fake at first sight. Suspecting your assigned ivory of being a fake was one thing, but proving it in class was another. I pointed out its clumsy carving, but the swisher at the buzzer was that I had discovered what the forger was using as his model. It was clear that the Byzantine jewelry box was actually a modern pastiche based mostly on a genuine box in an Italian church. But what really blew everyone away was that I found the very book the forger must have owned. Professor Weitzmann told the class that I had nailed it, and I was thrilled.

Between that faked rosette casket in 1968 and *Questions of Authenticity* thirteen years later, I had put my stake in the ground as the aspiring forgery sleuth among the medievalists of my generation. In 1973, I uncovered the largest group ever of faked Byzantine manuscript miniatures and icons, all painted in the 1930s in Athens, by a man named Demetrios Pelekasis. Four years later, I was asked to vet three seemingly Coptic (early Christian Egyptian) sculptures in deep storage at the Hirshhorn Museum in Washington, DC. Not only were they clearly fake, they were the tip of an iceberg of forged late-ancient sculptures—more than 150 in all—churned out in Egypt, at Sheikh Ibada, from the late 1950s into the 1960s, and funneled to the western market via a well-known Swiss dealer. Most major museums on both sides of the Atlantic have at least one of these Sheikh Ibada fakes.

I included Pelekasis and Sheikh Ibada forgeries in *Questions of Authenticity,* but the big scandal of the show was caused by the surprise piece in the first case: a purportedly early Byzantine marble relief showing Christ Healing the Blind Man acquired by DO in Istanbul in 1951, and prominently displayed in its galleries ever since. The buyer was the

2

Too Easy?

Dumbarton Oaks moves slowly, thanks to its many revered traditions and to the enormous endowment left by its founders, the Fletchers Castoria heir, career diplomat, and voracious collector Robert Bliss and his wife, Mildred Barnes Bliss. After my four-mile walk to work, I'd go to my office on the second floor of the Bliss mansion, close the door, and then turn to the shroud. My mail sat unopened for days, because those few scholars who wrote to me hardly expected a speedy response. Dumbarton Oaks was that way in 1981 and, I suspect, is that way today; institutions as wealthy as DO can be that way. This glacial pace was meaningful to my shroud quest insofar as it allowed me to devote lots of my paid DO time to studying the shroud.

First, the Shroud of Turin presents itself as a relic—that is, as something made sacred by contact with Christ's holy body. As its Latin root *reliquia* indicates, a relic is a "thing left behind" by a holy person. This can be a body part of a saint, or something the saint—or Christ or the

Virgin Mary—had touched, like a piece of clothing. By extension, a reliquary is a container for a relic. Beyond an isolated reference in the Old Testament to the power of Elisha's bones to bring a dead man back to life, and the claim in the New Testament that Saint Paul's handkerchiefs had healing powers, the Bible is silent about relics. The authors of the Gospels, in their descriptions of the Nativity, the Passion, and the Crucifixion of Christ, pass over the objects that later became so important to Christianity: the Holy Crib, the Crown of Thorns, the Holy Nails, and the True Cross.

For the first few centuries after the death of Christ, Jerusalem was no more meaningful to a Christian than Athens was meaningful, as the historical place of the brilliant philosopher Socrates, to a Greek. Christ's Tomb, now the focus for Christian pilgrims from around the world, was then hidden in the landfill beneath a pagan temple. It was not until the early 4th century that relics emerged as central to Christian life. Rome's first Christian emperor, Constantine the Great, sent his mother Helena to Jerusalem in 326 C.E. in search of the most holy sites associated with Christ: the Cave of the Nativity, the Holy Sepulchre, and the site of the Ascension on the Mount of Olives. Miraculously, Helena "discovered" the sacred tomb beneath a pagan temple, and she is believed to have found Christ's cross—the True Cross—nearby as well, which proved its authenticity by bringing a man who had just died back to life. From that point, the cult of Christian relics grew, such that by nine centuries later, around 1200, a Russian pilgrim named Antony, during his visit to the Byzantine capital of Constantinople, describes seeing more than three thousand relics in nearly one hundred different shrines.

But how about the Man of the Shroud? I knew right away that the Shroud of Turin is not a work of art in the conventional sense, nor is it a conventional relic. Rather, it belongs to a revered tradition of legendary sacred objects that are both reputed relics and iconic images, exactly the sorts of things I had been studying for my little exhibition on Byzantine

pilgrimage art. These hybrid relic-icons are called in Greek *acheiropoieta*, which means "not made by human hands." Their most familiar example, besides the Holy Shroud, is Our Lady of Guadalupe in Mexico City, but that is only one of a long line of miraculously created images of Christ or the Virgin Mary, including the Veronica Veil in Rome and the *Black Virgin of Czestochowa* in Poland. And I already knew their stories well. The famous Black Virgin—who cradles the Christ Child in her arms—is believed to have been painted from life by Saint Luke, even though Luke is known to have arrived in Jerusalem only after the Crucifixion. Thus, the miracle. The Veronica Veil gets its name from Saint Veronica, who, by medieval tradition, is one and the same with the "Woman with the Issue of Blood," who, according to the Gospels, was healed of her hemorrhage by touching the hem of Christ's cloak. As the story goes, Christ's face was miraculously imprinted on a sweat cloth pressed forward by Veronica as he stumbled on the road to Calvary.

My favorite, though, is *Our Lady of Guadalupe*. According to official Catholic accounts, Juan Diego, while walking from his home village to Mexico City one morning in December 1513, saw a vision of a teenage girl surrounded by light on the slope of a hill. The girl asked him to build a church on the site in her honor. Juan Diego recognized the apparition to be the Virgin Mary and went to tell his story to the Spanish bishop, who responded with skepticism. Juan Diego then returned to the hill and this time the "Lady of Heaven" was waiting for him and insisted that he pursue the bishop, who, on his second encounter with the peasant, showed more interest, asking that he secure a sign from the lady. When the Lady of Heaven heard this, she instructed Juan Diego to gather flowers from the top of the hill, even though it was winter and no flowers were in bloom. To his surprise, he found and gathered fragrant Castilian roses, which the lady herself rearranged on his outstretched peasant cloak. Juan Diego went to the bishop and, after telling his story, opened his cloak. As the flowers fell to the floor, an image of the Virgin Mary

appeared in their place. Another miracle, and another sacred image not made by human hands.

Our Lady of Guadalupe was a late arrival among Christianity's relic-icons. The story of relic-icons begins in the later 6th century in Byzantium, not long after Emperor Justinian built the great church of Hagia Sophia in Constantinople. It starts with an account I knew well in the diary of an anonymous pilgrim from Piacenza, in northern Italy—a diary he kept during his journey to Jerusalem and beyond, around the year 570 C.E. In Memphis, the capital of Egypt, the Piacenza pilgrim is shown a textile with a faint imprint of the face of Christ:

> We saw there a piece of linen on which is a portrait of the Savior. People say he once wiped his face with it, and that the outline remained. It is venerated at various times and we also venerated it, but it was too bright for us to concentrate on it since, as you went on concentrating, it changed before your eyes.

The most famous among Christianity's earliest images not made by human hands, though, is not that Memphis face towel, which was never mentioned again by anyone, but rather the Holy Face, or *Mandylion* (Greek for "towel"), of Edessa. Its fame derives from its many reputed miracles, its extensive travels, and its later misidentification in the medieval West with the Veronica Veil. The basic story evolved to its full richness in the legendary *Narratio de imagine Edessena* of 944 C.E., which was written by a cleric in the court of Byzantine Emperor Constantine VII to celebrate the Mandylion's arrival in Constantinople. The Mandylion narrative, ever evolving, basically involves an exchange between Jesus and King Abgar of Edessa, in Syria. The outcome of this exchange is that Jesus sends something to the king, since he cannot visit him in person, and that thing either heals him, converts him to Christianity, or provides

a guarantee that his kingdom will not fall, depending on which version of the legend you read. According to the 10th-century *Narratio,* King Abgar's messenger, Ananias, was unable to make a drawing of Jesus for the king because of his divine radiance. So instead, Jesus washed his face and dried it with a towel, which miraculously retained his likeness. After the knights of the Fourth Crusade sacked Constantinople in 1204, the Mandylion likely passed, along with most of the Byzantine emperor's enormous relic collection, from the Latin emperor of Constantinople to King Louis IX of France. It found its home in Sainte Chapelle in Paris, where it remained until the French Revolution, when it disappeared.

We do have at least a general idea of what the Mandylion looked like. From texts we know two things: that those who tried to copy the Holy Face "dulled the paint" to make their copies look old and that, at least by the time the Mandylion made it to Constantinople, the image was faint and dim, since Constantine VII needed divine help to see it. When I read this, I thought again of the Man of the Shroud and that holy face in Memphis that was so hard for the Piacenza pilgrim to see. We also know the Mandylion from its two famous copies: the San Silvestro Holy Face in the Cappella della Matilda in the Vatican and the *Volto Santo* ("Holy Face") in the Church of San Bartolomeo degli Armeni in Genoa.

And there is another very important fact about the Mandylion of Edessa, namely, that it has a pre-image existence—that is, a time in the evolution of its legend when what Jesus gave King Abgar had no image at all. A Spanish noblewoman named Egeria kept a travel diary much like that of the Piacenza pilgrim, in which she describes her journey to Jerusalem around the year 380 C.E.: that is, almost exactly two centuries before the pilgrim from Italy. Egeria tells us that during her visit to Syria, she was given a replica of the "thing" that Jesus had sent to King Abgar. What she got, though, was not an image-bearing textile but rather a papyrus letter. Only much later, toward the end of the 6th century, was a towel with a miraculous image said to accompany the letter. So in other

words: That category of thing to which the Shroud of Turin belongs, namely, the relic-icon, or *acheiropoieton,* makes its debut in Christianity in the later 6th century. This means that the Shroud of Turin, unless it behaves by its own rules, cannot date before ca. 600.

◆

Not only does the Holy Shroud present itself as an *acheiropoieton,* it presents itself as a work of art—albeit an odd work of art. I say this not only because of the iconic clarity with which Christ's dead body is displayed, with hair, hands, and blood flow all carefully arranged, and genitals discretely covered, but also because the Man of the Shroud conforms physically not to what we can conjecture of the appearance of a crucified Jewish male in Roman Palestine but rather to iconographic conventions for Christ current in the art of the Middle Ages.

So, given that, and with the assumption that the Holy Shroud does not bear witness to a miracle, it was pretty easy for me to push that earliest possible date for the shroud forward by more than half a millennium, thanks to the axiom that all art is not possible at all times and in all places. Every Art 101 student learns that artistic style changes over time—for example, in ancient Greece, from archaic to classical to Hellenistic. And that classical art in Athens looks different from classical art in Corinth. Beginners in art history also learn that iconography, the story art tells, also changes over time and from place to place, in response to the evolving beliefs and rituals to which it gives visual expression.

My little art history outline for assigning the Holy Shroud to the Middle Ages, which I developed in the first months of my research, included a survey of a few facts about the evolution of Christian iconography that, to the non-specialist, are surprising. The earliest representations of Christ in any guise date from around 250 years after the historical Jesus, and the first images of the Crucified Christ date about

200 years after that, in the 5th century, and those images show Christ with eyes wide open and no hint of pain or blood. The earliest representations of the Crucified Christ showing him with his eyes closed, his head tilted, and streams of blood, date from around 700 C.E. And the first images of Christ laid out dead after the Crucifixion—the Lamentation over the dead body of Christ in the Byzantine East, or, in the Latin West, the Anointment or Entombment of his dead body—date from the later 12th century. Just about then, around 1200, he is also depicted for the first time as what the Greeks call Christ of Utmost Humility, which shows him bust-length, upright, and dead. These last two images, finally, begin to look like the Man of the Shroud.

In the 12th century, Byzantine Easter rituals were becoming more emotional and dramatic than in the past. Unsurprisingly, this new approach to piety had its counterparts in new Passion iconography and in new relics associated with the Passion. Almost exactly contemporaneously with the earliest surviving images of the Lamentation, Emperor Emanuel I Komnenos brought the recently discovered Stone of the Anointment to Constantinople from Jerusalem and installed it in the Monastery of the Pantocrator, where it was widely venerated as a Passion relic. Now lost, this was the stone slab upon which the body of Christ was believed to have lain after the Descent from the Cross, as it was anointed in preparation for the Entombment.

In the summer of 1200, Nikolaos Mesarites, Keeper of the Palace Chapel in Constantinople, inventoried, along with a dazzling array of Passion relics, including the Crown of Thorns, a Holy Nail, and the Holy Lance, the "burial cloths of Christ . . . of linen still smelling of perfume." Mesarites doesn't say that those sheets bore an image of Christ. But from the year 1204, the diary of a French knight named Robert de Clari contains a passage that has long been believed to describe a figural Passion textile. Like a modern tourist, de Clari describes items of interest in the exotic Byzantine capital, including a cloth in the Church

of the Virgin of the Blachernae, that "raised itself upright every Friday so one could see the form of our Lord." That image of Christ, given the principles of Art 101, probably looked much like the Nerezi Lamentation from a few decades earlier, provided, of course, that it was not simply a figment of Robert de Clari's imagination. Or, as Andrea Nicolotti has recently argued, this passage more likely references a liturgical textile with an image of the dead Christ that covered a revered icon of the Virgin and Child, and was raised each Friday to reveal "the form of our Lord" (in his mother's arms) for veneration.

The next step in my iconographic survey is represented by a spectacular altar cloth of the early 14th century whose Christ figure is in a pose remarkably like the Man of Shroud. It is called the Belgrade *Epitaphios* (Greek for "sepulchral cloth"), because it is preserved in that city. Like the Shroud of Turin, this category of Byzantine liturgical textile, which first appears in this form around 1300, shows Christ full length and laid out in death, with his hands crossed over his groin area. Clearly, the Christian world was very slow to embrace the implications of the incarnation in terms of picturing Jesus in his human form, and much slower still in picturing his physical pain and suffering on the cross, and his death. And so just as clearly, the Man of the Shroud cannot, by the rules of art history, date before around 1200 and, given its close similarity to the Belgrade *Epitaphios*, that date is more likely around 1300.

The final iconographic ingredient in my outline of the evolving history of Christ's Passion imagery is the bloody beating evidenced by the Man of the Shroud, which stands in sharp contrast with the nearly bloodless serenity of the *Epitaphios* Christ. This defining aspect of the Holy Shroud resonates with a broader "blood frenzy" that characterized Western European art from the 13th to the 15th centuries, as exemplified by a gory *Andachsbild* ("devotional image") in the Cathedral of Fritzlar, Germany, from around 1350. There was increasing emphasis in Gothic art on intense suffering, especially as revealed in images of Christ beaten,

crucified, and lying dead on his mother's lap. This critical bit of iconography not only helps to firm up a date for the Holy Shroud to around 1300 but it also puts its creation in the Latin West as opposed to the Byzantine East, which never embraced that bloody aspect of Christ's suffering.

◆

Relics and artworks—all artifacts, like all people—have histories, and in search of the history of the Shroud of Turin, I took a deep dive into the medieval texts dealing with the shroud's first appearance in the historical record. The key documents had been assembled, translated, and interpreted around 1900 by two great Catholic scholars: Canon Ulysse Chevalier, responsible for the monumental *Répertoire des sources historiques du moyen âge,* and Herbert H. C. Thurston, S.J., author of more than 150 articles in the *Catholic Encyclopedia.* (Their work has now been updated and the relevant texts explored in much greater depth by historian Andrea Nicolotti, in his monumental volume *The Shroud of Turin: The History and Legends of the World's Most Famous Relic.*) This is what I learned: The Shroud of Turin's story begins not in biblical times and the Holy Land but in 14th-century France. It was being displayed in the mid 1350s in a tiny wooden church in the hamlet of Lirey, just a few miles south of Troyes, which is about one hundred miles east-southeast of Paris. That church, which has since been supplanted by one in stone, was built in the early 1350s by the celebrated French knight Geoffroi de Charny. Geoffroi, who wrote *The Book of Chivalry,* the handbook of knightly behavior, died a hero's death in 1356 defending his king, John II, at the disastrous Battle of Poitiers, the low point for the French in the Hundred Years' War.

I learned that the first thirty-five years in the shroud's history were tumultuous. Initially, in the mid-1350s, it was displayed for a short time, to great public acclaim, but then its legitimacy was challenged by

the bishop of nearby Troyes and it was hidden away, out of the diocese. In the late 1380s, it reappeared in Lirey, in the possession of Geoffroi's widow and his grown son, Geoffroi II. The shroud's legitimacy was again challenged, this time by the successor bishop of the diocese. Finally, in January 1390, Pope Clement VII tried to put the matter to rest by issuing a bull allowing for the continuing display of the shroud in Lirey, subject to two basic conditions: that it be explicitly described as a figure or representation and not as the true burial cloth of Jesus, and that it be denied the ritual honors reserved for relics.

Now, a closer look. We know the story of the shroud between the mid-1350s and 1390 thanks to a series of tense exchanges in 1389 and 1390 involving a number of major figures in French history, with two key players: Bishop Pierre d'Arcis in Troyes (d. 1395) and Pope Clement VII in the Papal Palace in Avignon (d. 1394). Clement VII was the first antipope of the Western Schism of 1378–1417, when there were rival popes in Rome and Avignon. The key documents are that Papal bull of January 1390 (as revised in late May), and the so-called Memorandum d'Arcis, a long letter of complaint to the pope, which likely preceded that January bull by a few months and is what that bull is responding to.

The bishop's memorandum is vivid and compelling, and it lies at the very heart of the question of the shroud's authenticity, as it sums up the over thirty-year scandalous history of the image-bearing cloth in Lirey, and makes a recommendation for what should be done to set things right. He begins with the dramatic claim that in the mid-1350s, the dean of the Collegiate Church in Lirey:

> deceitfully and wickedly, inflamed with the fire of avarice . . .
> arranged to have in his church a certain cloth . . . on which
> was portrayed in a subtle manner the doubled image of a
> single man . . . ; [the dean] falsely asserted and pretended that

this was the very shroud in which our Savior Jesus Christ was enrobed in the sepulcher. . . .

[Bishop Henri de Poitiers] discovered the deception, and how [the image on] that cloth had been artificially portrayed. It was even proved by the artist who had portrayed it that it was made by work of a man, not miraculously wrought or bestowed.

According to Pierre d'Arcis, not only was the dean of the Lirey church falsely claiming the cloth to be the true burial shroud of Jesus, he was faking miraculous cures to dupe the faithful out of their offerings.

Case closed, I thought! Bishop Pierre d'Arcis is telling the truth: The Holy Shroud is a forgery of the 1350s, which is a perfect match for what I had already concluded through my analysis of the Man of the Shroud as a work of art.

But there were two other important things I learned from the Memorandum d'Arcis. The first is that at the moment of its first appearance in the human record, the Shroud of Turin was enveloped in intense controversy. In the Middle Ages, relics meant money and prestige for those who possessed them, so there was fierce competition for the most important relics. I could not think of another major relic that entered the world so thoroughly enmeshed in charges of fake and fraud.

But more striking still, it is exactly when charges of legitimacy are leveled against a relic that pedigree and miracles are invoked as vindicating evidence of authenticity. In the case of that cloth in Lirey, the miracles were said to have been faked, but more important, no pedigree was being offered by its defenders. This object appeared *out of nowhere* in the mid-1350s in Lirey, without an accompanying legend to explain how the "true" burial shroud of Jesus happened to show up in a French village thirteen centuries after the Crucifixion. Why is this silence so

damning? Because supernatural events and accepted legends are essential for relics of Christ and the earliest saints, since the first Christians did not bother to preserve the remains and effects of holy people or mark the locations of sacred events.

According to the Book of Acts, Saint Stephen was stoned to death in the year 34 C.E. by a crowd of Jews after he described his vision of Christ at the right hand of God. But nearly four hundred years passed before his sacred body turned up. According to legend, a priest named Lucian had a dream in which Rabbi Gamaliel, Saint Paul's teacher, told him where to find Saint Stephen's bones. Once unearthed, Lucian was certain it was the "true" body, thanks to the scores of miraculous cures, the earth tremors, and the beautifully scented air that accompanied the discovery. A legend and a miracle. Similarly, the relics of Saint James ended up, centuries after his death, as the magnet for pilgrimage to the famous shrine of Santiago de Compostela in northwest Spain thanks to the most improbable of journeys. According to a 12th-century text, the Apostle James evangelized in Spain but returned to Jerusalem in the year 44 C.E., where he was beheaded by Herod Agrippa. As legend has it, the body of Saint James was transported in an unmanned boat back to Spain and buried somewhere in the northwest. The burial spot seems to have been forgotten until 813 C.E., when a shepherd tending his flock at night saw a bright star that guided him to the sacred bones in the "field of the star" (*compostela* in Spanish). The pope offered generous indulgences to encourage pilgrimage, a magnificent cathedral was built in the 12th century, and soon Santiago de Compostela was among the three great destinations for Christian pilgrimage, along with Jerusalem and Rome.

◆

So in short order I had the answer: The Shroud of Turin was a concoction of the medieval West and most likely dates to the 1350s. And from

the beginning, it was being called out as a fake. What could be easier? In just a few months, I had come up with all the evidence I needed to condemn the Holy Shroud as one great hoax. Why hadn't someone done this sooner? Sure, I had to admit that the Man of the Shroud doesn't look like any work of art I had ever seen, and certainly not like what I knew of the Mandylion of Edessa from its copies, which are clearly works of art. No matter, the shroud was obviously a medieval creation, and someone, someday, would figure out how its image was made.

But beyond that lingering question of "how" there was a second question. From the moment of my first encounter with the shroud, I intuitively felt that something was amiss, but I couldn't put my finger it. The Mandylion of Edessa has a fantastic story linking it back to biblical times and the Holy Land, accounting for its improbable journey westward over the centuries. But the Holy Shroud does not. Why? And more to the point: Why didn't anyone who favored its display in Lirey step forward with a legend to explain and vindicate it? It would be years before I understood why this silence was so important to understanding the shroud's true identity.

3

Banished to the Basement

I was a year into my shroud studies, and it was nearing Easter. It was late morning, and I was in the basement of Dumbarton Oaks, wearing my blue velvet suit, which I otherwise never wore to work. The bright lights were set, the camera was rolling, and the interview began. The Canadian Broadcasting Corporation had learned that someone at DO had strong opinions about the Shroud of Turin, and they had come down from Ottawa to tape an interview to be broadcast Easter week. As it turned out, I would never see the interview, but my mother claims she did, and I believe her. Because she's my mother, and because my hometown in Minnesota is near the Canadian border. I have no idea, though, what she was doing up at 3:00 A.M.

This was my first TV interview. My forgery exhibition a year earlier, *Questions of Authenticity*, had been covered by DC's Channel 5, but the

face of DO on the evening news was not mine but Susan Boyd's, curator of the Byzantine collection and my boss. Sure, it was my show, but that's the way the world works, as I discovered that day.

It was clear to me that TV cameras inside the walls of DO was something that made Director Giles Constable very uncomfortable. Giles was a senior Harvard medievalist with an international reputation who had been sent down from Cambridge by the university's president to oversee this distant DC enclave for research. Most of us didn't like or trust Giles, and it didn't help that he was tall and hunched over, vulture-like, and reminded me of Boris Karloff, both in his looks and his voice. We suspected that his priorities lay with that great parent university of ours up in Massachusetts, which must have its greedy eyes on the huge DO endowment and the fantastic DO library.

Giles Constable was gifted at birth with that aristocratic sensibility that gets neither pissed off nor even angry, but rather, miffed. I'm pretty sure Giles was very miffed—got his feathers really ruffled—when he learned that I had agreed to this CBC interview about the shroud without asking him first. Fakes were bad enough, but the association of this ivory tower among ivory towers on television with a topic as sensational as the Shroud of Turin was really just too much. I suspect Giles considered making me do the interview on a sidewalk somewhere in Georgetown. But as a compromise, he settled on an antiseptic room in the basement, where nothing in the field of vision of those Canadian TV film people—and thus, of the television audience—could connect myself with Dumbarton Oaks or Harvard University.

By then, I should have been better at reading his sensibilities. I had, after all, crossed Giles and the ethos of DO on several fronts already, and had registered various degrees of "offense taken." I taught students using artworks from the Byzantine collection even though Mildred Bliss's mission statement for DO, inscribed in limestone on an exterior wall, makes it clear that this was not to be a place of pedagogy. Much

worse, in my evangelical zeal for spreading the word of Byzantium far and wide, I started a docent program, without asking anyone. Lots of DO people were intensely miffed about that, which took endless tense meetings to sort out. Then I did the fakes show, and now I was pontificating about an object—the Shroud of Turin—that Giles and his ilk certainly considered unworthy of their scholarly attention. It was, after all, something that you would see in the tabloids in the checkout line at the grocery store.

Despite being banished to the basement, my CBC interview went off beautifully. Five minutes with one prop: my Holy Shroud Miracle Cloth from that little green house on the north edge of Richmond. My idea was to pretend that someone walked into my office at DO and presented me with this object, with the aim of learning what it was. I would know nothing of its history and would have to deal with it there and then, with no research. For me, this was like that part of the *Tonight Show Starring Johnny Carson* when Johnny would go out into the audience and invite someone to give the name of an obscure song as a challenge to his band leader, Doc Severinsen, to see if he could play it. "Stump the Band" is what he called it.

This is a game I liked. I especially loved when someone would bring in an object they believed to be a valuable ancient or medieval artifact, and challenge me to identify it. Usually they were fakes, and while Susan Boyd would always beat around the bush, likely to protect our visitors' feelings, I'd jump immediately and gleefully to the painful conclusion.

One day a tony businessman came in and made it a point, up front, to let me know how successful he had been in life and how clever he was at buying art. He then proceeded to show me with great ceremony what he claimed was a medieval ivory carving showing an Evangelist sitting at his desk writing his Gospel. I knew in an instant that the piece was a fake, since it belonged to a group of fakes I'd seen before. Because my visitor was, as we would have said in my hometown in Minnesota, a little

too puffed up, I decided to hone in right away on a damning detail that would deflate his balloon.

"Don't you see?" I said, "The Evangelist is writing his Gospel with a feather quill pen? These pens didn't come into common use until the 18th century. So this carving, which, by the way, is not ivory but cow bone, simply can't be medieval." He left thoroughly irritated with me, and, I suspect, still convinced he had bought a treasure.

Exposing fakes comes at the financial and reputational expense of dealers, collectors, museum directors, and scholars. And while it may seem like a wicked game, it's a game with one overarching noble goal; namely, the truth. A forged work of art tells lies about the past. In the early eighties, the forged "Hitler diaries" were grabbing the headlines. And they offered a perfect example, on a very grand and sinister level, of how fakes can distort our collective understanding of history. Our job as scholars and museum professionals is to construct and understand the past as accurately and truthfully as we can.

The ultimate "catch" for me would be the Shroud of Turin, and that day, in the basement of DO, I had a chance to do that on camera. I recall that I was sitting on the left side of a long wooden table; the camera was at the end of the table, so my chair was pulled out at an angle. As we started filming, my Miracle Cloth from Richmond was resting on the table in front of me, as if just placed there by my visitor, who I pretended was the cameraman. I said that this thing looked like a Christian relic, and Christian relics did not exist before the 4th century. Further, that it was an image-bearing relic, which would push its date forward to at least the 6th century. And finally, the fact that it shows the dead Christ lying out pushes things forward in time much further still, to around 1200. I closed by saying it had a Western look to me; that it was unlike anything I had ever encountered in Byzantium, whose images of Christ in his Passion were characteristically more reserved. So I guessed Italy, around 1200, or perhaps a bit later. (Given the rules

of this staged encounter, I couldn't know anything about Pierre d'Arcis and his memorandum.)

I kept it simple; end of story, and my interview was in the can. I felt good about it, but, as I said, I never saw it on TV. Anyhow, from that day forward, I was, among family members and the folks at DO, an authority on the Shroud of Turin. Over the years, I'd occasionally get a call from a documentary filmmaker, usually looking for some background on current shroud research. Never again, though, was I on camera talking about the Holy Shroud. I suppose it should have been obvious: The shroud documentary filmmakers were in the mystery business, and I was in the business of debunking mystery. And, after all, it was Easter.

4

Through the
Looking Glass

Case closed? Well, not exactly. In the course of my shroud
readings, I came across a recently published lecture by
Averil Cameron, a brilliant classicist and historian of the
late ancient world, whom I had met at several conferences and greatly
admired. It was her 1980 inaugural presentation at King's College,
London, and was entitled "The Sceptic and the Shroud." Averil's lecture
was mostly about the Mandylion of Edessa, which was more than fine by
me, since she agreed with and confirmed what I had already concluded
from my other readings. No, what disturbed me was that Averil Cameron
had crafted her talk as a refutation of the central thesis of a 1978 bestseller
on the shroud by Ian Wilson. His book, perfectly timed to coincide with
the showing that year, was provocatively titled *The Shroud of Turin: The
Burial Cloth of Jesus Christ?*.

The library at Dumbarton Oaks is a medievalist's candy store. It has every book and periodical you could possibly want for your research, and the stacks are closed, which means that if a book is not to be found in its normal spot, which is very rare, you can easily find it on the desk of one of the DO fellows or staff. Nothing ever leaves the building. I rarely used the card catalog, since I knew which specific stack had the books I was interested in. So I would just go upstairs to those stacks, usually after lunch, when the pace of activity was even slower than normal, and roam around, all by myself. I knew many publications that were important to my work by the color of their bindings, so it was very easy.

Over the years lots of books have been written about the Shroud of Turin, and there are periodicals devoted solely to the most recent shroud research. But at the time, in the early eighties, I did not find it at all odd that none of this burgeoning Holy Shroud literature—with the exception of Averil Cameron's lecture—was to be found in the greatest medieval library in American, and perhaps the world. Nor did I then find it strange that virtually none of my fellow scholars had shown any interest in the Shroud of Turin. Many of them studied Christian relics and holy sites, like the Mandylion of Edessa and the Church of the Holy Sepulchre. And there were several renowned academics in my orbit of research who explored in depth the history and meaning of Our Lady of Guadalupe and the sacred cloak of Juan Diego. But almost no one I knew ever mentioned the Shroud of Turin in their publications, despite the headlines it was then grabbing after its 1978 blockbuster showing to more than three million pilgrims.

Perhaps I should have suspected that what I was spending my time on was a topic that my DO colleagues simply didn't care about. Or maybe they thought it was just too obvious. In any case, off I went to the legendary Kramerbooks in Dupont Circle, which stocked loads of publications that everyday people read but would never make the cut at DO.

I found Ian Wilson's *Shroud of Turin* thick, heavy going, and a revelation. I felt that I had passed with him through the looking glass, like

Alice, into a parallel universe, where up is down and clocks run backward. Wilson's main point, which Averil Cameron so elegantly refuted, is that the Shroud of Turin and the Mandylion of Edessa are one and the same. They certainly are not. The Mandylion was a face-only image of the living Christ, whereas the shroud is a full-body image of the dead Christ. But forget that: Ian Wilson somehow convinced himself that the shroud was folded up over those many centuries so that only the face could be seen. And not only that, he believes that since only a few very special people ever saw the folded shroud, that pretty basic live-face versus dead-face distinction was simply overlooked. Why fold it in the first place? Because, says Wilson, the Holy Shroud was understood by those insiders to be so incredibly powerful that knowledge of it was intentionally kept secret.

And I thought: So what? Even if Wilson's readers follow him down that Alice-in-Wonderland rabbit hole they will come to a dead end around the year 600 C.E., when Mandylion's miraculous image first appears in history—which hardly justifies the book's explosive subtitle "The Burial Cloth of Jesus Christ?" Well maybe, I thought, that question mark gets Ian Wilson and his publisher off the hook. But why this convoluted reasoning? And why does Ian Wilson straight out reject what is well-known among scholars of the early church, that relics play almost no part in Christian life before the 4th century? And how can he ignore what everyone who cares knows for certain, that the legend of the iconic towel that Jesus supposedly gave to King Abgar is itself a concoction of the 6th century?

Ian Wilson is honest. Right there on page one of his preface, Wilson tells us where he picked up his cockeyed logic by revealing that he's a true shroud believer, and why. In the sixties, Wilson writes, a British medical practitioner named David Willis "transformed my early agnostic skepticism into total commitment both to the authentication of the Shroud and the essential truth of the Christian faith." Ian Wilson had bought into Willis's belief that the Man of the Shroud is Jesus, which Willis based on his medical man's analysis of the figure's

apparent wounds of scourging and crucifixion. And with that epiphany, Wilson crossed over into the parallel universe of shroud authenticators, who collectively identify themselves as "sindonologists." The word comes from the Greek *sindon*, which in the Gospel of Mark identifies the fine textile Christ was wrapped in after the Crucifixion.

Sindonology, I learned from Wilson, began in May 1898, with the first photograph of the shroud by the amateur Italian photographer Secondo Pia and his discovery that his glass plate negative was much clearer and easier to "read" than the shroud itself. Why? Because unlike the textile, the black and white glass plate shows protruding parts of the body as light against dark. This discovery that Jesus had revealed himself in a photographic negative nearly two thousand years before photography was invented was instantly sensational. That launched what sindonologists call the "scientific age" of the shroud.

Ian Wilson's hefty book covers the gamut of current shroud thinking. His pantheon of sindonologists includes noted physicians, photographers, criminologists, textile experts, forensic scientists, hematologists, historians, and theologians. Wilson sets forth a detailed analysis of the seeming wounds of the Man of the Shroud coupled with evidence that such an apparent beating and postmortem wrapping is consistent both with the Gospels and with ancient Jewish burial practices. He cites an example of fine, herringbone linen from the Roman period as evidence that the shroud could be that old, and invokes a Swiss pollen expert who had access to the shroud in 1973, and claims to have found pollen traces from plants specific to the area of Jerusalem in springtime. And, of course, we are left to ponder with Wilson that baffling discovery by Secondo Pia of the shroud's embedded photographic negative: Can that be anything other than some kind of miracle?

Having assembled this seemingly definitive case for the shroud's authenticity, Wilson moves on to trace its history. He cites, among other things, various medieval works of art where Christ's face looks like the face of the

Man of the shroud, claiming that the shroud's contact capture of Christ's "true" face set the canonical standard for the others. Wilson's main task, though, is to offer a plausible story line to fill in the missing centuries between the shroud's first documented public showing—in the 1350s in the French hamlet of Lirey—and the time of Christ. He does this by linking the shroud to the Mandylion legend, which he accepts as historical fact.

The sindonologists' convoluted writings reflect teleological reasoning. That is, they are looking back from today to the Crucifixion with the foregone conclusion that the shroud is the actual burial cloth of Jesus. And so their job is to fill in the blanks over time with bits and pieces of evidence that seem to support that truth—like the shroud's iconographic footprints across medieval art. This thinking not only leads to inversions of logic (Why couldn't the face on the shroud be copied from medieval art instead?), it inspires the seeing of things that simply are not there, as if the elusive image of the Man of the Shroud were one giant Rorschach test. Francis Filas, longtime Jesuit faculty member in the theology department of Loyola University in Chicago, imagined that he saw the imprint of copper coins of Pontius Pilate over the eyes of the Man of the Shroud. And, most recently, Barbara Frale, a researcher in the Vatican's Secret Archives, claimed to decipher Jesus's death certificate in three languages—Latin, Greek, and Aramaic—faintly imprinted across the shroud.

And I learned something else. Like the evolution versus creationism debate, the shroud debate is not a debate at all; rather, it is an ideological battle, in which credentials and motives are either inflated or impugned. Jewish ancestry, agnosticism, having a generally skeptical nature, and being a "world authority" are all offered as evidence by sindonologists that the source of the opinion is critical and dispassionate. In the much expanded 2010 edition of his book, *The Shroud: Fresh Light on the 2000-Year-Old Mystery*, Wilson ups the ante on his innate skepticism by telling his readers that he had been a "rabidly agnostic south London school boy" and that in his "rampantly anti-Christian mindset at the

time, any Roman Catholic relic automatically had to be a fake." Conclusion: Wilson is trustworthy.

This made me wonder: Am I trustworthy? Should shroud enthusiasts trust a Minnesota Lutheran who quietly became an atheist at age thirteen? Was my skepticism born of the dispassionate thinking of a DO scholar or of the resentment of a Midwestern kid who had turned against his God? And wasn't I thinking teleologically as well, but as a "sindonoclast," with the opposite foregone conclusion?

One thing was certain: I was not going to leave the Shroud of Turin to the sindonologists. It is too important in the history of Christian art and belief not to have the attention of the caliber of scholars I knew at DO. So I formulated my exhibition plan for 1983. It would be called *The Scholar Looks at the Shroud* and it would include the voices of people I already knew: late ancient and medieval historians, art historians, and archaeologists, as well as scholars of medieval religion. And where better for this exhibition and scholarly conference to take place than DO? Who would lead the effort from the academic side? The choice was obvious: Averil Cameron of King's College would chair the conference that would accompany my exhibition of shroud photographs.

◆

Critical deconstruction of the sindonologists' authentication arguments, as they are based on confused linkages of unrelated historical texts, the supposed blood and wounds of the Man of the Shroud, the nature of the linen, the "erroneous" carbon-14 tests, the supposed Holy Land pollen and limestone traces on the shroud, the imagined inscriptions and impressions of Holy Land flowers and coins on the linen fabric—et cetera—may be found in the recent publications of Hugh Farey (2019) and Andrea Nicoletti (2020). Nicoletti also gives a detailed account of the shroud's travels after Lirey.

5

Body Violated

W as I persuaded, even for a moment, by Ian Wilson? No, since for me, the rules of forgery detection are like the rules detectives follow in solving a murder: No amount of seemingly positive evidence in support of the accused can offset that damning, incontrovertible 1 percent that is revealing of guilt.

Nevertheless, Wilson's book left me doubly perplexed: first, by the seemingly violent beating evidenced by the Man of the Shroud; and second, by what is apparently a bloody wrist wound which, one has to assume, is the point of the penetration of a nail during crucifixion. Whoever this man was, he certainly embodies an extraordinary story. Wilson, for his part, gives the account of a French doctor and part-time sindonologist named Pierre Barbet, who in the thirties conducted a series of experiments with cadavers. He discovered that the human body cannot be supported on a cross by nails through the palms of the hands; the nails must be driven through the wrists, since the flesh of the hands will

simply rip away and the body will fall to the ground. In medieval art, the nails of the Crucifixion are invariably set in the palms of Christ's hands. Crucifixion was abolished in the 4th century by Emperor Constantine. So how did the person who created the Man of the Shroud come up with that realistic crucifixion iconography? Obviously, I needed to take another, closer look.

But I was frustrated with how difficult it was to understand the shroud's elusive image. When I look at a work of art for the first time, it will almost always remind me of something I've seen before. And so begins the trail of discovery: Is it authentic? When and where was it created? What does this work of art reveal about its time? The problem was that the Man of the Shroud reminded me of nothing else I'd ever seen. Staring at it did no good. Sure, it's easy to say that the Man of the Shroud doesn't look like a work of art, but that leads nowhere, except for those believers who take this quality as evidence of its authenticity. The Man of the Shroud was initially for me a profound enigma.

What was I to make of that spectacular Byzantine textile, the Belgrade *Epitaphios*, which has virtually the same iconography: the dead Christ bearing the wounds of his Passion lying out flat, with arms extended and hands crossed over his lower torso? The Christ figures are compositionally identical and nearly the same size, and both objects, of course, are textiles. But yet, the two are profoundly different. The Shroud of Turin is linen, as the Gospels require, and the Man of Shroud is difficult to see. The figure appears to have been brutally beaten and is shown front and back, as if having been enfolded in the cloth head to toe. The Man of the Shroud is at once mesmerizing and disturbing, as if it were a photo of a murder victim.

By contrast, the *Epitaphios,* which is red silk, is a highly stylized work of art, with clear and elegant lines and only the most discreet references to the wounds of Christ's Passion and Crucifixion. This Jesus, who shows no signs of a beating, seems to be peacefully sleeping. He has a huge halo

and is accompanied by symbolic, decorative elements that have nothing to do with the reality of a seemingly dead man. While the Man of the Shroud's long arms stretch to cover his genitals, the *Epitaphios* Jesus elegantly maintains his modesty with an elaborately decorated towel. And beside him are his own mourners: six distraught angels, each exclaiming him holy through an accompanying Greek inscription. As I looked at pictures of the Man of the Shroud and the *Epitaphios* Jesus side by side, it suddenly seemed to me as though the shroud's Jesus had been cleaned up, as if by a mortician, for public viewing on the *Epitaphios*. It would be years before I finally figured out how the two are related.

I wondered if there might be other holy shrouds surviving out there that are (or were) believed to have touched the body of Jesus, and pretty soon I came up with two. (There are scores of texts going back to the early medieval period describing a variety of now lost, presumably non-figural sacred shrouds and holy head cloths, and fragments thereof, from Jerusalem, Constantinople, and all over medieval and post-medieval Europe.) One, which is believed to be the Sudarium ("sweat cloth") described in the Gospel of John as lying outside the tomb on the morning of the Resurrection, is kept in an elaborate reliquary in a special chapel of the Cathedral of San Salvador in Oviedo, in northern Spain. This blood-stained, nonfigural cloth was part of a cache of relics preserved in a chest that, according to one version of the legend, remained in Jerusalem until the sack of the city by the Persians in 614 C.E. The chest somehow made its way out of Jerusalem and was ferried from one port to the next along the north coast of Africa until it reached Toledo, the first Christian capital of Spain, and finally came to rest in a cave near Oviedo. Only centuries later, in 1075, was this much revered, awe inspiring container finally opened, in the presence of the King Alfonso VI. The chest was itself considered a relic since it was believed to have been made by disciples of the Apostles; moreover, it contained, in addition to the Sudarium of Christ, what is believed to be some of his blood,

part of the True Cross, some bread from the Last Supper, as well as blood from the Virgin Mary and her robe.

The other holy shroud I found is in the Cistercian Abbey in the tiny town of Cadouin, in southwest France. This cloth, which bears neither image nor blood, is said to have been brought back from the Holy Land after the First Crusade; legend has it that it was preserved after the Crucifixion by a Jewish family. In the later 19th century, the Sainte-Suaire de Cadouin was a huge pilgrimage attraction in that region of France, and was believed to have performed many miracles, some of which are attested by marble votive plaques still in place in the church. In the thirties, though, the Sainte-Suaire was examined by a textile expert, who concluded from its decorative border that it was woven in Egypt in the 11th century.

So what had I learned? While the Man of the Shroud is not a conventional work of art, it is compositionally very similar to the Byzantine *Epitaphios* and it is related, in its creation through sacred contact and its elusive image, to the holy face in Memphis that the Piacenza pilgrim saw and to the Mandylion of Edessa. Of course, the Memphis textile has long since vanished and copies of the Mandylion don't look anything like the Man of the Shroud. I also learned yet again that relics have fantastic stories, but also, that the Christian world can tolerate multiple holy shrouds at a time; and that it's possible for a relic to perform miracles in one century and to be debunked and then ignored in the next. A good start, but what next? Had I hit a roadblock? Perhaps, but as I searched for a way forward, my thinking about the Man of the Shroud took an unexpected turn.

◆

When did I conclude that the Man of the Shroud was created by contact with a real human body? It was just over a year into my shroud

studies in May 1982, around the time of my first public lecture in the Music Room, that grand and historic space where in the fall of 1944, the United Nations had been formulated by world leaders. As far as I could tell from the famous photograph taken on the first day of the conference, my podium was set near the spot where Soviet ambassador Andrei Gromyko was sitting that day.

My first Dumbarton Oaks public lecture was a career milestone, and I remember it vividly. The room was set with rows of folding chairs; the DO El Greco was hanging in its usual spot, just to the left of my podium, and on the Steinway grand piano, just to my right, sat that familiar photograph of Igor Stravinsky in the Music Room. I was wearing my new blue velvet suit, and given that I was then skinny and blond, with short cropped hair, I had the look of a Minnesotan version of David Bowie. And yes, I felt out of place in that oaky, historical setting. The lights were low, and the atmosphere hushed. Perhaps two hundred people were in attendance, with a smattering of Georgetown fans of Byzantium, including Alfred Friendly Jr., son of the renowned *Washington Post* journalist, who usually had an interesting question after the talk, and the venerable *Washington Post* columnist Joe Alsop, who lived just a few blocks south of DO and loved all things artistic and exotic. But mostly the room was chockablock with Byzantinists, including some of the most respected scholars in the world. Just thinking about the Music Room and my lecture makes me feel again like a small-town kid trying to hide his shaky Greek language skills.

I was really nervous. Sure, I had been giving lectures at conferences since the midseventies, but the Music Room is different. I suppose it is a Byzantinist's version of Carnegie Hall. I had typed my lecture, timed it, and rehearsed many times. My slides would be projected by a capable DO staff member sitting in a glass-walled booth at the back of that elegant space, awaiting my cue. Despite his familiarity with the equipment and my meticulous preparation, embarrassing glitches were almost inevitable,

the anticipation of which added greatly to my anxiety. Imagine a darkened room full of very serious, very accomplished scholars, with those just a bit older than me eager to stand up and offer an instant analysis of my paper after I said my thank yous. Typically, they would turn to address the audience and present an exposition on the evening's topic intended to let everyone know how smart they were. My great hope—the hope of any coming-of-age Byzantinist speaking in the Music Room—was to get some sign of approval from one of the truly great senior scholars in attendance. This could be very subtle, such as, literally, a nod and a smile. But it meant everything. So yes, I was anxious. And I recall for one of the first times in my life, at age thirty-five, having trouble sleeping.

The focus of the lecture, which was scheduled to coincide with my little exhibition on Byzantine pilgrimage art in the hallway outside, was Saint Simeon Stylites and the art associate, with his 5th-century shrine, Qal'at Sim'an, in northern Syria. At the center of the shrine's open octagon, where its four huge basilica churches converge, is what remains of the column of the first and most famous Byzantine column-dwelling saint. Simeon Stylites stood in prayer for more than three decades on top of that column, exposed to the elements, as an act of spiritual self-discipline. From that perch, he prognosticated for emperors, healed the sick, and settled domestic disputes. Emperor Zeno built the architectural complex shortly after Simeon's death to enshrine his now-vacant column, and to accommodate the thousands of pilgrims who came to venerate it, many with the hope of sacred healing. Simeon's miraculous powers remained on site in the column itself, which was gradually chipped away by pilgrims, but also in the dirt upon which the column stands. This holy dirt was formed into small balls and stamped with the saint's image, and given out to pilgrims as a sacred souvenir that had the power to do miraculous things far away, if ingested or rubbed on the body.

My lecture—titled "How St. Simeon Made House Calls"—was about those healing dirt tokens and how they did their work. Showing

that they were medicinal, that they were Byzantium's version of aspirin, and much more, was not so difficult. There are many texts describing how these tokens were used in supernatural healing, and my star token, up on the screen, conveniently had the word "health," in Greek, stamped across its front. I ended, though, with a much riskier claim. It involved the palm print that appears on the back side of nearly all Simeon tokens. I took the clarity of the prints to mean that they were intentional. I suggested that pilgrims wanted direct contact with the saint and, specifically, the blessing of his right hand. But this was usually not possible. So I figured that the impression of a human hand on the reverse of these tokens was there to convey the effect of Simeon's healing touch. Did pilgrims believe that was really the impression of Saint Simeon's hand—which it was not, since these tokens were given out only years after the saint had died? Perhaps the monks at Simeon's shrine intentionally allowed them to believe so, and maybe even lied, for the health and salvation of the infirm. It's impossible to say, but my guess is that when his followers were back home and near death, they could easily delude themselves into believing Simeon's healing hand was with them.

I went on to explain how sacred impressions of hands and feet ranked high among early Christian pilgrim attractions, and that they seem to have been used frequently as sources of miracle working. A 5th-century writer describes a famous set of holy footprints atop the Mount of Olives, the site where Jesus is believed to have ascended into Heaven. Even though pilgrims "vie with each other" to get their hands on some of the sand that Jesus had once stood upon, "the earth still preserves the same appearance which it presented of old," as if the sand had been sealed by the sacred feet. Equally renowned were the handprints of Jesus on the column to which the faithful believed he had been bound while scourged—the Column of the Flagellation in the Church of Holy Sion in Jerusalem. These marks are described in the diary of the Piacenza

pilgrim, who claimed that he could see the marks of both of Christ's hands, including his palms and fingers.

There was one troubling question from the audience at the end of my talk. It came from an aspiring DO fellow a few years older than me, and while I don't recall exactly what he said, it was clear he didn't buy into my palm print idea—which made me wonder if others in the room shared his skepticism. But no matter: Palm prints and velvet suit notwithstanding, my Music Room debut was greeted with general endorsement. I had made the cut and was now a bona fide Byzantinist.

Afterwards, though, I remember thinking that I had left something important out—namely, the Shroud of Turin. After all, wasn't it just like those palm prints on the Simeon tokens, except that a whole body was printed on linen—which, after all, is exactly what it's supposed to be, as an "image not made by human hands?" And while I assumed that seeing Christ's footprints on the Mount of Olives and his handprints on the Column of the Flagellation were both products of wishful thinking (like Francis Filas's coins of Pontius Pilate on the shroud), the Simon palm prints and the whole-body print on the shroud are real. In both cases, there is anatomical accuracy in detail that transcends photography and, obviously, neither is a conventional work of art. What elevates these respective prints to the level of unending speculation is just *whose* hands, and *whose* body? And how did they get there?

A palm printed in soft clay is easy to understand. But what does it suggest, if anything, about how a body might have been printed on linen? All I could think of was that the Man of the Shroud might have been lathered up with some kind of ink and printed like a human woodblock. But no, his image is too crisp and subtle, and there are no signs of ink having oozed into the cloth; the scientists of the STURP discovered that when they had access to the Shroud in 1978. And while some kind of ink impression might account for the body print, it would not account for the "blood" that seems to flow so elegantly from that body. Were there

two impressions? Or a single impression that was then doctored with paint? Or maybe it was a single impression whose transfer was achieved solely through the body secretions of the victim. Was the person printed on the shroud hurt? Was he dead? Had he been crucified? At the time, I suspected that he had.

So I was now sure the Man of the Shroud is a real body but, clearly, an odd body. I tried to imagine this shroud man without the wounds, as if I might encounter him on the street. He is big, for sure; seemingly just shy of six feet and more than 170 pounds. He certainly would have stood out in the alleyways of ancient Jerusalem, when the average man was much smaller. I pondered that "trueness" of the Man of the Shroud, and the more I did, the more his image seemed strange to me. Not only is he too big, his arms are much too long. I taught a graduate seminar on Byzantine art at DO in those days, and I devoted one session in my spring 1982 class to the Shroud of Turin. I recall the giggling when I asked one of the boys in the class to lie flat on the Persian carpet in the old DO library where I held class, and overlap his hands, arms extended, across his body. Of course, his hands were over his lower abdomen, well above his genitals. My point was obvious and got the whole class laughing.

There is no way that the Man of the Shroud has normal arms: they are too long by at least six inches. One of the most inventive among the sindonologists, Dr. Frederick Zugibe, longtime chief medical examiner for Rockland County New York and author of *The Cross and the Shroud: A Medical Examiner Investigates the Crucifixion*, claimed that Jesus, like Abraham Lincoln, had Marfan syndrome, a hereditary disorder effecting the connective tissues, of which one of the telltale symptoms is unusually long arms. When I did this little class demo, and invoked the Marfan syndrome idea of Dr. Zugibe, I would send the class into paroxysms of glee as I invited them to speculate from whom Jesus inherited the disorder, from his mother Mary or from God.

So the Man of the Shroud is a real man, presented in such a way as to match conventional iconography of the dead Christ—with a conventional Christlike face. But not so real after all. He is too tall and husky for his time and his arms are too long. And that's not all. It's obvious that his fingers are much too long as well, and he has no thumbs. And one arm is longer than the other. Who is this strange man? This was all both obvious and puzzling to me soon after I began my research, but it would be twenty-five years before I understood why this shroud man was so strange, and why his strangeness is so damning. This is the double paradox that I was trying to work through at the time: that the Man of the Shroud, a human being, is both a real and unreal; and that his image, while obviously not a conventional work of art, is certainly artful.

6

Abort

By the spring of 1982, my quest was becoming an obsession, which was all the more reason to press ahead with my exhibition plan for 1983: *The Scholar Looks at the Shroud.* The show would give me cover for my shroud research, which I was doing when I should have been attending to what Giles Constable was paying me to do, writing a catalog of the sculpture in the collection.

But the shroud called to me, and I had to make this exhibit a success. To start with, I needed high-quality photographs of the shroud for the exhibition, and this brought me into contact with the STURP, which was comprised of a group of more than two dozen American scientists, engineers, blood experts, photographers, et cetera, that was given five days of privileged access to the shroud after its 1978 showing. And in any case, I wanted to include STURP in my conference, since what's the good of humanists talking just with humanists, or scientists talking just with scientists?

After a year, I had gotten to know a few of the STURP group, and other prominent sindonologists as well. My favorite was Alan Whanger, whose day job was practicing psychiatry at Duke University. But in the evenings, Alan and his wife, Mary, would devote themselves to sindonology in their home laboratory, which was their kitchen. In some odd way, the Whangers reminded me of my parents. Like my father, Alan combed his graying hair straight back, wore a large tie clasp, and had the habit of saying "and so forth" as he was trying to explain things. At once Christian and earnest, the Whangers seemed to me always smiling and optimistic—though I knew them only by way of his telephone voice and their videos. I could not imagine either one saying anything bad about anyone, including me, even though I was setting out to debunk the very thing to which they were so devoted. They remained unfailingly cheerful as they tried to set me straight. It reminded me of Sunday school at Hope Lutheran Church.

By the time I was aware of the Whangers' work, they had staked out the "iconography theory," which was their attempt to fill in the thirteen missing centuries in the shroud's history by identifying its iconographic "fingerprints" on works of art going back to early Byzantine times. The Whangers lectured as a sindonological couple and happily sent out video cassettes of their presentations, just for the asking. They had a signature gimmick that required audience participation. Before their lectures, Alan and Mary would hand out large polarized viewing cards that allowed their audience alternately to see one of two faces superimposed as projected on a large screen: either that of the shroud or that of the famous Pantocrator ("All Powerful") icon of Christ at Mount Sinai—or else, that of Christ on a coin of Justinian II. They would painstakingly point out multiple areas of seeming compositional overlap as their audience would rotate their viewing cards, from icon to shroud and then shroud to icon. Among these supposed overlaps was that between a seeming stream

of blood on the forehead of the Man of the Shroud and one of the two wisps of hair at the center part on Christ's forehead on the coin of Justinian II. Alan, who did most of the talking, would then invoke the techniques of fingerprint experts, and claim that the odds are all but zero that the two faces are not causally related. Their basic idea, of course, is that the Shroud of Turin was around from the beginning of Christian time and, because it was recognized early on as the true shroud with the true holy face, it served as a guide for artists as they created the true facial type for Jesus—as exemplified by the Sinai icon and the Justinian II coin.

In the spirit of Occam's razor, though, the iconographic genealogy that connects the three Christ images would logically place the Sinai icon first, the coin second, and the shroud third, for the simple reason that the icon, by its technique and style, is datable to around 600 C.E. and the coin is dated to between 692 and 695 C.E., while the shroud appears in historical sources only in the 1350s. I ran this thought by Alan several times, but he chose to ignore me, and pressed ahead with his polarized viewing cards.

❧

As it turned out, neither the exhibition of shroud photographs nor the conference of scholars and scientists ever took place. And it was not because of the reluctance of Giles Constable to associate Dumbarton Oaks with such a controversial project. True, he may eventually have killed it, but before that possibility arose, I killed the project myself.

I aborted *The Scholar Looks at the Shroud* because of some startling news I received from New Haven one day by phone. Among members of the STURP group I had gotten to know and like was one of the two STURP blood experts, Yale biophysicist John Heller. John was more than happy to endorse my exhibition efforts and to debate the shroud for

hours by phone from his office in New Haven. He and I had a standing bet about the outcome of carbon-14 testing of the linen of the shroud, which John kept saying would happen "soon." He was convinced that the shroud was authentic, so his money—$5 as I recall—was on the year zero, plus or minus. I, on the other hand, said the dial would come to rest no earlier than 1200.

John called me out the blue one day and asked if I knew what "chain of evidence" meant. "Hell no," I said, or something like that. He went on to say that Gilbert Raes of the Ghent Institute of Textile Technology had removed two postage-stamp-size pieces of the shroud in November 1973. He then announced to me "in strictest confidence" that those Raes fragments *had* been carbon-14 dated! He quickly went on to say that the dial had come to rest at 700 C.E., with an error factor of 500 years. I damn near jumped out of my chair! I had won our bet, and he had to agree, since my date worked, while his didn't. But of course, he said, this carbon-14 dating result, by the rules of evidence, really didn't count. Why? Because the Raes fragments could have been tampered with while unattended. Were this a trial, they could not be admitted in court, since the chain of evidence had been broken.

Whether the carbon-14 dating result was legitimate or not, I knew that my planned exhibition and scholarly conference aimed in part at dating the shroud had been preempted by a scientific test that I was not at liberty to reveal. With that, *The Scholar Looks at the Shroud* project was dead. But I can't say that I cared that much, since I now knew for certain, thanks to that test, that I had the right answer, and I felt I could prove it, even without talking about carbon-14. So, what did I need Averil Cameron for? I could have the Holy Shroud spotlight for myself. But I began to wonder: Was that news of this carbon-14 test to be withheld from the public because the chain of evidence had been broken, as John claimed, or because the test was relatively crude and the error factor too great? Or was it because the STURP folks didn't like

the outcome, which would, in effect, have put them out of business? If so, I figured we could expect a second carbon-14 test soon.

After that bombshell phone call, John Heller and I fell out of contact. The last time I saw John was a year later, around Easter, 1983. I was sitting up in bed in my Military Road row house watching Johnny Carson. John, the blood man, was sitting next to Johnny, the legendary host, plugging his new book, *Report on the Shroud*. He was trying to convince all of late-night America that there was human blood on the Shroud of Turin—presumably, the blood of Jesus himself. And I think he succeeded. I had no quarrel with John Heller's blood claim, since I believed at the time that some sort of beating had taken place. Nor did I shout "Liar!" at my television screen, since John could maintain in his own mind the illusion that the Raes linen samples *had* been tampered with along the way, and so the carbon-14 test results were not only invalid as evidence, they were just wrong. And no, I wasn't disappointed that my hero, Johnny Carson, hadn't invited me to be a guest on his show. Johnny's audience wanted to hear about blood and Jesus, not about the history of relics and forgery—and it was Easter. But still, I felt I was getting closer.

7

But for That Call

Had John Heller kept that little nugget about chain of evidence and carbon-14 dating to himself, my life might have turned out very differently. Not necessarily better; just different.

Within a few days of that late-night television encounter with John Heller on the Johnny Carson show, I recall driving up Charles Street, Baltimore's grand old north-south artery, with Alexander Kazhadan, a Russian Jew of enormous scholarly achievement who had recently taken up residence at DO. We were on our way to Johns Hopkins, where he was to deliver a lecture that touched on his current grand project: *The Oxford Dictionary of Byzantium.* I was the dictionary's art editor and had negotiated its funding with the National Endowment for the Humanities and its publication with representatives of Oxford University Press. This was some of the easiest and smoothest dealmaking of my life, not because I'm such a good negotiator, but because Alexander's stellar reputation paved the way.

During his Soviet career, Alexander Kazhdan had written more than five hundred articles, books, and reviews, and now, in the United States, he had taken on the enormous task of this dictionary, with seven thousand entries on all aspects of Byzantine life; to me, this was nothing short of superhuman. Alexander and his wonderfully animated wife, Musja, would never have crossed my path but for the fact that their son, David, was a mathematical genius who somehow got out of the Soviet Union for a position at Harvard. As retribution, Musja lost her job at a Moscow publishing house, and Alexander faced increasing harassment from the academic establishment. The Kazhdans eventually received a visa to Israel and in 1978, ended up at Dumbarton Oaks, where they would stay until Alexander's death in 1997. They were a marvelous, talkative pair beloved by all at DO, and they took great interest in my wife, Elana, and me, in part, I'm sure, because Elana spoke Russian with them, and her parents had been forced out of their homeland for being Jewish. Alexander was the kind of gentleman and scholar that I encountered again and again at DO. Somehow, it seemed that the more accomplished the Byzantinist, the less susceptible he or she was to professional jealously, and thus more generous to people like me.

I remember thinking, as I drove Alexander the two miles north from Baltimore's elegant 19th-century residential center at Mount Vernon Place to the Homewood Campus of Hopkins, that the gulf between those two locations, despite the rows of blossoming dogwoods, was dreary and filled with signs of urban decay. I was surprised that this prime stretch of Baltimore real estate had not undergone some form of revitalization, as so many of DC's struggling neighborhoods recently had.

For Elana and me, Baltimore was a place to visit on a Saturday afternoon—the Lexington Market in particular, for oysters and crabs. We marveled at the fish stalls, where in the spring, next to the rockfish, we first encountered "marsh rabbits," which are muskrats of the sort I trapped as a kid in the little swampy lakes around my hometown

for 50 cents a pelt. In the Lexington Market, though, they were without their pelts, which exposed their dark, bloody bodies and made their enormous teeth look all the more threatening. Sure, we understood Baltimoreans somehow cooked these muskrats, and that made sense. Baltimore, by contrast with Washington, DC, was what we then referred to as a "real city," with neighborhoods of Greeks, Italians, and Poles that had escaped the urban transformations of the sixties and seventies and did old-fashioned things that we found exotic.

But, marsh rabbit aside, Baltimore was also the home of the Walters Art Gallery, which Professor Weitzmann, my Princeton thesis adviser, again and again told me was the finest museum in the United States. I believed him, and why not? The Walters's collection of illuminated manuscripts is second only to the Morgan Library and its medieval collection is second only to the Metropolitan Museum of Art. No, it didn't have the A+ pieces that I saw daily at DO, but it had hundreds and hundreds of fabulous second-tier works that would make for several lifetimes worth of research. And in those days, that's what my world was about. But I didn't have such good feelings about the Walters. Its long-time director Dick Randall was a specialist in medieval ivories, but not, in my view, a very good scholar. In addition, he had a thoroughly unpleasant personality and a condescending manner, which I took as confirmation of my theory about the inverse relationship between achievement and pettiness. Or at least that was my conclusion after 1974, when I applied for the position of curator of manuscripts, and Dick gave the job to his wife instead.

I have always been taken with coincidences. It's possible that Margaret Ingalls died the very day of the Kazhdan lecture at Hopkins, which was around Easter; if not, it happened only a few days before or after—and just a few blocks from the Homewood Campus. Margaret Ingalls, society columnist for Baltimore's evening newspaper, *The News American*, fell dead from a stroke in her backyard while hiding eggs for her annual

neighborhood Easter egg hunt. I could not have dreamed that just fifteen months later, Elana and I and our two daughters would be living in her house and I would be working at the Walters.

With John Heller's surprise phone call, my *Scholar Looks at the Shroud* idea died, which meant I had to come up with another exhibition concept quickly for the spring of 1983. As it turned out, that was not so difficult. DO, with my help, had just bought a spectacular icon of Saint Peter—the finest Byzantine icon in the United States—and I thought: Why not create an exhibition of Byzantine icons with Saint Peter as its centerpiece? The show, the first of its kind in America, was called *Masterpieces of Byzantine Icon Painting*, and while it included just a dozen works, it earned a half-page review in the *New York Times* by the newspaper's leading art critic John Russell. He characterized the show as "One of the more distinguished exhibitions of the year." Kurt Weitmann wrote a short book on our Saint Peter and gave the opening lecture, which was followed by an elegant reception in the fabulous DO gardens. What could be better?

Unfortunately, danger was lurking in my triumph. It was an unusually warm spring evening, and everyone I hoped would show up at the opening did, from as far away as London and San Francisco. It occurred to me that there were different camps of dealers and collectors gathered with their drinks who were unlikely to socially intersect otherwise. The only hint, though, that something might be amiss was an offhand comment from someone whom I trusted that the icon collector from San Francisco was "playing it fast and loose." And then there was my brief encounter in the mail room earlier that week with a senior Byzantinist, whom I very much admired, Speros Vryonis, who told me that the person who formerly owned our Saint Peter icon, the notorious Dutch dealer Michel van Rijn, "[ate] people like you, Vikan, for breakfast."

Had Giles Constable been willing to commit some significant cash for my icon exhibition, permitting loans from Greece, I may have remained

in the dark much longer about antiquities looting, but he had not—and I'm pretty certain I never asked. Because there were very few Byzantine icons to borrow from American museums, I looked for loans from the main icon collectors and dealers in Europe and the United States, among whom was the suave Greek from London, Yanni Petsopoulos, of AXIA Byzantine and Islamic Art. The day after the exhibition opened, Yanni came to my office, closed the door behind him, and then showed me, in strictest confidence, a set of cut-up 13th-century frescoes from a looted church in Northern Cyprus. By then I had figured out that the current flood of icons on the market mostly came from churches in the northern part of the island, which were plundered in the wake of the Turkish invasion in the summer of 1974. I had even become convinced that several icons in my little show were part of that loot, which made me very nervous.

That conversation with Yanni Petsopoulos, on April 28, 1983, was my point of entry into a dark and vast world. Unwittingly and, initially, unwillingly, I became ensnarled in an international web of dealers and collectors linked to the looting of Northern Cyprus. The outcome of my involvement over the next several years turned out to be mostly good. The cut-up frescoes, after having been restored, were eventually returned to Cyprus. So, too, were the looted 6th-century mosaics from the Church of Panagia Kanakaria, thanks in part to my role as expert witness for Cyprus in their famous repatriation trial in Indianapolis.

It was a crazy, sometimes scary, but ultimately exhilarating period of my life that I tried to capture in my book *Sacred and Stolen*. But it was, at times, a very bumpy ride. At its low point, on November 7, 1983, Giles Constable, Harvard's tony DC lawyer Bill Stanley, and I were summoned by the Cypriot ambassador to his embassy on R Street for a stern scolding prompted by my involvement with those looted frescoes, albeit unknowingly at the time. My multiple infractions of DO protocol—my docent scheme, the shroud interview—were minuscule by comparison with the

institutional and personal embarrassment that I had brought on my boss that day. I knew my time at DO had come to an end.

On Christmas Day, 1983, I accepted the position of chief curator at the Walters Art Gallery. My Princeton graduate school friend and fellow medievalist, Bob Bergman, had been appointed director of the Walters in 1981, and he was eager for me join him as chief curator. In retrospect, I count myself very lucky, and perhaps I owe that luck to John Heller and the bombshell phone call with the leaked news of the carbon-14 test. Otherwise, I would likely not have taken on that icon exhibition, and those Cypriot frescoes would not have entered my life. And I probably would have stayed at DO, perhaps for years. In any event, the Walters was a great fit for me; I stayed for twenty-eight years, the last nineteen as the museum's director. And we are still in Margaret Ingalls's house.

◆

When I left DO for the Walters, I brought my shroud quest with me. I suppose, given that I had learned about the secret carbon-14 test, I could simply have declared a private and personal victory and put the Shroud of Turin aside. But I didn't. I felt that there still were many important things to be discovered about the shroud—how that image was made was one of many mysteries I still had to solve. Besides, there was a disturbing question that was filling my head around the time of that drive up Charles Street with Alexander Kazhdan. It had to do with the right wrist of the Man of the Shroud and a bloody wound that began to shake my confidence in much of what I had come to believe was true.

8

Blue Jesus

Sometimes I was confused, but there was only one period, in the mid-eighties, when I had profound doubts about everything I believed about the Shroud of Turin and the Middle Ages—because of that wound on the wrist. This was not just an intellectual questioning; it was a disturbing challenge to what I have always held to be logical and true. Since I was convinced by then that the shroud bears the imprint of a real body, either one of two things had to be true: Either the man printed on the shroud had been crucified, or the artist who enhanced his body print with the Passion wounds had to have witnessed a crucifixion. This, in turn, required either that the shroud dates to before Constantine outlawed crucifixion—violating all the rules that govern the history of relics and the evolution of Christian iconography—or people were being crucified in 14th-century France.

For a while I even thought: Could it possibly be true that the Man of the Shroud *is* Jesus—not the divine, risen-from-the-dead Jesus—but

rather the historical Jesus, that charismatic breakaway Jewish rabbi who had assembled a band of very loyal followers? So loyal that they held on to his burial cloth? And through some natural process combining decaying flesh and the spices then used to anoint the dead, was that cloth somehow imprinted with an image of his dead body?

In the spring of 1983, I made a bet during the dinner after Alexander Kazhdan's lecture at Johns Hopkins. John Baldwin, professor of Medieval French at Hopkins, sat beside me that evening, and over dinner and lots of wine, we became friends. John had a wonderfully agile mind and boundless curiosity. He eagerly engaged with my shroud thinking and, specifically, with my fixation on that wrist wound. Knowing that a second carbon-14 test would happen soon, I offered John this odd bet: the shroud would have to date before 300 C.E. or after 1200, but it could not date somewhere in between. Caught up in the momentary excitement of my formulation of this strange idea, John happily took me on. And while I don't recall what we bet, when he paid up, more than five years later, it was with a fine bottle of French pinot noir.

❖

Fast forward to 1987: Three years have passed since my move to Baltimore, and my shroud research had ground to a halt. Yes, by then I knew quite a bit about the Shroud of Turin, but I was stalled by and disturbed about that wrist wound, plus the brutal beating. I tried to put the shroud behind me and I almost succeeded, given the hectic pace of work at the Walters, which was far more intense and demanding than the slow-motion world of Dumbarton Oaks. Then came an unexpected breakthrough that changed everything.

It was the late winter of 1987, and Baltimore couple Juli and George Alderman had invited me to an exhibition of their collection in a small gallery at Loyola College. It was Friday and I was not at all eager to go;

I was exhausted after a busy week and dozing on the couch. But, after all, Loyola was just a five-minute drive away. I recall circling the small parking lot in the dark a few times and finding nothing. One more shot, I thought, and I'll go home. Then suddenly, with the purposefulness of that *National Enquirer* lying open on the ground six years before, a parking spot appeared. Had that not happened, I suspect that the trajectory of my quest to solve the mystery of the Shroud of Turin would eventually have come to earth with the quiet thud of failure.

I entered a small white box of a gallery. I first saw an interesting Russian icon of Saint Nicholas to my right, but as I approached it, something truly bizarre caught my attention over my shoulder. It was something I had never before seen but immediately understood: a blue Jesus. According to its label, the work, a crudely carved wooden statue, perhaps three feet tall, was created in New Mexico during the later 19th century by a member of the Brotherhood of Penitents. Entitled simply *Blue Crucifix*, it was apparently used in processions during Holy Week.

The instant I saw this blue Jesus, my troubling confusion over the wrist wound and what it implied about crucifixion evaporated. Emperor Constantine's edict outlawing crucifixion no longer mattered, and I was once again on solid ground with my understanding of the milestones in the development of Christian relics and iconography. Why? Because I knew that whoever created that blue Jesus had seen a real crucifixion. It wasn't the anatomical sophistication of the sculpture, which was in the style of folk art—quite simple and rough compared to medieval crucifixes at the Walters. No, it was simply its greenish-blue color, which the carver must have chosen in response to seeing someone turn blue in suffocation—which is how crucifixion takes the victim's life. With that encounter, my shroud quest was reignited.

The Aldermans invited me over to their home a few days later to view their wide-ranging art collection, which includes some superb Pre-Columbian terra-cottas. They also collected, though on a smaller

scale, the art of the *Penitentes,* and they were eager to both show and tell. From the Aldermans, I learned that the Penitente Brotherhood is a secret lay society of Spanish American Catholic men that has been active in northern New Mexico and southern Colorado since the early 19th century. They trace their origins to late medieval Spain and identify themselves with the Third Order of Saint Francis, though for much of their existence, they have been at odds with the formal hierarchy of the Catholic Church, mostly because of their brutal Holy Week rituals. The Penitentes meet in simple adobe halls called *moradas* and are legendary for their hostility to outsiders, who may be greeted with gunfire if they get too close. Initiation into the Brotherhood includes a cross-shaped incision between the shoulders with a sharp flint. The Penitentes are sworn to strict secrecy, which, if violated, can lead to severe punishment behind the closed doors of the *morada*.

Up until at least the thirties, the Penitentes practiced various forms of extreme body mortification during Holy Week, including brutal self-flagellation with braided cactus-fiber whips. One among the brothers would be chosen to be that year's *Christos.* After a solemn procession from the *morada* to a nearby hill, the *calvario*, accompanied by the singing of hymns in rhythm with the strokes of the whip, the Christos would be hooded, and then affixed to a cross with ropes. Gradually, his body would turn blue from suffocation as he would struggle to raise his chest and breathe.

Because of the opposition of the Catholic Church, the Penitentes performed their Easter rituals in secrecy. Nevertheless, a few artists in the thirties captured this bloody drama, and the Aldermans had a recent exhibition catalog of Taos painters with illustrations. The paintings are matched by this eye-witness account from around 1940:

The Penitentes, numbering about thirty, led the procession. First, walked the flagellants, their bare backs streaming

with blood. In unison their whips were raised first over one shoulder and then over the other. They took two or three steps, paused, and then swung the palm whips over their shoulders again.

This kind of penance [the Christos being bound to a cross] used to be one of the most severe, as, after a few minutes of being bound in this manner, the retardation of the circulation of blood would cause the veins of the arms to stand out like cords and the trunk of the body to assume a purplish-blue color.

It wasn't clear to me, either from our conversations or from what the Aldermans had given me to read, whether any of these Christos Brothers ever died during that excruciating ritual. But I was certain that the folk artists who made their wooden crucifixes blue were depicting in their art the physical reality of crucifixion as they experienced it in their own lives. Exactly, I thought, what had happened with the Holy Shroud.

◆

April 19, the Thursday before Good Friday, and just a few weeks after my encounter with blue Jesus. I was heading out of the Albuquerque airport in my rental car on a moonless night—down Highway 25 toward Santa Fe, where my hosts for the weekend, Juli and George Alderman, awaited my arrival. The distance is about sixty-five miles, and every now and then, my headlights would reveal a small group of people walking in the ditch or on the shoulder of the road, heading toward Santa Fe. I had never been to New Mexico, or anywhere else in the American Southwest, so I concluded that was how really poor people got from one place to the other. Elana and I lived in Romania for a year in the mid-seventies, and

we often saw individuals or whole families walking between towns. The next day I found out how wrong I was.

With the Aldermans' advice, I had set out on a mission in search of the Penitentes because I was convinced they held the key to the Man of the Shroud. Before arriving in New Mexico, I had spent a day in Colorado Springs at the Taylor Museum, which has the largest collection of Penitente art in existence. I was in awe, especially of the nearly life-size, free-standing wooden statues of Jesus Nazarene, crowned with thorns and covered with blood. I was immediately reminded of the Man of the Shroud. Christ's knees are especially gory, which made me think that the Penitente Brothers had been walking on their knees to their *calvario*. And Christ's elbow and shoulder joints are hinged, so that he can be affixed to a cross and, when taken down from that cross, will seem to be embracing the Penitente Brother holding him.

I went into storage and found that some Penitente sculptures have human hair, obsidian eyes, and goat teeth, which makes them eerily human. One was outfitted in his open chest cavity with a pig bladder that could be filled with animal blood, making it appear that Christ was bleeding from the spear wound in his side. This must have been especially powerful when experienced in the flickering candlelight of the windowless *morada*.

Our destination on Good Friday morning was El Sanctuario de Chimayo, a small adobe chapel in the desert hills twenty-four miles north of Santa Fe. I had little hope of seeing the Penitentes in action, but Juli and George assured me that this sacred place, where thousands of Hispanic believers would be converging that day, was the next best thing. As we drove out of town, I understood why people were walking in the ditch the night before: They were Holy Week pilgrims walking one hundred miles from Albuquerque to Chimayo as an act of penance. Some traveled in groups carrying large wooden crosses. Because of the press of the crowd on the road, we abandoned our car half a mile from the shrine and

joined the procession. The weather was beautiful, and though the occasion was solemn, the mood was festive, with a family feel. Strategically placed along the final stages of the pilgrims' route were portable toilets, taco trucks, and venders hawking souvenirs to recall the day.

Chimayo is one of Christianity's newer sacred places. Unassuming by medieval standards, its shrine is a simple adobe sanctuary, its attraction a kettle-size hole in the clay floor of a side chapel. According to an often-repeated legend, Chimayo is a holy site—most notably for New Mexico's Hispanic Catholics—because on the night of Good Friday in 1813, a Chimayo friar performing his penance saw a light radiating from a hillside near the Santa Cruz River. He dug a hole at the source of that light and discovered a miraculous crucifix, which was soon named Our Lord of Esquipulas. A small chapel was built on the site. Miracles followed, and in 1816, that chapel was enlarged into the present sanctuary. It is to *El Posito*, the "sacred pit," that the lame and blind come to this day seeking cures from soil sanctified by contact, however indirectly, with the sacred crucifix.

I joined the crowd of pilgrims with Juli and George as it gradually funneled its way into the tiny walled cemetery in front of the chapel. Those carrying crosses deposited them at the chapel's entrance. Then, four or five abreast, we slowly pressed forward down the aisle toward the altar with its mound of packets of holy dirt. We then made a turn to our left, and exited through the side chapel, which was stuffed with votives, including many crutches and prosthetic limbs, signaling that Chimayo is a destination for the miraculous healing of the lame.

Once we joined the crowd in the courtyard, there was no turning back. For the next half hour we were stuck in a glacially slow procession of the pious, packed tightly against one another. This was very difficult for a claustrophobe like me, and there was an added anxiety. Many signs, inside and outside the chapel, warned of the danger of fire, and instructed the crowd in the strongest terms not to carry or light votive candles. I could only conclude that everyone else had put their life in the hands of their

Lord, since that tiny chapel was glowing, warm, and scented, thanks to hundreds of burning candles. My heart was pounding, and all I wanted to do was break loose and run.

◆

That Easter visit to Colorado Springs and Santa Fe in 1987 convinced me that the Penitentes and their art would provide the solution to the mystery of the Shroud of Turin. And of course I wondered: Is there any connection between 19th-century New Mexico and 14th-century France? Once back in Baltimore, it didn't take much digging to discover that the practitioners of the Penitente rituals of self-mortification were inspired by their patron saint and spiritual model Saint Francis of Assisi, who died in 1226. And specifically, by his stigmata, the miraculous wounds of the Crucifixion his body bore—and, more directly, by the Franciscan lay brotherhoods in Italy, France, and Spain that his piety of self-mortification inspired. I soon convinced myself that some 14th-century followers of Saint Francis, in northern France, chose their own version of the Penitentes' Christos, though using nails instead of ropes to affix him to the cross. And I felt my theory was all-but-confirmed when I saw a photograph just after Easter in the *Baltimore Sun* that showed devout Filipino Catholics being nailed to crosses.

I believed I had I uncovered a profound truth about the shroud, whose telltale clues are the wrist wound and the brutal beating: The Man of the Shroud is not just a real man, he's a man who has been crucified. Did he die from crucifixion, or did he pull through after being cut down in time? How could I tell if he was still alive when his body was printed onto the linen? How, chemically, did that print happen? And what role did an artist play in giving that man's body image its iconic clarity? Lots of questions, but one thing I now knew for certain: The carbon-14 dial would come to rest in the 13th or 14th century.

9

Elvis and the Shroud

By the mid-eighties, I was on the lecture circuit earning a little extra cash, which Elana and I desperately needed with our two girls in private school. Mostly, my lectures were some version of the "Glory of Byzantium," which soon became boring to me. I was looking for something more exciting and topical—that is, something that would connect to the lives of real people. And now, with blue Jesus in my pocket, I was trying to figure out how to turn my shroud discoveries into a public lecture. I didn't have to wait long and, as it turned out, my entrée to shroud speaking was Elvis Presley. Together, they made for a volatile combination, as I would soon discover.

I like to think that the architect Philip Johnson introduced the Man of the Shroud to Elvis, though I know it's a stretch. What Philip Johnson did was decide he had something better to do than give the keynote address at Emory University on December 4, 1987, for a scholarly conference called "Medieval Mania." He had agreed to speak, but six months

out, he changed his mind and said no. So the conference organizers called on me to be his replacement. The idea, they told me, was that I should talk about how medieval things live on in modern times, thus the "mania" of Medieval Mania. I assumed that they had wanted Johnson because he could speak about medieval motifs in postmodern architecture. And they told me that one of the speakers was going to compare the current AIDS epidemic to the Black Plague. I, on the other hand, had absolutely no idea what I was going to say.

Weeks went by and I was getting anxious. But then, on August 17, I opened the *Washington Post* to discover the banner headline: "Saint Elvis." The dateline was Memphis, and the reporter was describing what was then unfolding as fifty thousand devoted Elvis fans were converging on Graceland to mourn the tenth anniversary of the King's death from a drug overdose in the second-floor bathroom of his mansion. I had written extensively about the art and rituals of early Christian saints, and now in the *Post,* I was reading about a huge figure in popular cultural associated with pilgrimage, relics, iconic portraiture, and even miracles. Not only was the cult of Elvis an obvious example of Medieval Mania, it provided the key to what would be the remainder of my talk. I had what I thought was a brilliant idea: Elvis is to early saints as the *National Enquirer's* Miracle Cloth is to the shroud, as the Penitentes are to the Franciscan lay brothers of centuries past. In what seemed like an instant, I had all the pieces to my Emory presentation in my head. Yes, our modern world is awash in all sorts of medievalism, but they are not anachronistic. Because every age needs such eternal, charismatic images, and they remain remarkably constant over the centuries. I would call my talk: "The Eternal Power of Eternal Images." And I would begin with that eternal, powerful image of my childhood: Paul Bunyan with Babe the Blue Ox, on the shores of Lake Bemidji, forty-five miles east of my hometown on Highway 2. This, my small-town Colossus of Rhodes, has towered seventeen feet above the prairies of northern Minnesota since 1937.

A few weeks after that moment of epiphany, while checking out groceries at the supermarket, my eye caught a headline on one of the tabloids: "Elvis Reading Religious Book on the Shroud of Turin When He Died." Years later, I found out that was a lie, made up by the King's Memphis Mafia to mask the truth, that the book in Elvis's hands when he went into cardiac arrest on the toilet was devoted not to the shroud but to pornography. At the time, though, I felt I had come as close as an atheist can to divine endorsement.

I was by then so comfortable with my conclusion that the Shroud of Turin was a concoction of the Middle Ages that I didn't feel I needed to argue the point with an academic audience. Rather, my tone would be light and humorous. A jovial mélange, I thought, of inspired silliness, where the shroud would be in the company of blue Jesus, a tabloid ad, a concrete statue of a lumberjack on a Minnesota lakeshore, and, of course, the King of Rock 'n' Roll. This formula worked beautifully on December 4, when I spoke after dinner to a jolly bunch of academics at Emory who had loaded up on wine. There was plenty of laughter when I bet the group 20 to 1 that the shroud, when the carbon-14 tests came back, would turn out to be a medieval fake. I recall one angry grunt from the back of the room at that point, but I dismissed it. Well, I shouldn't have.

Six weeks later, I gave exactly the same talk as the First Annual Johns Hopkins Masters in the Liberal Arts Alumni Lecture in an auditorium on the Homewood Campus. The problem may have been the context, which was serious and wine-less, and the title, which for some reason I changed to "Looking behind the Turin Shroud"—with no mention of Elvis. The audience, I realized only in retrospect, skewed toward shroud enthusiasts, and they wanted a serious talk on the Shroud of Turin with serious evidence that it might be genuine. But I totally dismissed it, within the context of Elvis and Paul Bunyan, as an obvious fake and offered again that 20 to 1 bet on the forthcoming carbon-14 test to drive my point home. This time, though, there was no laugher.

When I finished, the audience of about two hundred was silent. There was a chill in the air, and all I wanted to do was go home. Then a man near the front leapt to his feet, identified himself as a Jew, and angrily took on the bet. I retreated to the punch bowl and thought I had found some relief when a large man came up, very close, to ask me where I had gone to school. Princeton, I said, thinking he had gone there and remembered me. His angry response, which captured the feeling that night, was: "What a waste."

The worst, though, was yet to come, in a letter that arrived two days later from a Walters trustee—and devout Catholic—who felt I had insulted both his religion and his intelligence. He began the third paragraph of his angry two-page denunciation of the evening with this: "You spent an embarrassing twenty minutes of my time leveling your heavy guns at the Elvis cult unfortunates and *National Enquirer* curious as a demeaning paradigm for the Christian faithful." I had never before so misjudged my audience. I was learning the hard way that what is obvious and merely factual—and comical—to me is not at all obvious and merely factual to everyone else. Much less, comical. And that debunking something that people love and believe in can really piss them off.

I figured I had better lay off this shroud-Elvis idea for a really long time. But that didn't stop me from gleefully tracking broad hints in the newspapers the following summer that the results of the carbon-14 testing of the Holy Shroud's linen were going to be announced soon, and that Catholics were not going to be happy. I had been waiting more than six years for this, ever since that call from the Yale blood man, John Heller, in 1982. This would be my vindication. The indignant Walters trustee and all those other angry people in the audience that evening of my fiasco of a lecture at Hopkins would read the headline and gasp: Vikan was right after all! Maybe that grumpy trustee would call to congratulate me; maybe he would single me out for celebration at the next meeting of the Walters board and admit that he was wrong.

10

Right, but So What?

The official announcement was made in Turin on October 13, 1988. I opened my front door early the next morning, just as I did every morning, to fetch my copies of the day's *Times* and *Sun* from the curb. But first, there at the top of the steps, was a bottle of French wine tied with a ribbon and bearing this note: "Congratulations! John Baldwin." I was puzzled, until I opened the *New York Times* and saw the front page banner headline: "Church Says Shroud of Turin Isn't Authentic." The shroud's linen had turned out to date between 1260 and 1390, with a midpoint of 1325. Perfect, I thought.

According to the article, the STURP scientists had been pressing the case for carbon-14 dating of the shroud since 1984. Finally, in late 1987, the Cardinal of Turin, Anastasio Ballestrero, relented, and small bits of linen were snipped off the lower left corner—next to the spot where the Gilbert Raes pieces were snipped in 1973. The three laboratories selected

by the church to do the testing were Oxford University, the University of Arizona, and the Federal Institute of Technology in Zurich. Each was given a postage-stamp-size piece of the shroud along with control specimens of various ages. Only the British Museum, which coordinated the tests, knew which pieces of linen came from the shroud.

The science is pretty simple. A radioactive carbon isotope with the atomic weight of 14 appears naturally in all living things. But when that thing ceases to live, its carbon-14 spontaneously decays back to normal carbon-12 atoms, and it does so at a predictable rate. So by measuring the ratio of carbon-14 atoms to normal carbon atoms, one is able to determine how long ago the living thing in question died. And of course for the shroud, that test would tell us when the flax from which the shroud's linen was made was cut and woven. The shared conclusion of the three labs, with "95 percent certainty," was that the flax of the linen of the shroud was harvested sometime between 1260 and 1390. Bingo: game, set, match, and I win!

Once the carbon-14 test results appeared in print, fully endorsing what I'd been saying for years, I thought two things: first, that my shroud-sleuthing days were over; and second, that the Shroud of Turin was now fair game for lectures like the one I gave at Emory and Hopkins. Walters's director Bob Bergman thought the same thing and invited me to give my Elvis-shroud talk as the keynote for the museum's next black-tie donor dinner. Wonderful, I thought, and I decided on the spot to end my lecture with an absurd bit of theatrics, working off the popular notion that just maybe Elvis was still alive, and that he might at any moment appear anywhere.

My talk, delivered after cocktails, went beautifully, and elicited roaring laughter. Then came the tricky part, which lives on as myth and legend in the minds of the four hundred or so in attendance that night. When I got to the point in my talk when I brought up the idea that Elvis was still alive and among us, the lights in the auditorium were suddenly turned off. A pause, in total darkness and in total silence. Then, from

a little office at the back of auditorium, came the driving rhythms of a small band. A spotlight fell on the door of that office, it burst open, and then, to the grinding beat of a Presley hit of days gone by, appeared an over-the-top Elvis impersonator. He weighed the requisite 250 pounds and covered his totally bald head with a huge, wavy wig that looked like black whipped cream. He wore a silver jumpsuit that was several sizes too small, and it was opened down the front to his waist; it looked like his chest hair was pasted on. Singing a deep-throated imitation of Elvis's ("a hunk, a hunk a") "Burning Love" at full sonorous pitch, he leapt onto the stage beside me, sang a few bars, then worked his way up the side steps of the auditorium toward the exit at the top. Singing all the way, he paused at every third row of seats or so to take a sweaty Elvis scarf from around his sweaty neck and place it around the neck of one of his adoring female fans. A kiss on the cheek and, in a flash, he was gone. The lights were off again, for just a moment, and then on. Had it really happened? Had the King of Rock 'n' Roll really appeared at the Walters?

Six months pass, and I'm at the Giant getting some groceries. At first, I couldn't believe what I was seeing: There in the rack of tabloids was a headline I never expected to see, and it gave me a chill. Sort of like a horror movie from a few years earlier, *Carrie*, when the bloody hand of nutty, pyromaniac, Carrie, who we think is finally dead, reaches up from the earth to grab the wrist of her school chum Sue. Yikes! "New Evidence: Holy Shroud is NOT a Fake," screamed the front page of the *Sun* tabloid for the week of December 19, 1989. I tossed the paper in with my groceries and took it home. The short article invoked the voice and authority of "a top-notch forensic scientist" named Samuel Pellicori. Passing over the recent carbon-14 test results, Pellicori claimed that since the shroud shows a "real body" with a variety of wounds corresponding to the Gospels' account of the Passion, and since Christ's side wound on the shroud matches exactly the size of a Roman spear tip, "it is definitely not a hoax." And in any event, it "shows no evidence of being created by a person."

I'm now amazed at how naive I was about the shroud in 1988. I assumed that with that carbon-14 test the case for its authenticity was closed, and that the STURP folks and the bevy of sindonologists that hovered around them, like the Whangers, would go back to their day jobs. I took my cue of success from that wine bottle delivered to my doorstep by John Baldwin, while I should instead have been paying attention to that angry Jewish guy who attacked me after my Hopkins lecture. A few days after the *New York Times* article, I received his $20 payoff on my challenge bet. The bill was stapled to a three-by-four-inch file card that bore the words: "You still haven't proven how it was made."

The door to the bright future of shroud studies was left open by Cardinal Ballestrero himself, during his announcement of the carbon-14 test results in Turin on October 13, 1988, and duly recorded in the *Times* article the next day. The cardinal said: "These tests do not close the book on the Shroud. This is but another chapter in the Shroud's story, or as some would say, in the mystery of the Shroud." And he was more specific about what that mystery was, when he added that "we do not have any plausible answers to explain how the image of Christ was created." The sindonologists' door was not simply ajar, it was wide open, and I simply chose to ignore it.

◆

Spring 1998, and the Shroud of Turin was again on display, twenty years after being viewed by more than three million and studied for five days by the STURP team of scientists. The occasion was the hundredth anniversary of the fateful photograph by Secondo Pia that rocketed the shroud to international prominence that, a century later, only seemed to be gaining momentum, despite the carbon-14 tests. I was astounded. It was as if that headline of October 1988, "Church Says Shroud of Turin Isn't Authentic," had somehow slipped from collective memory. Sure, I

could imagine that the tabloids and their audiences could just decide to ignore science, but the STURP folks and most of the community of sindonologists that they spawned *are* scientists. And how could the Catholic Church and Pope John Paul II, whom I admired, now sanction the fanfare of a public showing of the shroud that would invite millions of Christians to mistakenly believe that they were looking at the dead body of Jesus?

The worst, though, was *Time* magazine's cover story on April 20, 1998, "Science and the Shroud," which coincided with the events then unfolding in Turin. We see a close-up of the face of the Man of the Shroud, a magnifying glass to suggest the notion of science, and a text overlay, invoking the idea of renewed debate, and ending with the words: "Is this Jesus?" What debate, I thought? What is there left to debate? The short cover story mostly regurgitated what Cardinal Ballestrero said when he announced and endorsed the carbon-14 test results a decade earlier; namely, that despite these and other sophisticated scientific tests, we still don't know how the image of the Man of the Shroud was created. As if this failure by the STURP team and other scientists to understand and replicate the shroud image somehow undid the sophisticated lab work in Arizona, Oxford, and Zurich.

Of course, I hadn't yet figured out exactly *how* the crime was committed, but I was pretty sure I could prove *when, why,* and *by whom* it was perpetrated. The carbon-14 tests results were, for me, definitive, like a DNA match in a murder case. Guilt beyond a shadow of doubt, even if no one has yet shown exactly how the crime was committed, or what the motive was. What jury wouldn't vote to convict? But it made no difference what I thought. The sindonologists were churning out no end of theories by which to discount the carbon-14 dating, ranging from the almost reasonable to the truly bizarre. A group of scientists had recommended to Cardinal Ballestrero that seven samples go to seven labs, and that two different dating techniques be used by each lab. But, of course,

the cardinal sent only three samples to three labs, and only one dating technique was used. What was Cardinal Ballestrero thinking! And why had he not consulted with the sindonologists before he acted so rashly?

The most reasonable shroud defenders said a 5 percent possibility of error (100 percent minus the "95 percent certainty") warranted additional tests, given how important the object is, and how often carbon-14 dating has been shown to turn out wrong. Many others pointed out that the location from which the samples were taken, at the lower left edge, invited contamination, given that was one of the main areas by which the shroud was held up for veneration over many centuries. A corollary to that concern was the claim that the linen thread was not properly cleaned by the three labs and, given the absorbency of cellulose, the fabric could easily have taken on contaminants. Others said the sample patch was sewn on in the Middle Ages. At the extreme were those, like the Whangers, who said that the "atomic" nature of the image transfer would have skewed all the carbon atoms in the shroud. And toward the whacky fringe were the conspiratorial types who charged that the sample pieces had been replaced with medieval linen in order to discredit the shroud in the eyes of Christianity. And the most paranoid of all was the theory that the replacement linen pieces were known by the anti-Christian conspirators to provide a date that would coincide with the shroud's first appearance in the historical record, in the 1350s.

Shroud studies seemed to me awash in outlandish, convoluted theories that would probably have driven William of Occam absolutely nuts. I know for sure they were driving me crazy. I felt I was banging my head against the same wall: people—specifically, the sindonologists—who just wouldn't listen to what I considered nothing more than common sense. And sometimes I felt as if I was on the edge of my own nuttiness, somehow expecting different results from saying the same thing. I would have to find a new path.

11

Pummeled

I couldn't stay angry for long at those absurd tabloids or even at the earnest Whangers, with their polarizing viewing cards. *Time* magazine, though, was different. How could that prestigious publication even *suggest* the possibility of authenticity after the carbon-14 tests, simply because no one had figured out how that body was printed on the linen?

In my written rebuttal to their erroneous piece, I reinforced that relics did not exist before the 4th century, relics with contact images didn't exist before the 6th century, and Jesus lying on the ground appears in art only around 1200. I tossed in blue Jesus and Saint Francis to explain the wrist wound and brutal beating of the Man of the Shroud, I recalled the carbon-14 dating results to 1260–1390, and I finished with a look at the shroud's first appearance in the historical record, in Lirey around 1350. I referenced Pope Clement VII's bull of January 1390, which allowed for the shroud's ongoing display in Lirey, but insists that, when it is offered to pilgrims, there must be an official announcement in a

loud and clear voice that "the aforesaid form or representation is not the true burial cloth of Our Lord Jesus Christ, but only a kind of painting or picture made as a form or representation of the burial cloth." I made the obvious point that the Bishop of Troyes clearly understood the motive for the shroud's manufacture: the money that the Lirey church could wheedle out of gullible pilgrims who were led to believe that they were looking at the true burial cloth of Jesus.

I begged the question of whether the Man of the Shroud was a body print—dead man or living, crucified or not—but offered confidence that, since the carbon-14 test had settled the question of authenticity, someone would eventually figure out how the image was made. After all, I said, there have been lots of shrouds and Veronica Veils over the centuries, and what sets this one apart is simply that it survived. Yet again, I misjudged my audience; and yes, my tone was arrogant.

While *Time* magazine did not print my letter, Hershel Shanks, the publisher of *Biblical Archaeology Review (BAR)*, did. This made sense, given that Shanks had summarized the *TIME* article in his summer *BAR* issue, noting that "no one has been able to account for the image." My letter in rebuttal appeared as a fifteen-hundred-word article in *BAR*'s November/December 1998 issue under the title: "Debunking the Shroud: Made by Human Hands." It was accompanied by a sidebar titled "The Shroud Painting Explained." This was written by the eminent microscopist Walter McCrone, who had been studying the shroud at the request of the Catholic Church for nearly two decades. McCrone had long since concluded, on the basis of multiple samples taken from the shroud's surface with sticky mylar tape, that the Man of the Shroud is "a beautiful medieval painting." As evidence, he said that while there is no trace of blood on the linen, there is an abundance of two common medieval colorants, red ochre and vermillion. Walter McCrone's book *Judgment Day for the Shroud of Turin* would come out in 1999, and this was its thesis in a nutshell.

I was totally unprepared for the response to my "debunking"—much as I had been unprepared for the reaction to my talk at Hopkins a decade earlier. It was a veritable shock and awe onslaught of sindonological orthodoxy from a chorus of twenty voices; McCrone and I had launched a mere two thousand words in our direction, for which we got six thousand words in return. Seventeen of the twenty responses to *BAR* took the pro-shroud position to our con, and even the three who in some way or another questioned the shroud's authenticity steered clear of endorsing either myself or McCrone. Their collective tone was remarkably respectful, though. One dissenter saw in me someone "well intentioned but ill informed."

Nine responses to Vikan/McCrone were printed in *BAR*'s March/April 1999 issue, including a very short note from a preacher in Pennsylvania, who was so angry that he canceled his subscription on the spot. The three most thorough refutations, too long to be printed in the magazine, found eternal life on the internet. One of the three was sent to Shanks by Alan Whanger, and another, titled "Deconstructing the 'Debunking' of the Shroud," was authored collectively by a veritable international who's who of the sindonological academy. It includes arguments taken from an American and a German history professor, as well as from two American historians, two Italian classicists, a Spanish classics instructor, a Canadian physicist, and a librarian from Ohio State University. The lead author was Daniel Scavone, professor of history at the University of Southern Indiana.

Clearly, I had hit a nerve. But what was their aim with this multiauthored letter? It was not to prove that the Shroud of Turin was the authentic burial cloth of Jesus, but rather "to point out why the arguments of ('sindonoclast') Gary Vikan, a noted scholar, fall short of refuting it." Alan Whanger finished his two thousand-word piece with this scolding quote from the eminently quotable Bernard Baruch: "Every man has a right to be wrong in his opinions, but no man has a right to be wrong in his

facts." That pretty much summed things up. They were neither mean spirited nor unfair. The truth is, they had done their homework, and I had not. I blithely repeated the anti-shroud claims of earlier scholars with no verification, and I was dismissive of counterarguments, relying solely on the authority of my voice and reputation.

Walter McCrone and the carbon-14 scientists got more column inches of protest than I did, and I was already familiar with the litany of complaints about the carbon-14 tests. Yet even I was surprised by the vehemence with which McCrone's arguments were rejected, I suspected because they were already familiar to those who follow shroud studies, and because he had once himself been an enthusiastic sindonologist. Everyone much preferred the opinion of the two blood men of the STURP team, Allan Adler and my friend John Heller, that there was real blood there. They refuted McCrone's argument that the Man of the Shroud is a medieval painting with two compelling counterarguments: The Man of the Shroud can generate a digital body image in 3-D, whereas paintings cannot; and while a painter's fluid medium would necessarily soak into the linen, the image on the shroud is confined to the outer fibers. I was left believing that even though McCrone may have been right about the absence of blood and the presence of red ochre and vermillion, he was wrong in calling the Man of the Shroud a painting. The image is much more complex and sophisticated than that.

As for my attempt at debunking, its greatest weakness was that while I claimed, in error, that there had been at least three dozen body contact cloths of Jesus over the centuries, I couldn't produce one that looked anything at all like the Shroud of Turin. I relied heavily on that elusive image of Christ's face that the Piacenza pilgrim saw in Egypt around 570 C.E., but given that it disappeared centuries ago, it was easily discounted. And the surviving Veronica Veil copies in Rome and Genoa are clearly works of art in a way that the Man of the Shroud is not. Daniel Schavone and his fellow sindonologists spent considerable effort refuting

the memorandum of Pierre d'Acris, whom they dismiss as a jealous rival who wanted the shroud for himself, so he could raise cash to finish his dilapidated cathedral.

In essence, my accusers were saying: Put up or shut up. And they were right. In giving total faith to the carbon-14 test results, I simply assumed that the Man of the Shroud had to be a fake and didn't try to prove it, as I should have, by analyzing the image itself. Those who bothered even to acknowledge my blue Jesus idea pretty much dismissed it as coming out of far-left field. And one of my two tepid supporters was eager to point out what I had missed, namely, that crucifixion continued during the Middle Ages as a form of capital punishment in the Islamic world. So forget about New Mexico: look for 14th-century Frenchmen who traveled to the Middle East.

Some of the respondents bypassed us, two shroud heretics, altogether and instead seized on the opportunity, once they had impugned the carbon-14 tests, to recite yet again all their arguments for the shroud's authenticity: the pollen from the Middle East all over the linen; the evidence of blood; the anatomical specificity of the wounds; the link to the Mandylion; the photographic negative before photography; the iconographic trail of the Man of the Shroud on medieval works; and, as Alan Whanger would say, "so on." Since I had read Ian Wilson and kept up with the sindonologists' literature, I knew all of that already. I was even familiar with Alan Whanger's space age theory that the image of the Man of the Shroud was formed by two types of ionizing radiation. His response to my debunking included this provocative sentence: "The situation of a body disappearing from within a folded shroud with the release of electrons and x-radiation bespeaks of a nuclear event of some sort." I imagined, as I read this, how Hollywood would handle the special effects.

With that Canadian television interview in 1982, I became an expert on the Shroud of Turin. But it was only with my debunking attempt in

the *BAR* in 1998 that I entered the courtroom with my adversaries—the shroud defenders. And no jury, hearing McCrone and I argue the case, would have voted to convict.

◆

I felt I was at a crossroads, or maybe a dead end. The Shroud of Turin had come back to life, or rather, continued to live, despite the carbon-14 test results. The Catholic Church, the tabloids, the sindonologists, and even *Time* magazine would remain unconvinced unless and until someone figured out how the image of the Man of the Shroud was created, and then make its copy. I knew Walter McCrone got it wrong: This is not a clever painting. But how was it done? I didn't think I was the one to supply that piece to the puzzle. But if not me, who? And wouldn't that person need to have direct access to the shroud? The STURP folks and McCrone had access, had tried mightily to solve the mystery, and they had failed.

I had run out of ideas, and I just wanted to forget how poorly I had presented my arguments in *BAR*. I didn't need the sindonologists' verbal abuse, and besides, I had other things on my plate, namely, running an art museum. I could not have guessed, though, that at just about the time that those energized sindonologists were sitting down to draft their *BAR* responses to Vikan and McCrone—specifically, on Thursday, October 29, 1998—something was happening in New York City that would eventually lead to the solution of how the image of the Man of the Shroud was created.

An article on the front page of the *New York Times* that late October day caught my attention. It described the sale of the "Archimedes Palimpsest" at Christie's the day before for $2 million. The auction item, which was created in Constantinople in the 10th century, was characterized as the most important surviving manuscript of the works of the famous

Greek mathematician of the 3rd century B.C.E.; it had been studied by an eminent Danish philologist in 1906, but for decades, its whereabouts were unknown. The seller was French, and the buyer had chosen to remain anonymous. The article was accompanied by a photograph of the auction, so I assumed that the new owner of this long lost treasure was there to be seen. The rumor, I later learned, had it that it was a tech billionaire. The day before the sale the Greek government, together with the Greek Patriarchate in Jerusalem, sought an injunction in Manhattan Federal Court to stop the sale, claiming that the book had been stolen in the twenties from a monastic outpost of the Jerusalem Patriarchate in Istanbul. And maybe it *was* stolen, but since theft could not be proven, the auction went forward.

I read the *Times* article before I went in to work. By happy chance, I happened to have arrived at the staff entrance to the Walters at precisely the moment that my super-bright English manuscript curator, William Noel, arrived. I asked Will if he had read about the Christie's sale and he said yes—and wasn't it interesting? So I said, "Will, let's get that damn book and show it here." I wanted the Archimedes Palimpsest for two reasons, beyond the fact that it was now famous and to get it would be a coup: first, because I'm a Byzantinist, and this manuscript epitomizes a wonderful moment in Byzantine history when classical learning was revived and classical texts recopied, to be passed on to the Renaissance; and second, because the Walters has the second largest collection of illuminated medieval manuscripts in the United States. I figured, where better for the world to see this great book for the first time than in our galleries?

How could I know that the Archimedes Palimpsest would bring a brilliant chemist my way? And that his encounter with that manuscript at the Walters would offer him the key to solving the puzzling question of "how" the image of the Man of the Shroud was made? This all would unfold, though, only years later.

12

Thanks, Mel

I n the meantime, the Man of the Shroud reentered my life with a bang, in late February 2004. Thanks to Mel Gibson. First, there was the article in the *Baltimore Sun*. Our local Institute for Christian and Jewish Studies had sponsored an advanced screening of Gibson's *The Passion of the Christ* before a packed house at the grand old Senator Theatre. Their aim was to address head-on the film's potential incitement of anti-Semitism. The article included a picture of my friend Sigmund Shapiro walking out of the Senator in disgust. Too violent, he said, "like a Frankenstein movie." But Sig went on to opine that because the movie was so bad, he couldn't imagine anyone being duped by it into renewed hatred for Jews.

That same week, a friend who knows of my interest in the shroud sent me a link to an interview with Mel Gibson in an Australian online movie magazine. Gibson credits the inspiration for his dramatic lighting and gritty realism to a Baroque artist that he very much admires, the "jailbird

drunk" Caravaggio. And when asked how he responds to those—like Sig Shapiro—who say the film is too violent, Gibson claims that the Shroud of Turin was his guide in staging the ten minutes of unrelenting flogging that is the film's signature scene. "The markings on the shroud," Gibson said, "show there is no skin left on this man." I immediately thought the obvious: In the public's mind, the movie confirms the truth of the shroud, and the shroud confirms the historical accuracy of the movie. Millions of tickets were sold to *The Passion of the Christ* during its initial US run—which, of course, pushed those inconvenient carbon-14 test results ever further into the background of the public's thinking.

A few days before the Baltimore screening, the *New York Times* offered a provocative feature article prompted by Gibson's film titled: "What Did Jesus Really Look Like?" Most readers were probably surprised to learn that there are no representations of Jesus until the later 3rd century, and no biblical-era descriptions of his appearance. The author of the article recounted an effort to answer that question by a forensic anthropologist, who had been hired by the BBC to recreate a plausible face for a Jew in Roman Palestine around the time of Jesus, using a surviving skull from that place and time as his point of departure. The response to that reconstructed Jesus head was so negative—it looked, someone said, like a clueless New York City taxi driver—that the BBC turned it over to an artist to humanize, which he did by modifying the taxi driver's face to approximate his own features.

This was all very entertaining for most readers, I suppose, but for me, it brought home an obvious truth: The Jesus of the Holy Shroud is a typically medieval Jesus, who shares virtually nothing in common with that forensic anthropologist's reconstruction. Medieval Jesus typically has an oval, elegant face with delicate features, long flowing hair, and a short, neatly trimmed beard and mustache, in contrast to the rough, square face and crudely fashioned hair and beard of the forensic anthropologist's Jesus of Roman times. And as for a plausible Jesus body, the

Times article cited evidence from graves of the period to suggest that a walker with an ascetic lifestyle like Jesus would likely have been a sinewy little man, weighing perhaps 110 pounds and standing no more than five-foot-three—which is even shorter by a couple of inches than what I had long believed was normal for that period and region.

I had my own Jesus as a child, and he was pretty much the same as the one in *The Passion of the Christ* and on the Shroud of Turin. My father took a photograph of me in the basement of Hope Lutheran Church after a Cub Scout meeting when I was eleven. Just behind me, as I'm showing off my badges and my Elvis-inspired hairdo, is what I then considered to be the true portrait of Jesus. I was hardly alone in this belief; it was then and still is the most reproduced of all Jesus pictures. It's a head shot, with Jesus looking toward our right. He has shoulder length, flowing hair and closely trimmed beard and mustache; Jesus radiates in warm coppery tones, except for his sacred eyes. They're bright blue, just like mine.

While I fully accepted as natural that Jesus should have had blue eyes, I did not consider his coppery skin accurate. No more than I considered the sepia tones of the two reproduction engravings of Gothic cathedrals in our living room to indicate what those churches really looked like. All these hues told me was that the thing portrayed was really old—those churches I knew were really old, and Jesus was older still. And besides, the three images of Jesus upstairs in the church sanctuary—two in stained glass and the third, over the altar, in sculpture—show Jesus with appropriately pale skin and with light brown hair. This was certainly how he must have looked, given that he had blue eyes. In fact, he looked very much like my father and not so different from lots of those Scandinavian American men sitting in the pews of Hope Lutheran Church.

Of all the possible locations in the church basement for my photo, my father chose the spot just in front of the Jesus portrait. But more than that, he placed me in such a way as to make it appear that Jesus is speaking into my right ear. Seemingly odd, but maybe not. I now think

my father did this on purpose, to create the impression that I was being led and advised by Jesus. Surely, I'd turn out just fine.

Forty-six years later, in 1993, I curated an exhibition at the Walters called *African Zion: The Sacred Art of Ethiopia.* Jesus in that show was clearly a Semite, a man of color—in other words, the Jew that he was. This prompted me to revisit the Jesus portrait which was still hanging in Hope Church. With a little detective work I discovered that the original was painted in 1940 by a book illustrator from Chicago named Warner Sallman. The interesting part is that Sallman was first generation Swedish American. This made me think that this Nordic Jesus prompted the director of *The Greatest Story Ever Told* (1965), George Stevens, to cast the blue-eyed Swede Max von Sydow in the role of his Jesus.

The celluloid version of Jesus that I knew from my youth was very tame. It was as if that blue-eyed Jesus in George Stevens's 1965 movie had walked straight out of the stained glass windows of my church. So I was hardly prepared for *The Passion of the Christ,* with its ten minutes of nonstop flaying and blood everywhere. Not only did Mel Gibson's beat-up Christ remind me immediately of the Man of the Shroud, it prompted an insight that for years had been just beyond my grasp. I suddenly realized with absolute surety that the Man of the Shroud was a real human being somehow captured on linen and then "made up" by a very skilled artist—much as Mel Gibson's Christ, actor Jim Caviezel, had been prepared for his part by Gibson's expert makeup artists.

◆

A 16th-century miniature painting of the Deposition is revealing of the contrived artfulness of the Man of the Shroud, as he is so perfectly and elegantly laid out. In the miniature painting, Christ's arms are the normal length, and converge not above the genitals but higher on

the body—which requires that he be given a loin cloth. A telltale bit of artistry of the Man of the Shroud is the disproportionate emphasis that has been placed on his face and hands, as his torso, legs, and buttocks recede into fuzzy ambiguity. This is exactly what an artist would do, because face and hands are the features of their figural work that call for the greatest artistic skill and attention. And then there's the blood flow, which is smudge-free and almost picturesque. The more I looked at the Man of the Shroud, the more he appeared studied and icon-like.

After conjuring up in my mind what the Man of Shroud looked like when initially printed on that fourteen-foot sheet of linen, I try to imagine a clever artist setting to work. Whether the human model, as a medieval Frenchman, was clean-shaven like Charles VI or bearded like John II, he would certainly have needed the artist's attention to his hair, as well as to his various Passion wounds. It was critical as well that his face project the authentic holy image "look" shared by the Holy Face relics then on exhibit in Rome and Genoa. The shroud's artist achieved all of this with consummate skill.

I began to wonder as I explored the terms used by Bishop Pierre d'Arcis in his memorandum to describe the Lirey Shroud whether I had stumbled on a clue to how the shroud was created. He seems to equivocate on how the Lirey Shroud was made, using both the verb *impingere*, or "impress," as if it were a stamp, and *depingere,* or "paint, draw, depict, adorn" with a resulting *pictura*. I initially assumed that his use of these seemingly contradictory terms was a reflection of his own confusion. But then I thought: Maybe Pierre d'Arcis is passing along information that he got from Henri de Poitiers about how the shroud artist "cunningly" did his work, by impressing and then painting.

It was now obvious to me: The Man of the Shroud, like the Belgrade *Epitaphios* and actor Jim Caviezel in *The Passion of the Christ,* is a work of art, differing only in the specific purpose for which it

was intended and the means by which it was created. But the shroud is much more than that: The Man of the Shroud is an ingenious idea brilliantly executed—an artistic achievement without precedent in the history of art. The shroud's creator was more than a technical genius— he was a gifted artist, working at the intersection of art and science, much as Leonardo da Vinci would do 150 years later.

13

Solved at Last!

After a quarter century of struggling to solve the mystery of the Holy Shroud, I knew one thing for sure: My quest would never be over, and the jury never convinced until I figured out how the image of the Man of the Shroud was created. I thought I had pretty much solved the when, why, and by whom—but I couldn't solve the *how*. It was if I were playing a game of chess and my opponent was an artist who has been dead for more than six centuries. He was a genius, and I was beginning to think that it would take a genius to beat him at his own game. The STURP team tried and failed, as had any number of sindonologists and shroud skeptics, including the brilliant Walter McCrone. Everyone had failed, and so we were all stuck back in October 1988, when Cardinal Ballestrero, speaking for the Vatican, at once endorsed the carbon-14 test results and celebrated the mystery of the Holy Shroud, noting specifically that no one had figured out how

the image came to be. I dreamt of the day when I could call the cardinal and tell him the exciting news that I had solved the mystery. But I had no idea how that dream would ever come true. At least, not until the fall of 2006, when Bob Morton entered my life.

◆

In October 1998, I asked my medieval manuscript curator Will Noel to get the Archimedes Palimpsest for the Walters, and he succeeded brilliantly. The buyer soon became a friend of the museum, and that famous manuscript arrived in Baltimore a few months after the auction, to make its home in our conservation lab for the next decade. We arranged to have it conserved, digitized, and edited by an international team of conservators, imaging gurus, and classical text scholars. The Archimedes research team, assembled by Will and financed by the book's owner, whom we called "Mr. Big" to protect his anonymity, was the Walters's version of STURP.

The word "palimpsest" comes from the Greek *palimpsestos,* meaning "scraped again." The reason this manuscript is called a palimpsest is because it was written in 10th-century Constantinople and then erased and overwritten with religious texts in the St. Sabas Monastery in the Judean Desert in the 13th century. Our challenge was to read under the 13th-century writing to the original Archimedes text of the 10th century. In 1906, a Danish scholar read much of the erased Archimedes text using only a magnifying glass, whereas the Walters Archimedes research team had virtually all the technology in the world at its disposal, including the Stanford Synchrotron Radiation Laboratory. The reason we had access to such exotic equipment is that the quest to recover and read the Archimedes Palimpsest attracted brilliant minds from all over the world, one of the most exceptional being that of Robert W. Morton, PhD. Bob, who lives in a rural compound with its own gas

well several miles outside of Bartlesville, Oklahoma, was then a Phillips 66 chemist. Mostly self-taught, Bob has come up with unconventional and sometimes revolutionary, patentable ideas—like how, chemically, to remove sulfur from oil. The rumor among the Archimedes research team was that Bob's IQ was unmeasurable, and that Phillips had hired him straight out of college with the sole job requirement that he think up brilliant solutions to tough problems. Off hours, Bob Morton has always been a compulsive inventor and backyard experimenter. In his spare time, he used X-ray florescence to identify minute quantities of chemical residue on fossils and from that evidence reconstructed the animal's soft body parts. In 2004, Bob brought his X-ray florescence idea to the Archimedes Palimpsest project. He was convinced that even unseeable passages of the original text could be read through whatever was covering them by the X-ray florescence of the trace elements in their ink—and he was right.

Fast forward to an evening in November 2005. Bob Morton and his teenage daughter Rebecca happened upon a television documentary on the Shroud of Turin that was devoted, as they all are, to the mystery of how the image was created. The Morton family often tackled science projects together, whether for the Walters, NASA, Stanford, or Los Alamos, and they'd take every opportunity to critique one another's work. During a commercial break in the show, Bob explained to his daughter the background of the Archimedes Palimpsest and the chemistry behind iron gall ink; how it oxidizes from black to brown to sepia if it is not sealed with gum arabic (tree sap). When the show returned, Rebecca had a simple but brilliant flash of insight: Perhaps there is nothing at all unusual, much less miraculous, about the image on the shroud; perhaps it was made with the same familiar materials as the script and diagrams of the Archimedes Palimpsest and of virtually all medieval manuscripts: namely, iron gall ink. That would explain why the sepia tones of the Archimedes text and those of the Man of the Shroud are so much alike.

Bob called Will Noel to tell him about the Morton family epiphany because Will had once mentioned to him that the Walters's director was a Shroud nut. Will, of course, passed this on to me. By the time I reached Bob by phone, he and his family had gone from the insight stage to the experimenting stage. Bob told me that he believed that the Man of the Shroud was a body print, and that the medium was iron gall ink. It was not a direct print, though, which would have spread the ink deep into the linen fabric and created a very fuzzy image. Rather, the two constituent ingredients of iron gall ink—tannic acid and iron sulfate—were separately applied to the cloth and to the body, and then pressed together. The Mortons were experimenting to test this idea, with the self-imposed discipline that they use only commonly available materials—like tea and Blood Stop Powder, which is used to stop bleeding among animals. Their aim was to show how easily anyone now, or in the past, could have created a shroudlike image.

What Bob was telling me intuitively sounded right, even before he gave me a brief rundown of the chemistry of iron gall ink. Iron sulfate combined with tannic acid, distilled from the gall nuts of oak trees, mixed with wine or tea or urine, and suspended in gum arabic makes iron gall ink, which turns a deep, rich purple-black when exposed to sunlight in the process of writing on a manuscript page. With continued exposure to air and humidity, the ink fades (literally, corrodes) to brown and then to sepia.

After the call I fished around the internet and found a short introduction to making iron gall ink on YouTube called "Making of the Most Basic Iron Gall Ink." I was amazed to see how two liquids, one pale greenish-yellow and the other milky, turn purple-black when they're combined. So it seemed obvious: dip your hand in one dish and a kitchen towel in the other, and then put your hand down on the towel. And voilà, your handprint is there on the towel. Albeit, a little messy; plus, you've got a black palm for quite a while. I discovered that Pliny the Elder had

pretty much figured this all out in the first century. In order to verify the quality of the dyes that dye makers supplied, he conducted a little experiment recorded in *The Natural History*. He would soak a sheet of papyrus in a tannic acid solution and then dribble the (presumably high quality) iron sulfate dye across the papyrus, noting the deep black drop marks as evidence of quality. So, I thought, just maybe we're finally there. Maybe that essential missing piece to the shroud puzzle is at last falling elegantly into place, thanks to those brilliant folks in Oklahoma.

After a few more experiments, Bob sent a shroudlike print of his face. But for its roundness and spiky short hair, it could be almost mistaken for the face on the shroud. With that I was convinced: A genius had beaten a genius at his own game. And I was struck by how simple and obvious the answer was. Occam's razor proves itself once again. The difference between, on the one hand, Bob Morton and his daughter, and, on the other hand, myself and the STURP folks, is what sets really smart people apart from the rest of us.

Bob told me that all the shroud's creator had to do was apply tannic acid to the subject's body and then press a dampened cloth over him to pick up his latent image in tannic acid. That image could then be "developed" into a print using a second linen cloth dampened with iron sulfate. The image could be subtly controlled because a visible tannic acid body print would result only where the two linen cloths made contact. The contact print would match the Shroud of Turin insofar as it would appear, after corroding, in shades of sepia, with relative tonal saturation depending on the pressure of the contact. And it would be a negative, with the protruding parts of the subject's body revealed as dark against light. The shroud artist could rinse the linen and the print would remain permanently; he could repeat the process and gradually build up a full body image, front and back, taking care to keep each successive print in register with the one before it, like a multicolored lithograph.

Where the Man of the Shroud needed longer-than-normal arms to cover his genitals discreetly, the artist could simply insert another arm section until the hands could be added in their proper place. And where the body needed iconographic embellishment to approximate the wounds of the Passion, the artist could simply paint them directly onto the fabric—thus, the blob of "blood" over the upper hand. *Bingo!* I thought. I had read about what was discovered a few years earlier when the 15th-century backing was taken off the shroud: While the Man of the Shroud did not seep through the cloth to the back side, the prominent backwards "3" of apparent blood flow down his forehead did. So it suddenly seemed obvious to me. Using this approach, the artist of the shroud would, in effect, be the medieval equivalent of Mel Gibson's makeup artist of *The Passion of the Christ*. One applied his imagination and skills with makeup to an actor, while the other applied his imagination and skills with paint to a subject's body print.

14

Insulting Jesus

April 6, 2007, Good Friday, and the Walters auditorium was packed. I had invited Bob Morton up from Bartlesville, Oklahoma, to tag team with me on stage for an afternoon lecture entitle "Unravelling the Shroud of Turin." The regional press had been tipped off by the Walters's PR department that something big was going to be revealed about the shroud for the first time in public; both the *Baltimore Sun* and the *Baltimore Examiner* sent reporters. There were nearly four hundred gathered that afternoon, including, in the back row, Juli Alderman, my longtime friend and Walters trustee who had introduced me to blue Jesus two decades earlier. As I waited to take the podium, I recalled what I did as a child at precisely that hour on Good Friday. The seven Vikans gathered in a pew at Hope Church to hear Pastor Arvid Bratlee deliver his annual Good Friday sermon based on Christ's "Seven Last Words" spoken from the Cross. The passage "My

God, my God, why have you forsaken me" seemed to me a perfect match for the stained glass window showing Christ praying against a big rock in the Garden of Gethsemane. I wondered, when still a believer, how God could be so mean.

Bob and I talked over our respective presentations the evening before over dinner at The Helmand, a wonderful Afghan restaurant near the Walters that is owned by Qayum Karzai, brother of Hamid Karzai, then president of Afghanistan. I would speak first and handle the when and the why, and the by whom, reviewing as I did the history of relics and Christian iconography and, of course, recalling the carbon-14 dating and the Memorandum d'Arcis. I would, in effect, elegantly drop the Holy Shroud into a metaphorical little box labeled "forgery," precisely defined by time and place: the 1350s in Lirey, France. Then Bob would step to the podium and explain the "how." We challenged ourselves not to exceed sixty minutes: forty for me and twenty for Bob.

If only Cardinal Ballestrero were there in the audience, if only Ian Wilson was—or, at least, those wonderfully sweet and whacky Whangers. But I was certain that they all would soon read about our groundbreaking discoveries in the newspapers. The *Baltimore Sun* would surely publish a major article, perhaps on the front page, and that would be picked up by the *Washington Post* and the *New York Times*. And maybe before the week was out, Bob and I would be on NPR. What a triumph: twenty-five years and one month after finding that *National Enquirer* in a melting snowbank, I had, with Bob's help, finally solved the mystery of the Holy Shroud.

But the unequivocal agreement with our revelation did not happen quite as I had hoped. The response to the Vikan/Morton Shroud extravaganza ranged from silent acceptance, to various shades of grunting skepticism, to outright vocal hostility. Were there too many believers in the room? Was Good Friday a bad choice? Or maybe the

problem was that we had attracted all the sindonologists in Baltimore and Washington. It certainly didn't help that we went on for ninety minutes. Whatever the reason or reasons, our case was hardly enhanced by what Bob chose as the subject for his "shroud" body print demonstration. Not his own body, not that of his son, but rather that of his beloved family pet: Leo, the floppy-eared Bluetick Coonhound. There was Bob, stepping forward from the podium on the afternoon of Good Friday to unfold and display for all to see the "shroud of Leo."

The *Baltimore Examiner*, now defunct, ran a photo of Bob holding up his dog shroud, pretty much without comment. The *Baltimore Sun* said nothing. And Juli Alderman, among others, walked out before we had finished. In her case, I wasn't surprised. Our shared exploration of the Penitentes in the later eighties had the unexpected outcome that Juli and her husband George became shroud groupies. This meant not only a trip to Turin for the 2000 showing, but also excursions to various shroud conferences around the country, where they met the STURP team, the Whangers, and all the rest, including Jewish sindonologists, like shroud photographer Barrie Schwortz, who had come to believe that the Man of the Shroud and Jesus were one and the same. Juli and George knew all the arguments for authenticity, and from time to time, after a we had shared a few glasses of wine, they would launch into their shroud narrative, which they absolutely believed was the truth. The Holy Shroud and their Christian faith had become inseparable, and I began to think that my identification with the anti-shroud sindonoclasts was, for the Aldermans, an insult to their intelligence and a challenge to their faith. Our friendship was suffering, so I avoided bringing up the shroud and hoped, futilely, that they would stay home that Good Friday afternoon. Of course, the Aldermans were hardly the only ones who felt that their faith and intelligence were being insulted that afternoon.

◆

As a senior Byzantinist and as the director of a major art museum, my opinion on professional matters was sought and respected, but when it came to my ideas about the Holy Shroud, I grew to expect rejection. *National Geographic* was producing a documentary on the Holy Shroud on the occasion of its 2010 exhibition. Their editors had heard about me and were eager for an on-camera interview. Initially, there was a breathless intensity to our conversations. They would fly me up to their Toronto studio—or, better yet—they would bring their film crew down to Baltimore as soon as possible.

Then came the background conversation. It was clear that the *National Geographic* shroud team had heard that Morton and I had interesting things to say, but they didn't know much about what those interesting things were. I recall a long, one-sided conversation with one of the editors. I told her that the documentary's title, which included the word "mystery," was totally wrong. There was no mystery: The Shroud of Turin is a forgery from mid-14th-century France, and that's that. Bob Morton has not only figured out how the shroud's image was created, he has, in effect, recreated the shroud in his own home. There was mostly silence from the other end of the line; then the call was over, and I never again heard from *National Geographic*. I remember seeing the documentary, though, and my stand in, who had been flown to Turin for his segment of the piece, was filmed bounding up the steps of the Turin Cathedral spouting various versions of the word "mystery."

Oddly, this made me think of Natalie Wood, because she was the first movie star that I had a crush on when I was little, and her belief in Santa Claus. Natalie Wood was always, for me, the divinely cute eight-year-old Susie Walker in *Miracle on 34th Street* (1947). I saw the movie for the first time when I was five or six, and even then, I didn't believe in Santa. But Susie did. Could I imagine dissing Santa Claus, AKA Kris Kringle, AKA Edmund Gwenn, in front of little Susie? Hardly. Though maybe that's what I was doing in the Walters auditorium just before

Easter to the Holy Shroud. What has always seemed to me nothing more than solid scholarship was that day, for my audience, an assault on something sacred.

This means, I had finally realized, that the Holy Shroud would likely remain, for many, eternally stuck in the netherworld of the *Da Vinci Code* and creationism, where faith trumps science and where Occam's razor remains tucked away in its protective leather sheath. In this inverted world of the Holy Shroud, iron gall ink has no more meaning than does carbon-14 dating or the rules that define the history of Christian relics and the evolution of Christian iconography. Or what Bishop Pierre d'Arcis had to say. None of this makes any difference, since what is valued is not a solution to the mystery of the Shroud of Turin, but rather the mystery itself—which is a divine mystery. So I began to think "so what?" Santa is harmless, the shroud is harmless. Best to leave it alone. But I couldn't, which turned out to be a good thing.

15

Bodies in the Rhone

This time the shroud reentered my life in Avignon where, in July 2008, Elana and I were vacationing. Before lunch on our first day, we toured the Papal Palace and the nearby Musee du Petit Palais. In the Papal Palace, we encountered a drawing for a large fresco of Christ in Glory by the great Sienese master Simone Martini, who, we learned, died in Avignon in 1344, while in service to the papal court. That drawing got me thinking again about the shroud and, specifically, about Bob Morton's shroud recreations. When I compared in my mind's eye the face of the Man of the Shroud with Bob's version, it was obvious that the shroud is not just a tour de force of medieval technology, it's the creation of a talented artist. That morning my thinking about the Shroud of Turin took a U-turn. All those years I had been trying to prove what the shroud is *not,* and at that moment, it occurred to me that the more interesting question is what the Holy Shroud *is.* I began to wonder: Who was that artist and whom was he working for? And why did they do this?

From the palace we went the museum, where we saw plenty of medieval paintings by Italians, one of which opened another new door for me in my thinking about the shroud. It is an early 15th-century panel painting showing the *Bianchi,* the Confraternity of the White Penitents, in their hooded robes with bloody backs exposed, under the protection of the Madonna della Misericordia. Up until then, I had been thinking in general terms about Saint Francis, his stigmata, and the flagellant movement among the Penitentes. Now, I made the connection between the artist of the shroud and what he may have seen out the window of his studio that inspired the tormented version of Christ he created.

Back in Baltimore, I was off to the Hopkins library to learn what I could about flagellation in the Middle Ages. I already knew what the sindonologists' line was. Ian Wilson goes into great detail about the apparent flagellation wounds of the Man of the Shroud, citing Robert Bucklin, former Los Angeles County medical examiner, whom he credits with making the most exhaustive studies of the injuries visible on the shroud. Bucklin claims that the Man of the Shroud's wounds were "obviously" made with a whip with sharp edges, which was applied in a flicking fashion in order to pull out bits of the skin. Wilson and other sindonologists anchor their discussion of those apparent wounds in the brief Gospel references noting that Jesus was "scourged" before being crucified. Given their rejection of the carbon-14 dating, they go on to link that Gospel reference not with possible medieval sources on whipping but rather with what is known from ancient texts about the Roman *flagrum,* whose leather strips, they say, were tipped with metal pellets to enhance the damaging impact of each blow. But I soon found plenty of evidence of exactly those kinds of whips and scourging in Europe close to the moment when the shroud first appeared in Lirey. I discovered that in the later 13th and the 14th centuries, flagellantism was a popular form of public penance that existed on the fringes of Catholic Church control. The flagellants were at once washing away their sins and, in the manner of Saint Francis, sharing in

the suffering of Christ. Significantly, flagellantism's first appearance, in Perugia in 1260, in response to famine and political unrest, coincides with the first carbon-14 dating bracket of the shroud.

Participants, typically dressed in hooded white robes with open flaps on the back, would whip themselves violently with the medieval version of the Roman flagrum. There were solemn hymns and chants, and ritualized movements, which included falling to the ground the instant Christ was mentioned. A Paduan, Anonimo di S. Justina describes the scene as the flagellants processed through city squares stripped to the waist:

> they marched two by two, each one carrying a whip with which they continuously beat themselves on their shoulders until the blood began to flow, uttering groans and shrill lamentations.

The flagellant movement spread out of Northern Italy into most of Western Europe just after its first appearance in Perugia, and then died down as suddenly as it had appeared. It reemerged, though, with even more intensity, during the mid-14th century, in response to the spread of the Black Death. Heinrich of Herford, a critical observer of the brutality of the reemergent flagellants, provides the most detailed record of their activities in his *Book of Memorable Matters*, from 1349:

> With these flagella they beat and whipped their naked bodies to the point that the scourged skin swelled up black and blue and blood flowed down to their lower members and even spattered the walls nearby. I have seen, when they whipped themselves, how the iron points became so embedded in the flesh that sometimes one pull, sometimes two, was not enough to extract them.

Flagellantism was part of a broader "blood frenzy" that characterized European church ritual and art from the 13th to the 15th centuries and that stood in stark contrast with the first twelve centuries of Christianity, when references to the shedding of blood are extremely rare. Specifically, there was increasing emphasis in Gothic art, just as the shroud appeared in Lirey, on intense suffering, especially as revealed in images of Christ beaten and crucified. Inevitably, art is a reflection of its world, and the world of France, in the mid-14th century, was unhappy and dangerous. The Hundred Years' War had recently broken out, and France was off to a disastrous start, having lost major battles at Crécy in 1346 and Poitiers in 1356, when King John II was taken hostage and Geoffroi de Charny, the shroud's first owner, was killed. But worse by far was the Great Mortality of 1348–50, when fully a third of the population of Europe died at the hands of the Black Death.

The Pestilence entered Europe from Crimea two months after the fall of Calais to the English, by way of twelve Genoese galleys that put in at the Sicilian port of Messina in early October 1347. It spread northward rapidly, reaching Paris by summer; there, it quickly took fifty thousand lives. Destined to kill half of Europe's population in its multiple appearances over the second half of the 14th century, the Black Death came in two forms. The bubonic plague manifested itself in buboes (swollen lymph nodes) in the armpits and groin and was spread by rat-borne fleas, while the more virulent pneumonic plague attacked the lungs and was spread directly by coughing. Explanations—beyond the popular belief that God's wrath was at work on a sinful world—included the notion of corrupt air or miasma, the idea that the Jews had poisoned the wells of Christians, and, as its prime cause among the intellectual elite, the medical faculty of the University of Paris, the fact that Saturn, Jupiter, and Mars had converged in Aquarius on March 20, 1345. This released the "evil air."

I was never able to find out how the Great Mortality specifically affected Troyes and nearby Lirey, but I learned plenty about its impact

on the pope's city, Avignon, which in those days was said to have seven each of churches, monasteries, and nunneries, and eleven houses of prostitution. The Plague entered Avignon in January 1348 and lasted seven months, killing half the population in two phases, the pneumonic and the bubonic. Guy de Chauliac, physician to Pope Clement VI, the builder of the Papal Palace, didn't understand how contagion works, since he claims that "not only did one get it from another by living together, but also by looking at each other."

In Avignon, as everywhere else, trench graves were dug in churchyards. The stench was unavoidable, and these mass graves were filled so rapidly and haphazardly that dogs would drag cadavers away at night. In this city alone, eleven thousand bodies were buried in a six-week period. Eventually, the pope stepped in and consecrated the Rhone River, so that the dead could be tossed off the city's famous bridge and float out to the Mediterranean. Francesco Petrarch, a frequent visitor to Avignon, described a desolate postwar-like scene of "empty houses, derelict cities, ruined estates, fields strewn with cadavers, (and) a horrible and vast solitude encompassing the whole world." "Now we are quite alone," he observed and then noted that the human race is all but extinct and wondered: "is the end of the world soon at hand?"

The Great Mortality had a profound impact on art, beyond taking the lives of some leading artists, like the Lorenzetti brothers, Pietro and Ambrogio, the Sienese masters who had created some of the most spectacular frescoes of the era in Siena and Assisi. Two of the greatest works of 14th-century literature, Giovanni Boccaccio's *The Decameron* and Geoffrey Chaucer's *Canterbury Tales,* are set within the context of the Plague. In the former, one hundred tales are exchanged among a group of Florentines who have taken refuge from the Plague's initial onslaught in Fiesole, while in the latter, written just over a generation later, stories are recounted among thirty pilgrims fearful of the Plague as they travel from London to the shrine of Saint Thomas Becket in Canterbury.

The Black Death led to a dramatic increase in artworks showing Christ's Passion and saints who suffered like Christ, most notably Saint Francis. In addition, two saints specifically associated with the Plague gradually rose to prominence: Saint Sebastian and Saint Roch. The reasons are obvious. The Plague was evoked in iconography of the time as an attack on mankind with lances or arrows. Sebastian, an early Christian martyr, was shot full of arrows by Roman soldiers but was saved from death by God. Roch was a 14th-century pilgrim to Rome who got caught up in the Plague. He administered to the sick, miraculously healing many, but then became ill himself and was expelled from Piacenza. He retreated to the forest, where he was kept alive by a miraculous spring and a loyal dog, who brought him bread and licked his wounds until he recovered. Saint Roch is usually shown with a broad-brimmed pilgrim's hat and pilgrim's staff; he lifts his tunic to reveal a welt, and beside him is his faithful dog.

Images of death and decaying bodies became a signature for the age. One new and popular iconography, exemplified by the famous frescoes in the Camposanto in Pisa from the late 1330s, is the *Triumph of Death*, a composition in which three men on horseback encounter three dead men in coffins: one recently deceased, one bloated, and the third a skeleton. Even before the arrival of the Plague, there was clearly a fascination with the decaying of the body, and with the cautionary reminder that this is the state that we will all one day reach. After the arrival of the Black Death, funerary monuments for the wealthy not only became more common and elaborate, they now focused on the grim reality of disintegrating flesh, as if the entombed were visible as they decayed. Clearly, this was an anxious world, all too familiar with dead bodies in repose, like that of Christ on the Holy Shroud.

It was as well a time when comfort was sought in revered holy images of Christ, especially those in Italy. When Pope Boniface VIII initiated the first jubilee year in 1300, his intention was that these mass convergences

of the faithful on Rome for "great remissions and indulgences for sins," which were to be obtained by visiting Rome and "the venerable basilica of the Prince of the Apostles," would take place only once every century. But medieval Europe was in crisis at the mid-14th century and at the urging of Petrarch and Saint Brigitta of Sweden, Clement VI declared 1350, just at the end of the first devastating round of the Black Death, a jubilee year. Rome was again awash in pilgrims, many attracted specifically to view the Veronica Veil in St. Peter's Basilica (it was likely lost during the sack of the city in 1527). The much-depleted Holy City, at the time without a pope, then had a population of about fifty thousand, which must have made the influx of pious travelers—perhaps a million between Christmas and Easter—all the more dramatic and profitable.

In addition to the enormously popular Veronica Veil, which was called the sacred Sudarium, there was a second "true" holy face on display at that time for pilgrim veneration in northeastern France. This was the Holy Face of Montreuil, now called the Holy Face of Laon. In fact, it is a Serbian icon of the first half of the 13th century, bearing the inscription: "The Face of the Lord on the Handkerchief." The Holy Face of Montreuil was a major draw at the Cistercian Nunnery in Montreuil-en-Thiérache, where it was sent in 1249 by the abbess's brother, who was treasurer of the Vatican and later Pope Urban IV. Presented and understood as a copy of the St. Peter's Veronica, the Holy Face of Montreuil shows the Mandylion/Veronica iconic image: a neckless face of Christ in Byzantine style before a background representing the textile against which it was imprinted. According to the letter sent at the time of its donation, the image was understood as "a Holy Veronica" with a "true image" of Christ.

Famine, war, and pestilence all added up to a terribly grim world that was primed to receive yet another relic image of its savior. Though now, a version of Jesus fully in tune with the brutality of its time. Enter the Holy Shroud.

16

Lirey Comes to Life

The day the puzzle pieces of the Shroud of Turin all finally fell into place—more than three decades after I came across that article in the *National Enquirer*—I was squinting up into the sun, trying to make out what our eager guide, Alain Hourseau, was pointing toward with great enthusiasm. We had just met him, at the appointed time for our tour, beside the north tower of the Cathedral of Sts. Peter and Paul. Alain had long, disheveled grayish hair that seemed to cascade from his head, and for someone in his fifties, he retained the impish, irrepressible smile of a teenager, with energy to match. He was pointing up at the underside of the tower's base and chattering something that even Elana, after forty years of teaching French, could not make out. "Ah, there, I see it!" A little naked putto is having his way, doggy-style, with a pig. I took a look through my telephoto lens, and it was clear that the winged one is as happy as can be, but the violated pig is snarling like an angry dog. No matter, we were all bent over laughing, the ice was

broken, and we'd instantly bonded. This was not a small matter, since Alain and I have very different ideas about the Shroud of Turin, and on that day, he was going to introduce us to Lirey.

Even though I had convinced myself that the story of the shroud—at least its public story—began in the 1350s in the village of Lirey, in northeast France, I had never taken the opportunity to go there. It would hardly have been a natural stopping point en route to another travel destination. Lirey is the tiniest of tiny towns, with almost nothing to show nowadays of its medieval past. Geoffroi de Charny's wooden church, where the shroud was first shown to pilgrims, has long since vanished, and his nearby chateau, too, disappeared ages ago. So whatever could be learned from present day Lirey, I had picked up on the internet, via Wikipedia and Google Earth. From my cozy study on Chancery Road in Baltimore, with my two Boston terriers asleep on their dog bed at my feet, I effortlessly followed Highway N77 south of Troyes for about ten miles, took a left at Villery onto D108, and soon made another left onto D25, which blends on a curve into D88. There, I parked my virtual French rental car beside the 19th-century stone version of Geoffroi's 14th-century Collegiate Church. Lirey, whose official population at last count was eighty-nine, is noteworthy in cyberspace mostly for its role in the story of the shroud. I saw from Google Earth that the surrounding countryside is rolling farmland, which reminds me of northern Minnesota.

All very simple, and that's where I left it. Until the summer of 2017, as Elana and I were planning a September trip to Paris. By then, we were both retired and had plenty of time, so we decided to add a side trip or two. One would be to the capital of French cuisine, Lyon, where the spirit of the legendary Paul Bocuse reigns and the memory of *quenelle de brochet*—so inadequately translated as "fish cakes"—still lingers glowingly from my last visit, in 1971. Then we thought of Normandy, with its D-Day beaches, Bayeux Tapestry, and calvados. After all, we had not visited Normandy in more than three decades. Everything was set, until I recalled that intriguing

casting mold for Holy Shroud pilgrim badges that a jogger found beside a road near Lirey in 2009. A photograph of the mold had been published by an amateur scholar of the region named Alain Hourseau, but the mold was badly damaged and difficult to see, and nowhere in his 265-page book did he say where the mold is now. It occurred to me that I should see this important object first hand, as I had seen the shroud pilgrim badge at the Cluny Museum in Paris years before—the one that had been found in the Seine in 1855.

With an internet search, we discovered that Troyes is a beautiful small city filled with half-timbered houses and shops; it's easy driving distance not only to Reims and the Champagne region but also to some famous World War I battle sites. We'd take a train from Paris, hire a driver-guide, and make a day excursion north, then enjoy the sites and restaurants of Troyes for a day or two, and somehow slip in a quick trip down to Lirey by taxi to have a look around. I assumed that the shroud badge mold that turned up in 2009 had to be in the town's archaeological museum, next to the cathedral, even though it didn't appear on the museum's website.

Elana urged me to contact Alain Hourseau, via his personal website, just as a courtesy, which didn't appeal to me, since he finished the introduction to his book *Autour du Saint Suaire et de la Collégiale du Lirey (Aube)*, by thanking the "eminent specialist" Ian Wilson. I was certain that Monsieur Hourseau lived on the other side of Alice's looking glass and that our encounter would be tense. But I relented. And guess what? Our new best friend, Alain Hourseau, not only offered to be our tour guide to Lirey but also was going to take us to a fancy restaurant in nearby Bouilly. What are our favorite French dishes? He asked if *escargot* and *choucroute* were to our liking. And a few days later, we heard from Alain again: A friend of his is a reporter for the regional newspaper *L'Est éclair*, and he wants to interview me about the shroud, next to the church in Lirey. This unanticipated email exchange got us to the sidewalk beside the Troyes cathedral at 1:00 P.M. on

that beautiful and magical September day in 2017, looking up at a putto making love to a pig.

We very soon discovered that Alain Hourseau knows pretty much everything about the Department of Aube and the Region of Champagne-Ardenne, ancient, medieval, and modern, including the best outlet store for Lacoste shirts. (His wife Monique works for the company, which is headquartered in Troyes.) Alain is an associate member of the Société Académique de l'Aube, and while his day job is superintendent of some Swedish owned key factories in the region, his real passion is local history, and he has published lots of books on the topic. Plus, he referred a few times that day to a secret underground chamber connected to his house where the Knights Templar hid from the wrath of Pope Clement V in the early 14th century. What could be more exotic and wonderful? Not only had we found a serious guy, we had found a very generous and knowledgeable serious guy, with a great sense of humor, who loved to chatter away about all things local. And who seemed to be a bit hard of hearing, since as we drove off toward Lirey, Alain left his seatbelt unfastened and seemed oblivious to the relentless beeping.

Elana was the translator as we drove; I sat in the back. "Où est le chemin romain?" I'd shout from behind every now and then. Alain seemed not to hear, or maybe he just wasn't paying attention. Rather, he was momentarily enraptured with an ordinary looking hill off to our right, which he claimed is the site of a Roman fortress—and, of course, we believed him. Why shouldn't we? Then a quick left onto D108, a small road for local traffic with no center line. And just as quickly, Alain pulled his fancy new hybrid Honda onto the left shoulder. We got out, seeing nothing but fields of what looked to my Minnesotan eye to be soybeans, with just a few trees here and there. Alain was gesturing toward what I took to be an access road to the nearby fields for farm equipment. Just a pair of tire tracks in the white clay soil that dominates the area. Alain pointed up the road, which makes a slight detour around a tree about one

hundred yards in the distance, and exclaimed: "Voilà, la voie romaine!" He then pointed out the tiny Troyes cathedral tower ten miles in the distance and said that we were standing on what remains of the Roman thoroughfare that once connected the Champagne region to the north with Burgundy in the south.

Suddenly, in the light-headed delirium brought on by food poisoning I had picked up the evening before from steak tartare, I envisioned that little road clogged with pilgrims coming to venerate the Lirey Shroud. It is the year 1355, springtime, when pilgrims traditionally hit the road. Chaucer tells us that in his *Canterbury Tales*. There are pack animals, horses, and wagons, but most everyone is walking. I look for flagellants, but there are none, which is not so surprising, given that Clement VI outlawed the practice in 1349. I had recently seen a German-made video showing the medieval mode of walking: Soft leather shoes called for steps that came down on the ball of the foot, so there is a kind of dancelike elegance to the hoard of pious folks coming my way. They set out that morning from Troyes; perhaps they had come to town for the annual Fair of Saint John, which was said to have brought traders from "beyond the Alps." Commerce and piety make fine companions.

Later that day, after our stop in Lirey, Alain and I were kicking up the dirt in the field where he said that shroud pilgrim badge casting mold was discovered. We found no second mold with our shoe-enhanced archaeology, but Alain turned up a terra-cotta bowl fragment that he said was 12th century. He gave it to me, and I took it back to Baltimore. I remember the moment less for the digging than for Alain saying that it was odd to find the mold so distant from Lirey. But to me it wasn't odd. Much as I saw that Roman road packed with pilgrims, I envisioned this field chockablock with their tents, along with portable food stands and mead vendors, and little workshops for artisans casting pewter souvenirs; one has just damaged his mold and tosses it aside. Such was the magic of that day, which reminded me of my visit more than a quarter century

earlier to Chimayo, on Good Friday, with its thousands of pilgrims, some walking from as far away as Albuquerque. In my mind's eye, I could recall taco and beer vendors and all sorts of souvenirs for sale, some of which looked remarkably like shroud pilgrim badges. I wondered about medieval portable toilets.

After the Roman road and before that archaeology field, we visited Lirey, which had lots of surprises. There, parked opposite the church, was a sporty little car covered with pictures from front pages of *L'Est éclair* and, beside it, stood my new best reporter friend Jean-Michel van Houtte. (When Elana characterized Alain as like an American cowboy, Jean-Michel responded that he saw him as "un grand aventurier.") With the reporter's arrival in our group, there was a crescendo of syncopated chatter in rapid-fire French, suddenly broken by a sweeping gesture on Alain's part, as he pointed toward the *pigeonnier* in the distance, letting us know that this was the single bit of local architecture remaining from the time of Geoffroi de Charny.

Alain quickly explained to Jean-Michel that I was the only one of the many shroud enthusiasts he had welcomed to Lirey who does not believe that it is the burial cloth of Jesus. Ian Wilson's name was then invoked a few times, and I chimed in to tell them that my version of events has a huge local benefit over Wilson's, insofar as the Shroud of Turin is really the Shroud of Lirey, since that is where its story began. Alain and Jean-Michel are a very agreeable pair, and they seemed pleased with that idea, which, after all, leaves Alain, that mold, and his book as key components of my Lirey-centric interpretation. Just then a man appeared through the gate in front of his house opposite the church; he was older than me, short, and very trim, which made me think that he spent lots of time in his garden. Very French, I thought. Anyway, Alain quickly recounted to this man my idea that the shroud story began right there across the street, with Geoffroi de Charny. We then saw a broad smile, and my other new friend said something to the effect that he had believed that all along.

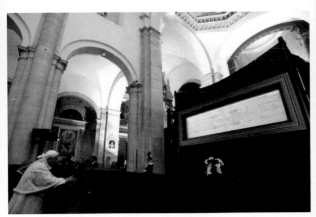

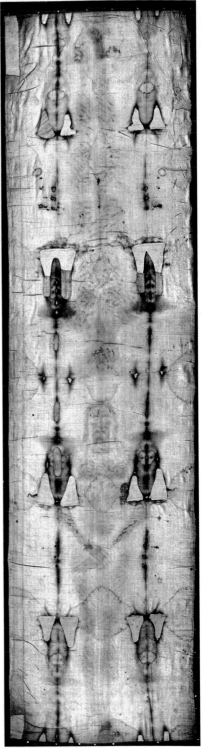

ABOVE: Pope Benedict XVI Praying before the Shroud of Turin, Cathedral of St. John the Baptist, Turin, Italy, May 2, 2010. RIGHT: Dead Christ, Shroud of Turin, embellished body contact print, iron sulfate and tannic acid with red ochre and vermillion on linen, Avignon or Paris, early 1350s; Turin, Italy, Chapel of the Holy Shroud, Cathedral of St. John the Baptist *(1978 Barrie M. Schwortz Collection, STERA, Inc. All rights reserved.).* BELOW: *Deposition from the Cross with the Shroud of Turin,* painting, oil on canvas, Giulio Clavio, Rome, Italy, ca. 1540, Galleria Sabauda, Turin (*Wikimedia*).

ABOVE: "The Holy Shroud," *National Enquirer*, Spring 1981. BELOW: Christ Healing the Blind Man, marble sculpture, ca. 1950 (modern forgery), Istanbul, Turkey(?); Washington, DC, Dumbarton Oaks, no. 52.8 (*photo courtesy of the author*).

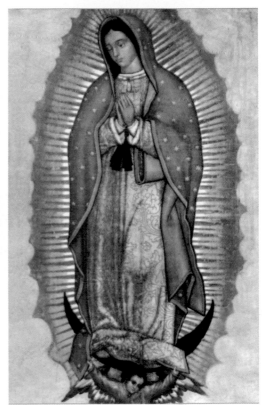

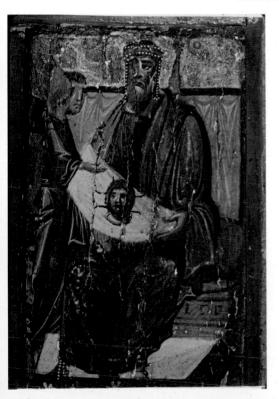

ABOVE LEFT: Road to Calvary (detail), icon (left panel of a triptych), tempera on wood, Georgios Klontzas, Venice, Italy, second half of the 16th century; Baltimore, MD, the Walters Art Museum, no. 37.628 (photo courtesy the Walters Art Museum). ABOVE RIGHT: Our Lady of Guadalupe, peasant's cloak (*tilma*), oil paint on fabric, Mexico City, 16th century; Mexico City, Mexico, Basilica of Our Lady of Guadalupe. LEFT: King Abgar Receiving the Mandylion of Edessa, icon (right panel from a triptych), tempera on wood, Constantinople, 10th century; Mount Sinai, Egypt, Monastery of Saint Catherine (after Weitzmann, 1976, B.58).

LEFT: *Volto Santo* or "Holy Face" of Christ, painted textile on wood, Italy, medieval; Genoa, Italy, Church of San Bartolomeo degli Armeni (after Il Volto, 2000, no. III.2). BELOW: Christ of Utmost Humility, icon (back of double-sided panel), tempera on wood, Constantinople, late 12th century; Kastoria, Greece, Byzantine Museum (after *Glory of Byzantium*, 1997).

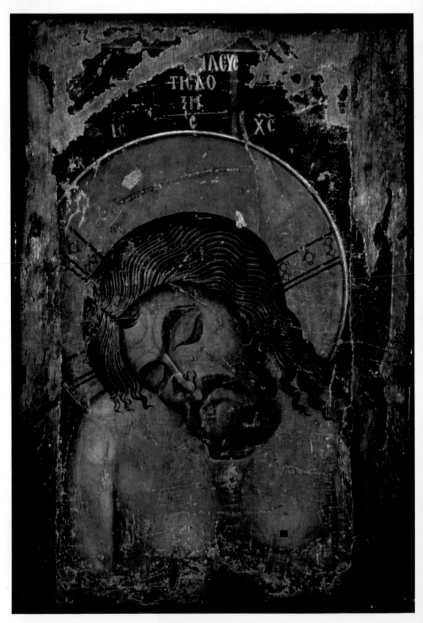

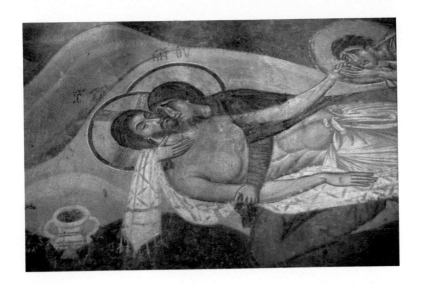

ABOVE: Lamentation (detail), fresco, Nerezi, Macedonia, Church of St. Panteleimon, 1164 (*photo courtesy of the author*). BELOW LEFT: Dead Christ, Epitaphios of King Stefan II Milutin, silk and velvet with gold and silver thread, Constantinople, ca. 1300; Belgrade, Serbia, Museum of the Serbian Orthodox Church, no. 4660 (after *Byzantium*, 2004, no. 189). BELOW RIGHT: *Andachsbild*, painted wood sculpture, Germany, ca. 1350; Fritzlar, Germany, Dom, Marienkapelle (after Walker Bynum, 2007, pl.15).

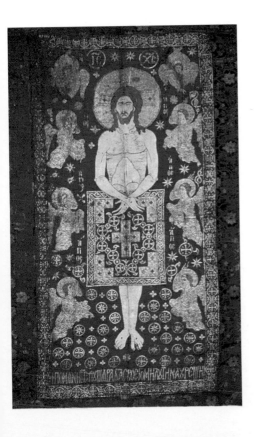

ABOVE: Collegiate Church of the Virgin, Lirey, France (as rebuilt in the 19th century), early 1350s (*photo courtesy of the author*). BELOW LEFT: Geoffroi de Charny (left) ambushed at Calais by King Edward III, *Chronicle of Jean Froissart*, manuscript illumination, tempera on vellum, Paris, first quarter of the 15th century; Toulouse, France, Bibliothèque municipal, ms. 511, fol. 117r (*Wikimedia*). BELOW RIGHT: King John II, panel painting, tempera on wood, Paris, ca. 1350; Paris, France, Musée du Louvre. (*Wikimedia*).

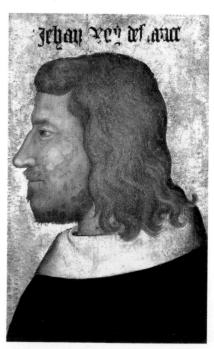

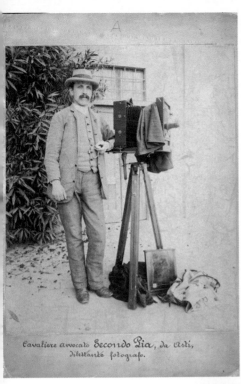

Cavaliere avvocato Secondo Pia, da Asti,
dilettante fotografo.

LEFT: Secondo Pia with his camera, Turin, Italy,
1898 (*SABAP for the Metropolitan City of Turin*).
BELOW: Secondo Pia's negative image of the face of
the Man of the Shroud, Turin, Italy, 1898 (*SABAP
for the Metropolitan City of Turin*).

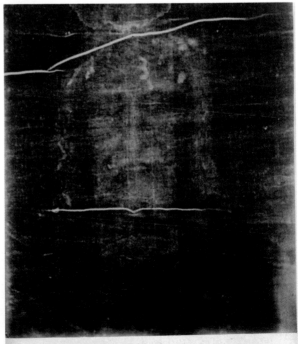

Torino - S.S. Sindone - ingrandimento Sacro Volto
dal negativo originale

ABOVE: Saint Simeon Stylites the Elder and the Baptism of Christ, pilgrim token, terracotta, Shrine of Saint Simeon Stylites the Elder, 6th–7th century; Houston, TX, Menil Collection, no. 79-24.199 DJ. RIGHT: Back side of the pilgrim token. (*Both photos courtesy of the author*).

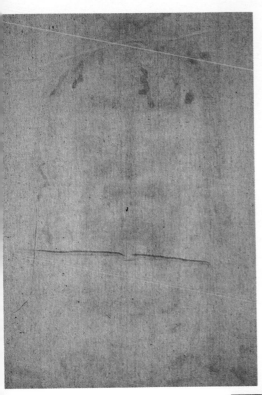

LEFT: Dead Christ (detail), Shroud of Turin, embellished body contact print, iron sulfate and tannic acid with red ochre and vermillion on linen, Avignon or Paris, early 1350s; Turin, Italy, Chapel of the Holy Shroud, Cathedral of St. John the Baptist (*1978 Barrie M. Schwortz Collection, STERA, Inc. All rights reserved.*). BELOW: Negative (detail), Shroud of Turin.

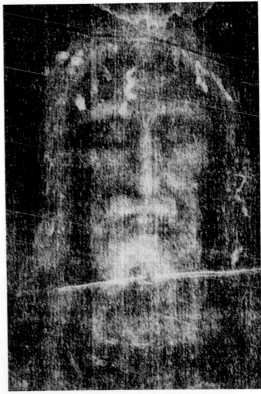

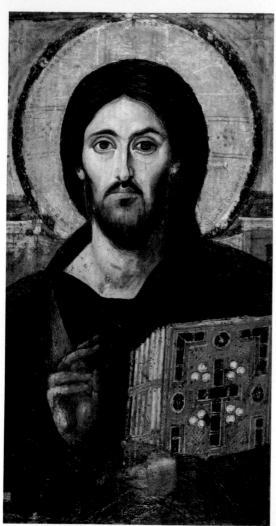

LEFT: Christ Pantocrator, icon, encaustic on wood, Constantinople, 6th–7th century; Mount Sinai, Egypt, Monastery of Saint Catherine (after Weitzmann, 1976, B.1). BELOW: Christ Pantocrator, gold coin (solidus) of Justinian II, Constantinople, 692–695; Baltimore, MD, the Walters Art Museum (*photo courtesy the Walters Art Museum*).

LEFT: Blue Crucifix, painted wood sculpture, later 19th; Baltimore, MD, Julianne and George Alderman Collection (*photo courtesy of the author*). CENTER LEFT: Penitente Crucifixion, oil on canvas, Will Shuster, 1930s; Golden, CO, the Harmsen Collection of Western Art (after Eldredge, 1986, pl. 157). CENTER RIGHT: Jesus Nazarene, painted wood sculpture, Taos County Santero, ca. 1860–1880; Colorado Springs, CO, the Taylor Museum, no 1605 (after Wroth, 1991, pl. 57). BOTTOM: Chimayo, NM, Sanctuary of Chimayo (El Sanctuario de Chimayo), 1816 (*photo courtesy of the author*).

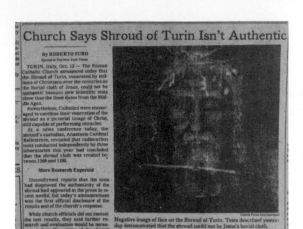

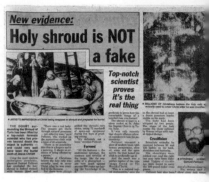

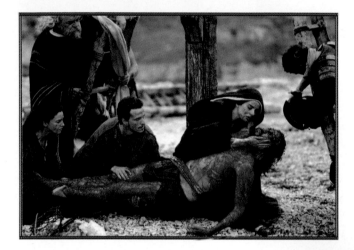

TOP LEFT: *The New York Times*, October 14, 1988. TOP RIGHT: *Sun*, December 19, 1989. CENTER LEFT: Lamentation, scene from the film *The Passion of the Christ*, Mel Gibson, director, 2004 (after *The Passion*, 2004, p. 133). CENTER RIGHT: Speculative reconstruction of the face of the historical Jesus, *The New York Times*, February 21, 2004. BOTTOM RIGHT: Gary Vikan at Cub Scout promotion ceremony, Hope Lutheran Church, Fosston, MN, 1955 (*photograph courtesy of Franklin Vikan*).

LEFT: Bob Morton in the backyard of his home outside Bartlesville, OK, holding the Jeff Johnson printing frame and textile (*photo courtesy of the author*). BELOW: Two-cloth contact print of Bob Morton's face, 2007 (negative).

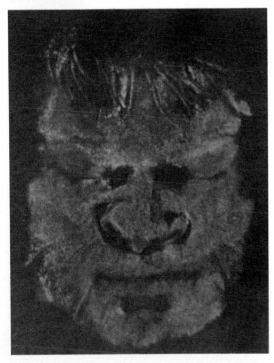

ABOVE LEFT: Avignon, France, Papal Palace, mid-14th century (*photo courtesy of the author*). ABOVE RIGHT: Christ in Majesty, preparatory drawing for a fresco, Simone Martini, ca. 1340; Avignon, France, Papal Palace (*photo courtesy of the author*). BELOW: Madonna della Misericordia with White Penitents (the *Bianchi*), panel painting, tempera on wood, Pietro di Dominico da Montepulciano, the Marches, ca. 1418–1422; Avignon, France, Musée du Petit Palais (*photo courtesy of the author*).

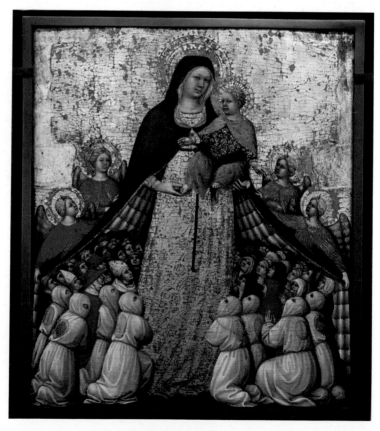

Procession of Flagellants, manuscript illumination, tempera on vellum, *Belles Heures* of Jean de France, Duc de Berry, the Limbourg Brothers, Paris, 1405–1408/1409; New York, NY, the Cloisters Collection, no. 54.11, fol. 74v (*photo courtesy the Metropolitan Museum of Art*).

ABOVE: Saint Sebastian Interceding for Victims of the Black Death, panel painting, tempera on wood, Josse Lieferinxe, Provence, 1497–1499; Baltimore, MD, the Walters Art Museum, no. 37.1995 (*photo courtesy the Walters Art Museum*). LEFT: Cadaver Tomb of William of Harcigny (detail), limestone sculpture, Laon, 1394; Laon, France, Musée d'art et archéologie, inv. no. 61.226 (*photo courtesy of Valeria Pezzi*).

 LEFT: Veronica Veil displayed for veneration in St. Peter's Basilica, *Mirabila Ubis Roma*, engraving, ink on paper, Stephannus Planck, Rome, ca. 1486 (after Morello and Wolf, 2000, no. IV.59). BELOW: The "Holy Face" of Montreuil/Laon, icon, tempera on wood, Serbia, early 13th century; Laon, France, Cathedral Treasury (after *Byzantium*, 2004, no. 95).

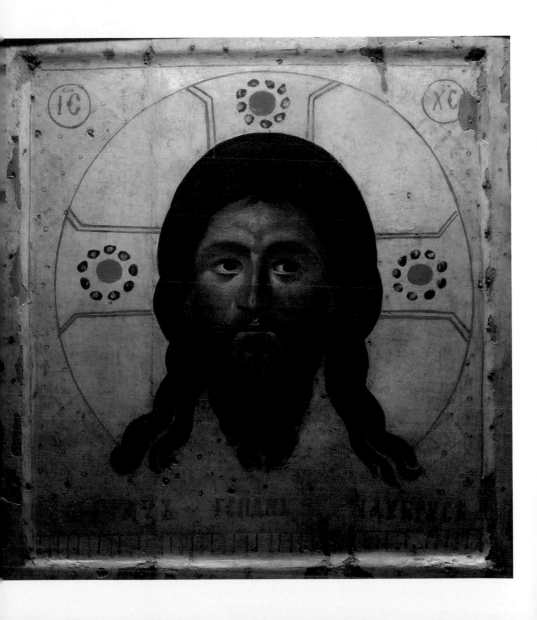

ABOVE LEFT: Roman road near Lirey (*photo courtesy of the author*). ABOVE RIGHT: Alain and Monique Hourseau dressed as Geoffroi de Charny and his wife Jeanne de Vergy (*photo courtesy of the author*). CENTER LEFT: *L'Est éclair*, Sunday magazine, January 14, 2018. BELOW: Artisan making a pilgrim badge at the *Fête Médiévale* near Troyes, September 2017 (*photo courtesy of the author*).

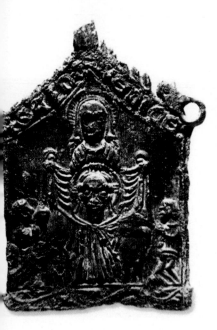

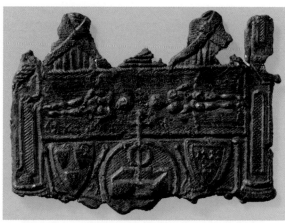

ABOVE LEFT: Saint Veronica Showing her Veil, pilgrim badge, cast pewter, Rome, 14th century (after *Il Volto*, 2000, no. IV.11). ABOVE RIGHT: Shroud of Turin displayed for veneration, pilgrim badge, cast pewter, Lirey, France, 1355(?); Paris, France, Musée de Cluny, CL4752 (*photo Jean-Gilles Berizzi/RMN/ distr. Alinari*). BELOW: Shroud of Turin displayed for veneration, casting mold for a pilgrim badge, schist, Lirey, France, ca. 1355; Machy, France (*photo courtesy Alain Hourseau*).

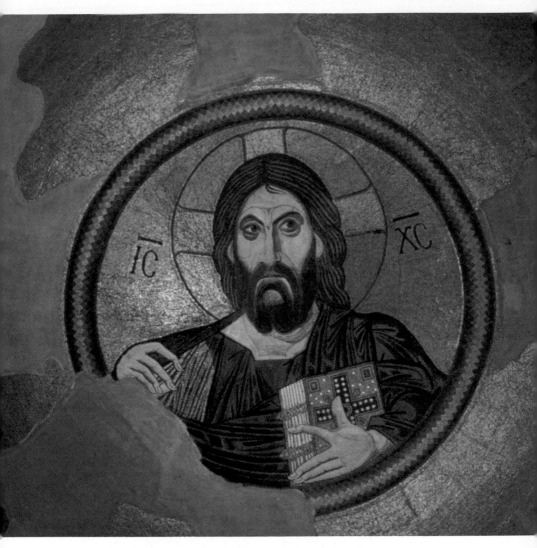

Christ Pantocrator, dome mosaic, near Athens, Greece, Daphni Monastery Church, ca. 1100 (*photo courtesy of the author*).

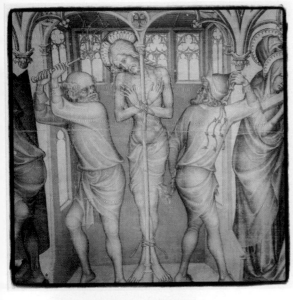

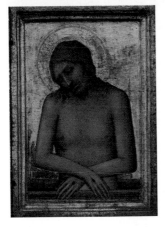

TOP: Flagellation of Christ, altar cloth, ink on silk, *Paremant* of Narbonne (detail), Master of the *Paremant* of Narbonne, ca. 1360, from the Cathedral of St. Just, Narbonne; Paris, France, Musée du Louvre (*photo courtesy of the author*). LOWER LEFT: Man of Sorrows, panel painting (right panel of a diptych), tempera on wood, Simone Martini, Siena/Avignon, ca. 1340; Florence, Italy, the Horne Museum (*Wikimedia*). RIGHT: *Crucifixion panel*, panel painting (central panel of a triptych), tempera on wood, Naddo Ceccarelli, Siena/Avignon, ca. 1350; Baltimore, MD, the Walters Art Museum, no. 37.737 (*photo courtesy of the Walters Art Museum*).

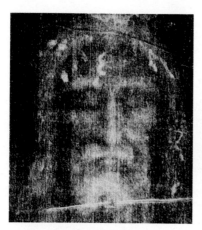

ABOVE LEFT: Dead Christ (negative) (detail), Shroud of Turin, embellished body contact print, iron sulfate and tannic acid with red ochre on linen, Avignon or Paris, early 1350s; Turin, Italy, Chapel of the Holy Shroud, Cathedral of St. John the Baptist (*1978 Barrie M. Schwortz Collection, STERA, Inc. All rights reserved.*). ABOVE RIGHT: King John II, panel painting, tempera on wood, Paris, ca. 1350; Paris, France, Musée du Louvre (*Wikimedia*). BELOW: Crippled and sick cured at the Tomb of Saint Nicholas, panel painting, tempera on wood, Gentile da Fabriano, Florence, 1370–1427; Washington, DC, the National Gallery of Art, no. 1939.1.268 (after *Treasures*, 2010, no. 67).

TOP: Open double page from the Archimedes Palimpsest. CENTER: Positive and negative of single-cloth contact print of a hand. BOTTOM: Two-cloth tannic acid/iron sulfate contact print method.

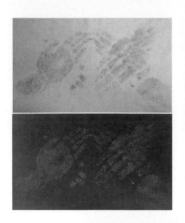 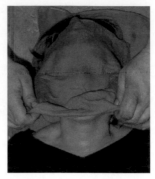 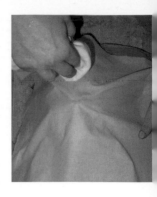

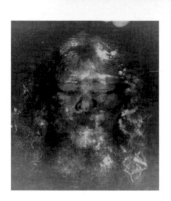 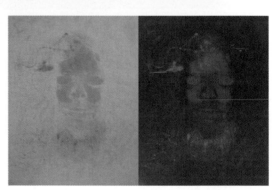

TOP LEFT, TWO IMAGES: Positive and negative of two-cloth contact print of hands. TOP CENTER AND TOP RIGHT: Making a two-cloth contact print of a face. CENTER LEFT: Negative of two-cloth contact print, without facial perspective adjustment. CENTER RIGHT: Negative of two-cloth contact print, with facial perspective adjustment. THIRD ROW LEFT: Adjusted-color-level (Photoshop 6) negative of a two-cloth multiple-exposure contact print of a face, without wetting agent. THIRD ROW RIGHT: Positive and negative of a two-cloth multiple-exposure contact print of face, a with wetting agent. BOTTOM RIGHT: The model: Jeff Johnson.

Pretty soon, we were trespassing on the grounds of a local farmer, absent that day Alain said, whose house was at the end of the street just beyond the church. We inspected the pigeonnier close up and then a low, narrow building nearby that Alain said was the present incarnation of the quarters for the half-dozen ecclesiastics who ran Geoffroi's church. I could not help at that moment thinking of their faked miracles and their lie that the shroud was the true Sudarium Christi. We then circled the equipment shed and arrived at an open space of about an acre next to a clump of trees. This, Alain told me, was where Geoffroi and his friends practiced jousting. And that clump of trees? That, he said, is where the chateau was (it was small, I thought). Before I knew it, Alain and Jean-Michel had made their way through some dense bushes and descended into the wide, muddy ditch, which was the moat of Geoffroi's chateau. They were both poking around in the low dirt wall on the far side of the ditch, taking turns shouting in French some version of "I've found one!" They were plucking terra-cotta pieces of the chateau's roof out of that embankment one after the other, and urging me to join them, which I did, even though it meant a tricky descent through those bushes, given that I had lost vision in my left eye in 2014, by way an odd neurological mishap. *Tout de suite*, though, I had my own piece of the chateau of the shroud's first owner!

On the way into Lirey, Alain had stopped by the house of Monsieur Cheviot, who I was led to believe was the local mayor as well as the keeper of the keys to the church. We were ready to go into the church, though no end of struggle on the part of Alain and then Jean-Michel could make that key work in the lock. Wrong key, dammit! Should I go back to Monsieur Cheviot, Alain asked? I said no, don't bother, since I knew the guts of this church were thoroughly modern and meaningless to my shroud story. But it occurred to me that there was an odd parallel between today and a day in August 1389. I told Alain and Jean-Michel, with Elana's help, the story of the day the agents of King Charles VI

showed up at this very spot and ordered the canons of the Collegiate Church to open the treasury door and produce the shroud, so that they could carry it away. And the key, the canons claimed, could not be found, so the royal agents couldn't get in. Both Alain and Jean-Michael found this story very funny.

Food poisoning relapse, that's what it was. I was fine, though light-headed, most of that afternoon, until we got to Alain's house, and his backyard. Then, intermittent waves of nausea that seemed to be getting worse. Belgian beer emerged from his nearby microfridge, and that was, at least for a while, my medication. But as the buzz wore off, the nausea returned, even worse. I suppose I could have left, but I knew that this moment would not return, when I could experience Alain Hourseau in his medieval element. This man not only studied and published about the Middle Ages and conducted his own version of archaeology in plowed fields around Lirey, he *lived with* the Middle Ages. And his name is Geof-froi de Charny. Hanging from one of the posts supporting the overhang in front of his backyard stone-built grill is his great sword; his shield and helmet are nearby. Alain then brings out his red tunic with its gold coat of arms, modeled exactly on the 15th-century manuscript page showing Geoffroi in his battle gear. He pointed to a metal basket hanging near the grill and described a dish he makes when his fellow medieval enthu-siasts come over that somehow involves a chicken wrapped in straw. All authentic, Alain said, and we believed him.

We retreated indoors when Alain's wonderfully warm and talkative wife, Monique, arrived home from work. No, as it turned out, we were not going out to that restaurant in Bouilly; we were going to eat here at home. And the dish of the day, which she had not yet begun, is *choucroute garnie*, sauerkraut with potatoes, bacon, sausages, and pig knuckles. It's a traditional fall dish in France because that's when the cabbage is har-vested. Yikes! I love *choucroute*, I make it at home, and I recall fondly the first time Elana and I encountered and then consumed an enormous

plate of *choucroute garnie* at a small restaurant in Alsace in the winter of 1971. What could be better? At that moment, almost anything could have been better, given the way I was feeling. I was going downhill, and the way I managed to stay at the table and pretend to eat involved drinking plenty of whatever was put in front of me that had alcohol in it: Belgian beer, followed by Alain's favorite local champagne, followed by lots and lots of wine. I assume that Monsieur and Madame Hourseau thought that I was a typical American, afraid of unfamiliar dishes and overly fond of wine. Anyhow, I made it. I survived that evening, and I don't think anyone was the wiser.

The next morning I was as good as new, wildly hungry, and I think a tiny bit thinner, when Alain and Monique arrived at our hotel to pick us up, wearing the medieval garb of Geoffroi de Charny and his wife Jeanne de Vergy. We were off a few miles northeast of Troyes to a Fête Médiévale staged at the edge of the tiny hamlet of Luyères, which is about half the size of Lirey. It was as if my imagined scene the day before in the field of the casting mold had, just for my benefit, come to life. Seemingly everyone but us was in some version of medieval clothing. Mead was being drunk from animal horns, sword fights were staged and judged, for participants of all ages. There were medieval horses and medieval dogs (Irish wolfhounds), canon shooting and magic making, medieval wenches, medieval monks, and even a medieval craftsman casting pewter pilgrim badges. And yes, I imagined that this guy somehow damaged one of his molds and simply tossed it aside, so that someday, decades from now, an archaeologist digging in this field will be thoroughly confused. Thanks to Alain, the magic continued, and I was feeling ever so much better.

◆

The train to Paris left early the next morning, and with it, Elana and I left the 14th century behind. What of the casting mold for shroud badges,

that elusive, ever so humble medieval antiquity that brought us to Lirey in the first place? Yes, I saw it, and yes, I handled it. It emerged from a wall safe hidden behind a small painting, in a basement. I offered $5,000 to get it for the Walters but was turned down.

A few weeks after our visit to Troyes and Lirey, a short article on me and my shroud ideas appeared in *L'Est éclair*. Jean-Michel's big article, titled "Cet Américain ne croit pas au Saint-Suaire," which made the front page of the Sunday magazine section for January 14, 2018, is an in-depth interview about my forthcoming "*livre explosif.*" I'm shown standing in front of a text panel just to the right of the gate to the Lirey church grounds. Not only is that panel the creation of Alain Hourseau, his Geoffroi de Charny tunic and battle gear appear just behind me, photographed as he set them at the very spot where Geoffroi died in battle, near Poitiers, on September 19, 1356.

17

Lie and They Will Come

This is how I believe the public story of the Holy Shroud
unfolded: It is early summer 1355, and the avaricious dean of
Geoffroi de Charny's Collegiate Church in Lirey, Robert de
Caillac, is falsely claiming to possess the Sudarium of Our Lord Jesus
Christ and marketing his attraction with great success. Just over a year
earlier, the foundation of the church had been endorsed by Pope Innocent
VI, and just over a year later, in September 1356, its founder, Geoffroi
de Charny, would die in battle. According to the memorandum of Pierre
d'Arcis, the dean's false story was put about "much more than throughout
the kingdom of France," but "throughout the whole world, so that people
have flowed from all parts of the world." Just as I had envisioned that
day as I stood with Alain Hourseau looking up the Roman road toward
Troyes. It's packed!

The Holy Shroud pilgrim badge in the Cluny Museum and the Holy
Shroud casting mold discovered near Lirey together speak to the popularity

of the Collegiate Church in Lirey as a pilgrimage destination. Pilgrim badges, the medieval version of those decals shaped like US states that, in my childhood, were plastered on the backs of the trailer houses, are small pewter souvenirs recalling the various holy sites pilgrims visited, like St. Peter's, with its Veronica Veil, and the Canterbury Cathedral, with its shrine of Saint Thomas Becket's martyrdom. They were mass produced in slate casting molds and sold by the thousands during the height of their popularity in the 14th and 15th centuries. Many badges have multiple small loops, so that they could easily be sewn to clothing and to hats; some have identifying inscriptions.

The Cluny Museum badge shows two elaborately garbed clerics (their heads broken away) holding up the shroud for veneration. Below are the coats of arms of Geoffroi de Charny at the left and of his wife, Jeanne de Vergy, at the right. Between them is a large circle with the empty Tomb, the Cross, and the Crown of Thorns, all flanked by two whips of the sort seen in contemporary images of the Flagellation of Christ. To the left and right of the coats of arms are, respectively, the Holy Lance and the Column of the Flagellation. The artist who cut the mold for this badge was skilled: The herringbone patter of the linen is meticulously rendered, and the front and back body images are surprisingly detailed, likely revealing of the clarity of the Man of the Shroud when the shroud was first offered for veneration.

The casting mold discovered near Lirey, by the village of Machy, was used for making pilgrim badges closely related in type to the one in the Cluny Museum. While its artist was less skilled than that of the Cluny badge, this mold offers an identifying inscription that the Cluny badge lacks: *SVAIRE Ih(S)VS,* "Shroud of Jesus." Above, two clerics, dressed like those on the Cluny badge, are offering the Lirey Shroud for veneration; behind them are two high Gothic arches with detailing suggestive of stained glass windows. Below are the same two family coats of arms, though reversed left to right, when cast, and between them the face of

the Man of the Shroud. The French word *Suaire* ("shroud," or *sudarium* in Latin) on the Lirey mold makes the claim that Henri de Poitiers attributed to the dean of the Lirey church, namely, that the textile on display in Lirey is indeed the Sudarium of Our Lord Jesus Christ and not some ordinary cloth icon. (The Latin word used for the contested object in Lirey is *pannus* and the French word is *drap,* both signifying a "cloth" or "sheet," with no implication that the cloth is sacred.) Also, the elaborate robes of those holding the shroud for veneration on both the badge and the mold leave no doubt that it is being displayed as the relic. This was an honor explicitly denied to the shroud by Clement VII in his papal bull of January/June 1390. The overall design shared by the Cluny Museum badge and the Lirey casting mold suggest that the shroud was being presented for veneration on a specially designed platform, with the coats of arms affixed to the front—a platform similar to that from which the Veronica was displayed for veneration in St. Peter's Basilica. When Geoffroi II asked the pope's legate in France for permission to return the shroud to the church in Lirey in 1389, he said that his father had made "a place . . . for a certain figure or representation of our Lord Jesus Christ's shroud."

Perhaps the coats of arms offer another clue to the pecuniary motives of the Lirey dean. On one level, of course, this heraldry simply identifies the families joined in marriage that built the Lirey church and owned the shroud. But given how rarely coats of arms appear on pilgrim badges, perhaps their inclusion here—and on the display platform—was intended to play on public enthusiasm for that famous knight, Geoffroi de Charny. In any case, that rustic little church in Lirey had suddenly struck the pilgrimage jackpot.

All that excitement in little Lirey got plenty of attention in high places. To quote Pierre d'Arcis' version of events, Bishop Henri de Poitiers, "struck by the persuasiveness of many prudent men . . . took it upon himself to investigate promptly the truth of this matter." Eventually,

after diligent inquiry, he "discovered the deception, and how [the image on] that cloth had been artificially portrayed. It was even proved by the artist who had portrayed it." What followed were formal proceedings, with the advice of both theologians and legal experts. The dean and his accomplices, once they had been found out, hid away the shroud so that Henri de Poitiers could not find it, and kept it hidden for "thirty-four years or so until this year." That is, from around 1355 to 1389.

After recounting these events of the 1350s, and Henri de Poitiers's failure to lay his hands on the Lirey Shroud, Pierre d'Arcis goes on to make a series of important points. He says, "for fear of the Ordinary [Bishop Henri de Poitiers] the cloth had been hidden, and even transported out of the diocese." But it is now, in 1389, back in Lirey, because the current church dean, Nicole Martin, has convinced Geoffroi's grown son, Geoffroi II, to display it again so that the church might be enriched. Geoffroi II had approached the pope's legate in France, Cardinal Pierre de Thury, likely that spring, for permission to reexhibit the shroud, since the interdiction of Bishop Henri de Poitiers was still in place. Thus, he effectively bypassed the bishop of his diocese by appealing to a cleric of higher rank. Not only that, in the process, Geoffroi II suppressed the facts from the 1350s, claiming instead that because of war and pestilence, and "also by the order of the ordinary [Bishop] of the place and for certain other reasons," the shroud had been placed "for a long time at a safe distance and preserved in safe custody."

All of these threads came together into an elegant bow for me when I learned that Geoffroi de Charny's widow, Jeanne de Vergy, had married Aymon de Genève, whose estates were in the Alpine High Savoy. That is certainly a place out of the diocese. Aymon died in 1369. For whatever reason, perhaps, as Geoffroi II later claimed, because the Hundred Years' War was now being played out in the region of Troyes, Jeanne waited two decades before returning to Lirey. When she finally did, she was likely in her upper sixties and her son, Geoffroi II, was likely in his upper thirties.

In the meantime, Geoffroi II had established a distinguished military career. This strange affair in Lirey suddenly began to seem like a Dickens novel to me: Could it have been mere coincidence that Geoffroi II would marry the niece of Bishop Henri de Poitiers, and, more interesting still, that Jeanne's second husband was the uncle of the future pope, Clement VII (Robert de Genève)? (Specifically: Geoffroi II's stepfather, Aymon, was the first cousin of Robert's father.)

As Pierre d'Arcis's narrative unfolds, it is clear that he is profoundly annoyed with Clement VII's legate, who not only failed to consult with him on Geoffroi II's petition to reexhibit the shroud, but failed to investigate the merits of the petition beyond the facts as selectively presented. The result of Geoffroi II's back door approach and selective memory is that he now has permission from the legate to "locate the representation or figure of the Lord's shroud in the aforementioned church," without explicitly being allowed to exhibit it for veneration. (That permission was granted in Clement VII's confirming bull of July 28, 1389.) Nevertheless, according to Pierre d'Arcis, the Lirey cloth was being exhibited "with greatest solemnity" on great holidays and feast days and, at other times, by two priests in full regalia with torches on a specially built platform. So alas, 1389 has effectively collapsed back into 1355. True, the Lirey Shroud is now not publicly stated to be the true shroud of Christ, as it was in the mid 1350s, and there is no mention this time around of faked miracles. Yet, "in private . . . it is asserted and proclaimed [to be the true shroud], and so it is believed by many, and especially because previously . . . it was said to be the true shroud of Christ." The clergy of the Lirey church have even gone so far, says Pierre d'Arcis, as to use the word *sanctuarium* ("sanctuary") in the context of showing the shroud. Why? Because "it sounds the same [as sudarium] in the ear of the people who are not at all discerning in such matters." (Especially the French *sanctuaire*, which is very close in pronunciation to *San(c)t-Suaire* ["Holy Shroud"].) Subtle rumors coupled with that cunning word game, plus the solemnity of the

shroud's presentation, must have been as effective as staged miracles and overt proclamations of Sudarium Christi in extracting money from the credulous crowds.

Obviously, this was carefully orchestrated with the goal of enriching the church. But all the while, as Pierre d'Arcis takes pains to point out again and again in his memorandum, the dean is violating the terms for showing the shroud laid down in the papal legate's letter. So, after consultation with his advisors, Pierre d'Arcis forbids the dean, under threat of excommunication, from showing the shroud "until otherwise might be determined" in consultation with the pope. Pierre d'Arcis goes on to complain to the pope that not only does Geoffroi II refuse to comply with his prohibition against displaying the shroud until the pope can investigate, he has upped the ante by holding the shroud himself on a certain solemn feasts, by lodging an appeal through ecclesiastical channels, and by securing "a safeguard of the king" by which "he had the cloth kept in his possession with the right of exhibition." At this point the bishop feels that both he and his predecessor, Henri de Poitiers, have been defamed, and he laments the fact that he is powerless.

The defining tone of the Memorandum d'Arcis is frustration. Pierre d'Arcis, the bishop of the diocese, has been sidelined by Geoffroi II, the dean of his church, by the papal legate in France, and now, by the pope himself. Moreover, supporters of the current exhibition of the Lirey Shroud are spreading rumors that he, the Bishop of Troyes, is acting out of "envy or cupidity and avarice" in order to obtain the shroud for himself—rumors mirroring those circulated against Henri de Poitiers in the 1350s. And to make matters worse, Pierre d'Arcis is now held, in some circles, to be a laughingstock for having allowed the abuse to continue. Defending himself, Pierre d'Arcis goes on to draw a distinction between what the legate's communication to Geoffroi II authorized and what Geoffroi II is actually doing; the shroud could be restored to the church but the legate's authorization "had not granted that the cloth could be

shown to the people or even venerated, but only that it could be placed and located in the already-mentioned church." Geoffroi II's failure to keep to the terms of the cardinal's permit is why, after taking counsel, Pierre d'Arcis felt he had to act.

I have this vision of the dean of the Lirey church, Nicole Martin, intersecting in his travels with Chaucer's merry band of pilgrims on the evening that the Pardoner tells his tale—and having a great laugh with them. (Chaucer was writing his *Canterbury Tales* in the years of the second Lirey Shroud dustup.) The dean and the Pardoner are, after all, in the same mischievous business. In his prologue, the Pardoner reveals himself to be an itinerant preacher and a peddler of indulgences, which he has stuffed in his pockets. The Pardoner claims to be a great orator, spicing his sermons with references to ancient philosophers and Latin quotes. (Recall the deceptive use of the word *sanctuarium* at Lirey.) He is without shame: His goal is to wheedle money out of his listeners, including widows and children. All the while, he sermonizes on one topic only: Greed is the Root of all Evil. Besides indulgences, the Pardoner carries an abundant supply of fake relics, including sheep bones and pig bones, that he claims produce miraculous cures. Then he extracts a fee from the sick to gain access to them. All of this is revealing of the same cynical, money-driven reality that is at work in Lirey.

18

What They All Knew

There are two things that I believe all the players in the prolonged Holy Shroud controversy from the 1350s to the 1390s knew to be true: First, that the Lirey Shroud was neither a relic nor ancient but rather that it was a manmade devotional cloth of recent manufacture; and second, that it possessed charismatic power, either to be exploited or to be controlled. Moreover, those 14th-century truths endure.

First, the relic/ancient question. In April 1989, six months after the Cardinal of Turin announced the carbon-14 test results, Pope John Paul II was asked about the shroud during an inflight press conference on his way to Madagascar. He was emphatic: "It certainly is a relic!" Of course, to be a relic requires that the shroud once touched the body of Jesus, which would make it the authentic burial shroud, as the sindonologists now claim and as Robert de Caillac and his

Lirey cronies claimed in the 1350s. Well, that may have been what the pope meant, but it certainly was not what the Catholic Church meant. The pope's backup team quickly stepped in to clarify what His Holiness really intended to say, namely, the shroud is, as Cardinal Ballestrero made clear on the day the scientific tests were announced, a holy *image*. Pope John Paul II scrupulously avoided the word "relic" during his lengthy address nine years later in Turin before the shroud, on May 24, 1998. He then said that it was, variously, a "mirror," an "image," and an "icon." The word used by his two successors, Benedict XVI and Francis I, is "icon."

When John Paul II used the word relic, he was veering radically off the official Catholic Church script, which had been formulated and promulgated 599 years before that flight to Madagascar. On January 6, 1390, Pope Clement VII issued a bull with the intent of putting to rest the ongoing dispute in the Diocese of Troyes between Bishop Pierre d'Arcis and Geoffroi II regarding the Lirey Shroud. This papal bull for "the future remembrance hereof" reaffirmed the position taken months earlier by the pope's legate in France and endorsed by the pope himself in his bull of July 28, which authorized the display of the shroud in Lirey for veneration. But what is most interesting about the January bull, as revised in late May, are the explicit restrictions Clement VII now placed on how the Lirey Shroud was to be identified and displayed, in order to remove all danger of error and idolatry:

> we want to remove any chance of error and idolatry . . . [therefore] we establish and ordain, whenever it happens hereafter that the already-mentioned figure or representation is shown to the people, the aforementioned dean and chapter, and other ecclesiastical persons showing this figure or representation and present during this sort of exhibition, they may not perform any of the solemnities that are customarily performed during

exhibitions of relics; and for this reason torches, flambeaux, or candles should on no account be lit for solemnity. . . .

So, to be clear, that means natural daylight only; though as a conciliatory gesture to the Lirey folks, the pope in May scratched the portion in the January version of the bull, which said that the dean and canons must, while showing the shroud to the faithful, dress in the medieval equivalent of street clothes, and certainly not in the fancy liturgical getups (copes) that those displaying the shroud are wearing on the Cluny Museum pilgrim badge and the Lirey casting mold.

The pope continued, giving the following strict protocol that must be observed whenever the shroud is shown to large groups:

> a sermon should be given . . . and [he should] say in a loud, intelligible voice, stopping any deception, that the aforementioned figure or representation they display not as the true shroud of our Lord Jesus Christ, but as a figure or representation of the aforementioned shroud that is said to have been that of our Lord Jesus Christ himself.

What could be more explicit? The pope states unequivocally that the Lirey Shroud is not a relic and should not be displayed as if it were a relic. Further, it is only a copy of the shroud that is *said* to have been that of our Lord Jesus Christ. So, not only does the pope make clear that the Lirey cloth is a figure or representation and not a relic (much less the "true shroud"), the shroud that it does represent may not even be the true shroud, since he insists on the explicit qualification: "is said to have been." This is the critical point: Throughout the various acrimonious exchanges of 1389 and 1390, the Lirey Shroud is identified and understood *by all parties*—those who favor its display and those who oppose it—as a manmade artifact, which is the absolute opposite of an "image not made by

human hands." This is even true of Geoffroi II, who in his request to the papal legate in France for permission to return the shroud to the Lirey church, noted that his deceased father "had a place made with reverence for a certain figure or representation of our Lord Jesus Christ's shroud, offered to him in generosity."

I was aware of this papal bull and the critical distinction the pope drew between reproduction and relic soon after I began to study the shroud. But it took more than two decades for the other shoe to drop. When the shroud appeared in Lirey in the mid-1350s, without any accompanying legend to explain how it happened to end up there thirteen hundred years after the Crucifixion of Christ, no one on either side of the contentious debate that it generated ever brought up the issue of sacred pedigree, pro or con. For years, I was perplexed by this. Until I finally figured out the obvious: The reason no one brought up the issue of a sacred legend for the Lirey Shroud is that they all knew there was none. Why? Because all parties, on both sides of the conflict, knew that the Lirey Shroud was, in fact, a recent artistic creation.

◆

Second, the question of the Holy Shroud's charismatic power. The dean and canons of the Lirey Collegiate Church understood and exploited the shroud's inherent power over the faithful for their own financial gain. Initially, they purposely misidentified the cloth as the true Sudarium Christi and faked miracles to enhance its impact. After the shroud's return to Lirey in 1389, they toned down their rhetoric and apparently steered clear of faking miracles. Nevertheless, they fueled rumors among the gullible that this was indeed the true Shroud of Jesus, and confused the naive by using the Latin word for sanctuary (*sanctuarium*) because it sounds like Sudarium. Moreover, they defied church proscriptions and, even knowing that the cloth (*pannus, drap*) was not a relic (*sudarium,* a cloth

that had absorbed sacred sweat), presented it to the faithful with all the pomp and ceremony reserved for relics, and then let its charisma go to work. Clement VII, too, clearly understood the charismatic power of the Holy Shroud. That's why he and his emissaries sought again and again to control the way it was displayed and how it was described.

As for Pierre d'Arcis, he was acutely aware of the shroud's charisma in a way at once more subtle and profound than the understanding of the folks in Lirey and the pope. This is clear from the specific request he makes of the pope at the end of his memorandum. The bishop has taken the story of the Lirey Shroud and the multiple deceptions surrounding its identity and display from the mid-1350s to the present: that is, to late 1389. He acknowledges his strained relations with the pope, complaining that "I am impeded by the Church in this sort of prosecution" while I "ought to be punished severely if I were negligent or remiss in this matter." He is clearly very troubled by the fact that Geoffroi II has obtained a letter from Clement VII confirming that "it might be permitted that the cloth be exhibited and shown to the people, and venerated by the faithful, imposing on me perpetual silence, as it is reported, since I was unable to have a copy of the letter." First, he was sidelined, and now, Pierre d'Arcis is being muzzled.

So finally, after a narrative of more than sixteen hundred words covering three decades, the bishop gets to the heart of the matter. He frames his specific request of the pope by explaining how he and his legate could have decided, mistakenly, to support Geoffroi II. Simply stated, they were deceived: "I am sure that this letter has been obtained through the suggestion of falsehood and the suppression of the truth." Having said that, and noting that His Holiness is now better informed of the truth of the case, Pierre d'Arcis requests that his memorandum be carefully considered and that measures be taken that "this sort of error and stumbling block and detestable superstition be utterly rooted out" and that the cloth be offered for veneration "neither as a shroud, nor a

'sanctuary' [*sanctuarium*], nor as a representation or figure of the Lord's shroud." But instead, "let it [the cloth] be condemned publicly." Why such drastic steps? Ostensibly, because the Sudarium never existed, so how could it be copied? Here, Pierre d'Arcis is following the lead of Henri de Poitiers, whom he quotes earlier in his memorandum explaining the absolutist's view on the question of the possible existence of an image-bearing Shroud of Jesus, or its copy:

> many theologians and other learned men assured him [Bishop Henri de Poitiers] that this could not in fact be the shroud of the Lord . . . since the Holy Gospel makes no mention of an impression of this sort, while, however, if it had been true, it is not likely that the holy evangelists would have kept silent or omitted it, nor that it would have remained secret or hidden up to this time.

This little excursion into the Bible's history was certainly purposeful, since Pierre d'Arcis wants nothing to do with the pope's cautionary dictum that the Lirey Shroud be identified as a figure or representation of the true shroud. Pierre d'Arcis asks instead that the pope publicly condemn what is going on in Lirey and declare his legate's letter of permission null and void. Full stop.

◆

When I was five or six, John Dillinger's "death car" came to our little town. It was on a flatbed truck parked on First Street, which is Highway 2, the major northern US interstate connecting Michigan with Seattle. For a dime, I was permitted to walk up the ramp and view that notorious gangster's 1934 black Essex Terraplane up close. It was long and boxy, and it scared me, even before I noticed the bullet hole in the back

passenger-side window and what I thought was a blood stain on the driver's seat. Dillinger's death car was accompanied by some enlarged photos of Dillinger, which were even scarier than the bullet hole and blood stain. One is seared into my visual memory: It shows the dead gangster on a slab in the Chicago morgue. His lower body is covered by a sheet, but he is exposed from the chest up and his arms are raised and crossed over his head. Were it not for the bullet wounds and bruises, Dillinger might have been sleeping. I was transfixed. Years later, I was reminded of that dead gangster icon when I saw Andy Warhol's car crash lithographs, with bodies hanging out of mangled Fords and Chevys. This, I realized, is the same power of the Man of the Shroud: the charisma of a brutally abused dead body, rendered as art.

I think of the Man of the Shroud as a charismatic. The social theorist Max Weber identified charismatics as possessing qualities that set them apart from ordinary people, who in turn endow them with "exceptional powers or qualities." Significantly, these extraordinary individuals (or objects) are identifiable not by any specific behavioral or physical characteristics but rather by the impact they have on others, by how they are treated as endowed by their followers. This "affectual action" definition is especially critical for charismatics whose lifestyles strike nonfollowers as inappropriate, since what counts is not exemplary behavior but rather audience reception and reaction. And as difficult as it is to gain that lofty pedestal of charisma, it is, ironically, not at all easy to fall back down to the mundane. Elvis Presley demonstrated the possession of Weber's charisma long before his premature death, thanks to his initial phenomenal success as an entertainer in the fifties. Through the dismal movie years of the sixties and the increasingly degenerate Vegas years of the seventies, and even as Elvis became bloated and drug dazed and began to forget the lines to his familiar songs, he remained endowed by his followers with inalienable charisma. In this respect, Elvis helps me

understand the shroud, which, even in the face of carbon-14 dating, retained inalienable charisma. Why? Because the very calculated, very effective manner of its creation, through contact with a body, mirrors precisely and brilliantly the category of relic that it purports to be, an image "not made by human hands."

Such is the enormous power, today, of that brutally beaten dead body, captured as if in a photograph, even for those who may not initially recognize the face to be that of Jesus. The extraordinary charisma of the Man of the Shroud explains the intense emotion and unrelenting zeal with which amateurs of the shroud strive, often in the face of common sense, to prove its authenticity. Director of the Turin Shroud Center (TSC) in Colorado and lifelong sindonologist physicist John Jackson recently recounted his transformative first encounter with the shroud, at age thirteen or fourteen, which was presented to him by his mother as "a picture of Jesus":

> Suddenly it dawned on me that I was looking at the face and the face was looking right at me . . . little did I know at that point that it was going to change my life.

The charismatic power of the Man of the Shroud is difficult to control, even for a pope. This explains much about the trajectory of the shroud after the papal bulls of 1389 and 1390. Whether or not Geoffroi II and his dean were, in fact, adhering to the pope's stipulations regarding how the Lirey Shroud was to be displayed and described, eventually it would make no difference. The charismatic power of the Man of the Shroud made it inevitable that the Lirey cloth, simply by being offered to the faithful, would quickly ascend to the status of "true shroud" that it enjoyed in the mid-1350s, and that, for millions of the faithful, it enjoys today. True, Pierre d'Arcis invoked the silence of the Evangelists regarding an image-bearing

shroud as his reason for condemning the cloth in Lirey—not mentioning that they were also silent regarding the Veronica Veil. But on a more basic level, I believe that the bishop understood that the shroud's inherent charisma was so powerful that even the designation "figure or representation" loudly proclaimed was not enough to control it. So that troublesome cloth in Lirey would simply have to be condemned, tucked away, and forgotten.

19

Before the Lying

L ooking back from the shroud's first big public splash, with accompanying deceptions, likely in the early summer of 1355: When, why, and by whom was the Shroud of Turin created? These questions invite a tantalizing range of answers, from the all but certain to the more than plausible to the truly spectacular but thoroughly speculative.

The carbon-14 results of 1260–1390 give a midpoint of 1325 for the harvesting of the flax from which the Holy Shroud was created, which is consistent with the dating evidence from the evolution of Passion iconography presented in chapter 2, where I concluded with the Belgrade *Epitaphios* from shortly after 1300 and the bloody Fritzlar Cathedral Andachsbild from around 1350. The abundance of seeming flagellation wounds on the Man of the Shroud suggests that its creation postdates the first brutal onslaught of the Great Pestilence in 1348–50 and the

reemergence of the societies of flagellants that came with it. And more generally, its brutal image of death is most at home in a post-Plague world. The impetus for the shroud's creation is also best understood, I believe, against the backdrop of the jubilee year of 1350, when St. Peter's sacred Sudarium, the Veronica Veil, was the main attraction for hundreds of thousands of pilgrims. Sacred "sweat cloths," pilgrimage, and lucrative offerings where then especially well connected and understood, and prime for imitation and exploitation.

More specifically, documentary evidence points toward a date shortly before 1355 for the shroud's creation. According to Pierre d'Arcis, the dean of the Collegiate Church in Lirey, Robert de Caillac, "arranged to have in his church a certain cloth, cunningly portrayed." He was dean from 1354, shortly after the Collegiate Church was built, until his death in 1358. It was in 1354 that Pope Innocent VI acknowledged the foundation of the church, and by then, indulgences were being offered to pilgrims who visited on various feast days. Pierre d'Arcis also tells us that Bishop Henri de Poitiers tracked down the artist who had painted the shroud, which means that artist was alive in the mid-1350s.

The simple answer to the "why" question is money, with devotional utility for the faithful being secondary. The Holy Shroud was created to generate wealth for its owner, and there is no reason to doubt that the intended owner was the Collegiate Church in Lirey. And I'm convinced that this incredibly powerful devotional image would have been a star attraction for Lirey even without the false claim that it was the true Sudarium Christi. That is, it could have been for the Lirey Collegiate Church what the Holy Face of Montreuil (which was understood as a copy of St. Peter's Veronica) was for Cistercian Nunnery in Montreuil-en-Thierache.

The question of "who" is more difficult, since it is twofold, involving both the artist and the person who recruited and directed the artist—and,

ultimately, the person who was the driving force behind the deception. And that multiple "who" answer is inextricably intertwined with the question of where the Holy Shroud was created.

First, the artist. The Man of the Shroud is much more than a simple contact body print; it is, as Pierre d'Arcis knew, the work of an artist. And like all artists, the creator of the Man of the Shroud reveals something of his artistic identity through his choice of iconography and the "figure style" he imposed on his body print. Specifically, the Man of the Shroud is a shrewdly contrived *iconic* body print, conforming to the most current iconographic models, as exemplified, for the pose, by the Belgrade *Epitaphios*. And as for the facial type, the Whangers were basically correct in positing a relationship between the face of the Man of the Shroud and the revered iconographic tradition for the face of Jesus going back to early Byzantium. Around 600 C.E. a facial type defined by long, flowing hair parted in the middle and by a short-cropped beard with mustache supplanted a variety of earlier versions of Jesus, including one that shows him with short hair and no beard. This canonical iconography is revealed near its beginning in the imposing icon of the Pantocrator at Mount Sinai, and in its medieval maturity in the dome mosaic of the Daphni Monastery Church, from around 1100.

As for the artist's style, it can be characterized—as one might characterize the style of a photographer—by its emotional *affect*, as one of profound, soft-focus pathos, infused with gravitas. And in this, the Man of the Shroud stands in sharp contrast with the almost-playful Parisian style of the period, as exemplified by the Narbonne altar cloth, with its thin, elegant figures, cascading drapery folds, and dance-like poses. The Man of the Shroud is much closer in its emotional power to works that Italian artists were then creating, which, in turn, were inspired by the art of Byzantium: for example, Simone Martini's Man of Sorrows from around 1340, which is an iconographic and stylistic descendant

by just over a century of Byzantium's Christ of Utmost Humility. Both convey the deep sense of sorrow and suffering that defines the Man of the Shroud. So, my assumption is that the artist who created the shroud was, like Simone Martini, an Italian—and, more than likely, from among Martini's circle of students.

Second, the identity of the person who recruited and directed the artist to create the shroud. According to Pierre d'Arcis, Robert de Caillac "arranged to have in his church a certain cloth." That's pretty simple and might seem to put that question to rest, but it does not. Recall that Geoffroi II, in his request to the papal legate in France for permission to return the shroud to the Lirey church, noted that his deceased father "had a place made with reverence for a certain figure or representation of our Lord Jesus Christ's shroud, offered to him in generosity." Medieval historians have taken this passage to mean that the elder Geoffroi was the first recorded owner of the Shroud of Turin. So perhaps Robert de Caillac got that cloth "cunningly portrayed" from Geoffroi himself. And then, driven by greed, the dean deliberately misrepresented what previously was understood as a benign devotional textile as being the true Sudarium Christi.

Who would have been motivated to give the shroud to Geoffroi? Both the Paris monarchy and the Avignon papacy gave gifts and favors to Geoffroi de Charny in honor and support of his new Collegiate Church during those critical years leading up to its dedication in 1356. Their intent was to ensure, through land grants and associated tax revenue, sufficient support for Geoffroi's dean and canons so that they could continue to pray for the salvation of his soul and the souls of his family members. The shroud, along with the granting of indulgences, would have guaranteed pilgrimage to Lirey, which was its own source of renewable income. After the corrected version of the January 1390 bull was sent out, Clement VII granted a-year-and-forty-days indulgence for those, being penitent and confessed, who visited the Lirey church and made donations.

The monarchy or the papacy, Paris or Avignon: Which is the more likely source of the gift of the shroud? The stylistic signature of Avignon, by contrast with that of Paris and most of the rest of France, was then thoroughly Italian, for the simple reason that the reigning pope of the time, who was a lavish patron of the arts, Clement VI (r, 1342–1352), brought Italian artists to decorate his new Papal Palace, with the great Sienese master Simone Martini at the head of the list. While Martini, who died in 1344, is, in my view, out of the running as the possible shroud artist, his gifted pupil Naddo Ceccarelli was active around 1350. Could it have been Ceccarelli, the artist responsible for the small but profoundly moving "soft-focus" Crucifixion in the Walters Art Museum, who was given the charge by the pope to make a devotional shroud of Jesus for Geoffroi de Charny's Collegiate Church?

But if so, which pope: Clement VI, who died in late 1352, or Pope Innocent VI, who succeeded him in that year? The frequent exchanges between Geoffroi and Innocent VI in the months leading up to his church's foundation prove not only that the two were well acquainted but also that Innocent VI was taking a keen interest in supporting Geoffroi. Nevertheless, Clement VI may be the better choice, not only because of his brilliance, audacity, and his attachment to the arts, but also because his successor was, by contrast, a timid and unimaginative pope, who was forced to sell art because his grandiose predecessor had emptied the papal coffers. Clement VI's bias in appointing cardinals from France is revealing of his aim to make the papacy thoroughly French. Perhaps the shroud was his way of creating a focus for pilgrimage in France similar to the Veronica, which so recently had attracted vast crowds of the faithful to Rome. An Avignon origin for the shroud (with either pope) might explain why, more than three decades later, Geoffroi II made a point of recalling to the papal legate that the shroud had been "generously given" to his father, since the gift came from the papal palace. This scenario would also explain the clear bias on the part of Clement VII in favor

of the folks in Lirey at the expense of the bishop of Troyes—a bias that Pierre d'Arcis bitterly lamented near the end of his memorandum. Sure, Clement VII put multiple restrictions on how the Lirey Shroud was to be identified and shown; nevertheless, his ongoing intent was clearly to ensure that this cloth realize its financial potential for the Collegiate Church and de Charny family.

◆

William of Occam would likely have found the alternative scenario I'm now about to offer overly complex; nevertheless, it rests on an exciting possibility that, while at once admittedly farfetched and certainly unprovable, is supported by a stunning visual juxtaposition.

While Avignon and Pope Clement VI, with an Italian artist in his service, like Naddo Ceccarelli, working ca. 1350–52, appear to me to provide a very compelling solution to the double "who" of the Holy Shroud puzzle, a combination of historical evidence and the artistry of the Man of the Shroud itself may offer an even more inviting case for King John II as the origin of the gift and Paris as its place of manufacture. The French court and the French papacy, after all, were closely allied, so the prospect of John II as the donor of the shroud hardly precludes an Italian artist as its creator. But, perhaps more likely, the unknown, thoroughly unconventional French artist who created the king's portrait in the Louvre also created the Man of the Shroud. I can imagine that someone so brilliantly attentive to the anatomical details of the king's face would have loved to experiment with iron gall ink in making a hyperrealistic iconic body print. Moreover, there was likely no one in all of France who had a closer personal bond with Geoffroi de Charny than King John II, a bond that preceded his elevation to the throne in 1350, when he was duke of Normandy. The king had ample reason to reward his favorite knight in thanks for his chivalric courage defending the crown and for

his diplomatic efforts on the royal court's behalf. It was very likely John II who commissioned Geoffroi to write the *Book of Chivalry* as a guide for the knights in the new Order of the Star, which the king created in 1352 as the French answer to King Edward III's recently created Order of the Garter. And, most significantly, in June 1355 John II named Geoffroi the bearer of the Oriflamme, the king's sacred banner that was raised in the front ranks of his major battles. This was the honor that a year later led to Geoffroi's death.

Against this backdrop, the most tantalizing evidence for placing the shroud's creation in Paris is the possible identity of the model for the face of the Man of the Shroud. Just as we can match Bob Morton's 2014 face print with its model, Jeff Johnson, we should be able to reverse engineer a real person's face from its print on the shroud. Indeed, Giulio Fanti, associate professor in the department of mechanical engineering at Padua University and longtime sindonologist, has created a full-body statue from the image on the Holy Shroud, which has been characterized in the press as a 3-D "carbon copy."

Granted that there were very likely distortions during the printing process, nevertheless, two things immediately come to mind as I look at the face of the Man of the Shroud. The first is that the shroud model very likely had long hair, a mustache, and a beard, just as Jesus was supposed to, and was chosen by the shroud's artist specifically for those signature qualities—as Jeff Johnson was chosen by Bob Morton because of his long hair, mustache, and beard. Why? So that these critical iconographic features would not have to be added, like the "blood," in vermillion pigment as after-the-fact makeup. The second quality of the Man of the Shroud that leaps out is the model's huge nose. That nose got my attention as I looked back over the photographs I had taken in the Louvre in 2013. The first work visitors see as they enter the French medieval paintings gallery is the powerful profile portrait of King John II with his extraordinarily big nose, and in back of the wall upon which

that portrait hangs is the Narbonne altar cloth with a profile portrait of John II's son, King Charles V. Again, the nose! The Habsburgs had their distinctive jaw, and the Valois had their distinctive nose.

So imagine that the shroud was given to Geoffroi de Charny not by a pope but rather by a king. And imagine, wildly, that the king himself was the model for that printed Jesus face, thus making it a personal gift to his closest ally. Pilgrims would see the face of Jesus, while Geoffroi would see the face of his dearest friend.

King John II enjoyed literature and acted as patron to painters and musicians. He was short tempered and secretive, and chronically in poor health, which meant that he only rarely hunted or practiced jousting. The king fathered eleven children in eleven years, but due to his close relationship with Charles de la Cerda, a Franco-Castilian nobleman and soldier, rumors were spread by his rival, Charles II of Navarre, of a romantic relationship between the two. La Cerda's preferential treatment by the king excited jealousy among the French nobles, several of whom, from the circle of Charles II of Navarre, stabbed him to death at an inn in 1354, leaving the king desolate. Might John II and Geoffroi de Charny have had a similar relationship, perhaps intensified by the assassination of Charles de la Cerda?

But if the shroud was a very personal gift from the king to his favorite knight and dear friend, how to explain the actions of John II's grandson, Charles VI, in the summer of 1389, when he seemed fully prepared to seize the shroud from Geoffroi's son as a fake? Well, King Charles VI had his own peculiarities. He had been crowned in 1368 at age eleven, and one might wonder if that summer, at age twenty, he had fully taken control of the reigns of authority. And perhaps he was then already showing signs of the strange psychosis that was to dominate his long reign: Three years later, the king had his first major breakdown, in a forest near Le Mans, when he suddenly killed four of his knights and nearly killed his brother, and then fell into a coma. And for a time later

in life, he believed that he was made of glass and had iron staves sewn into his clothing so he wouldn't shatter.

Charles VI was strange man, for sure. And there are two suggestive oddities about that tense encounter in the Lirey church on August 15, 1389 (described in the next chapter), when the king's bailiff showed up in Lirey to seize the shroud: The first is that the precursor of Bishop Pierre d'Arcis was pressing his case to get his hands on the cloth much more forcefully (he wanted to break into the treasure closet) than was the king's bailiff, who seemed willingly bamboozled at every turn; and the second is that the bailiff, despite his royal mandate, departed Lirey that day *without* the shroud, thus leaving it to do its good financial work for the de Charny family.

20

The Liars

The cloth "cunningly portrayed"—a devotional image of the dead Christ brilliantly created by an Italian (or French) artist with chemistry skills and given by the pope (or king) to Geoffroi de Charny as a moneymaker for his church—had come to rest in the Collegiate Church in Lirey at some point between 1353, when the church was built, and 1355, when Dean Robert de Caillac made the cloth public as the Holy Shroud.

In the opening lines of his memorandum, Bishop Pierre d'Arcis makes clear who is to blame: dean of the Collegiate Church Robert de Caillac. He is the one who "arranged to have in his church a certain cloth, cunningly portrayed" because he was "inflamed with the fire of avarice." So far, we have the shroud in the possession of the Lirey church and a money motive on the part of the dean, but no crime. That comes next. According to Henri de Poitiers, as channeled through Pierre d'Arcis, the dean "falsely asserted and pretended that this was the very shroud

in which our Lord Jesus Christ was enrobed in the sepulchre." And not only that, "miracles were fabricated" by men who were paid, "who pretended to be healed during the exhibition of the aforementioned shroud." All this, so that by "cunning cleverness gold might be exhorted" from the faithful. While the Holy Shroud—as a gift "generously given" to Geoffroi de Charny—may have been universally recognized as a benign image-bearing devotional textile up to this early point in its existence, it was transformed with those words and actions on the part of the dean of Geoffroi's Lirey church. The crime was twofold: fraud in secular jurisprudence and incitement to idolatry within the domain of the church.

The dean did not act alone. According to Pierre d'Arcis, once Henri de Poitiers learned from the artist about the shroud's creation, he launched formal proceedings against the Lirey dean and his "accomplices." Who were those unnamed accomplices? I think Geoffroi de Charny can be eliminated from the suspect list, mostly because of his busy life as a knight and diplomat away from Lirey, and his sense of honor and his profound piety; the "most stalwart and valorous man of all," according to Jean Froissart's *Chronicles*. Moreover, the shroud was unmentioned when the Collegiate Church was dedicated in May 1356, and Geoffroi de Charny and Bishop Henri de Poitiers were then on the best of terms. Further, Geoffroi made no mention of the shroud in his repeated communications with the papacy about his plans for the Lirey church. Was Geoffroi too preoccupied to be aware of the shroud? Or did he simply understand it to be nothing more than what it was: a manmade devotional textile? My guess is the latter, which leaves the five canons of the Collegiate Church, who certainly participated in their dean's cynical charade, as his accomplices.

Fast forward to August 1389, to a comical episode in the Lirey Shroud controversy that, while worthy of a television situation comedy, is at the same time revealing not only of a second set of Lirey liars but also of the texture of the liars' cat-and-mouse game of deceit. Bishop Pierre

d'Arcis had tried and failed with the pope, who in his July 28 bull not only supported his legate's decision to allow the return of the shroud to the Lirey church, he extended permission to Geoffroi II to exhibit the cloth for public veneration. In the meantime, Pierre d'Arcis had made an appeal to the King Charles VI seeking the annulment of the royal safeguard given to Geoffroi II. (This was the safeguard by which Geoffroi "had the cloth kept in his possession with the right of exhibition.") The bishop had made the claim before the king's parliament that "there was a certain handmade cloth, rendered skillfully in respect to figure and likeness, and as a tribute to the sacred shroud in which the most precious body of our Lord Jesus Christ was wrapped" and "to the aforementioned church the people of Champagne and the surrounding regions flowed each day in abundance to adore the cloth, without fear of committing idolatry." Indeed, they show the cloth "with torches lit and the priests robed in sacerdotal vestments, as if it were a matter of the true shroud of Christ." Convinced by the bishop's plea, Charles VI gave instructions in a letter on August 4 to his bailiff in Troyes to seize the shroud and transfer it to one of the churches in Troyes or to a secure location in the custody of the king.

The bailiff subsequently reported back to the king the actions he took eleven days later, on August 15, and the strange outcome. I assume that the bailiff chose that day, the Feast of the Assumption, because he was certain that the shroud would then be on display for veneration, and thus he could catch the culprits in the act. (The Collegiate Church was dedicated to the Trinity and the Annunciation to the Virgin Mary, so her major feast days were assigned indulgences that guaranteed both the shroud's exhibition and high attendance.) Did the king's bailiff known where Geoffroi II would be that day? This could be important, since according to the Memorandum d'Arcis, Geoffroi II sometimes held the shroud for veneration himself on certain solemn days.

This is how the day unfolded, as best as I can envision it from the bailiff's report back to his king: It is late morning, and the bailiff confronts

Dean Nicole Martin and a few of his canons in the nave of the church. Preparations are underway for the exhibition of the shroud for veneration, since torches stand ready to be lit and a crowd has gathered outside the church. The dean asks the bailiff why he has come; his response is that he has come to see the cloth. The dean tells the bailiff that he will exhibit the shroud shortly, but only if he goes back outside with the crowd. (It has become apparent that the shroud is at that moment nearby in a reliquary.) The bailiff doesn't want to leave the church because he fears that the shroud will be spirited out a side door.

At this point, the procurator (legal agent) of Bishop Pierre d'Arcis steps up, displaying his power of attorney and the letter of the king. He repeatedly demands that the letter be enforced and commands the dean, in the name of the king, to get the cloth. The dean says he can't turn it over. Apparently it is in a small closet at the end of the nave of the church, in a "treasure," where it is customary to keep relics, vestments, books, money, and such, and that closet is secured with several locks. The dean claims he has only one key, so he cannot open the closet by himself. The procurator insists that the closet be opened, even if that means breaking it open. The dean now says that the cloth is not in the closet!

Given the intractable dispute, and the time of day, the bailiff decides to go to lunch. And at the request of that suspicious procurator, he puts a royal seal on the door of the treasure closet and appoints two sergeants (royal servants) to stand guard during lunch.

It is now the later afternoon (the time of vespers) and the dean is now insisting that the royal seal be removed from the treasure closet so he can arrange his relics, vestments, and other church objects, and take out some money. And by the way, he says, the cloth is not there anyway. Not only that, the dean and canons are making a number of appeals against Bishop Pierre d'Arcis regarding this case. The procurator of the bishop is against removing the seal and opening the treasure's door

unless the dean opens it "widely and completely," presumably, so he could confirm that the shroud is truly inside—and lay his hands on it.

The dean again says he cannot open the door of the treasure as he has only one key and that the "men of the lord of Lirey" have the other key. The bailiff asks if he, the dean, wants to send someone to look for the key, and in the meantime, those two sergeants will watch over the seal until the other key appears. The dean says he has no idea when the person with the other key, on behalf of the Lord of Lirey (Geoffroi II), might show up. And he keeps insisting that the royal seal be removed. The bailiff decides that he will take until the next day to consider the matter. The dean, though, is greatly offended by all of this, including the threat earlier in the day that the material goods of the church might be put in the hands of the king if he didn't hand over the cloth. The dean and the canons make an appeal against the bailiff, who decides not to go further, but to hold "firm in that state." Was the seal then removed and did the sergeants go away? And how about that crowd of the faithful outside: When did they give up and go home?

Twelve days later, on September 5, the sergeant of the bailiff reported to the dean and canons that the shroud had been put "verbally" in the king's hands. He also went to the nearby chateau to inform Geoffroi II of that decree, but the news was conveyed in Geoffroi's absence to his squire.

What we learn from all of this is that the dean and canons are clearly in charge of what goes on in their little church. Moreover, the deviousness of this small group of insiders goes well beyond spreading rumors that their cloth is the true Sudarium Christi, using the word for "sanctuary" deceptively, and displaying what they know to be a representation of a relic as the relic itself. That day in August, dealing with an agent of their king, they were fully prepared to sneak the shroud out a side door of the church, to lie about where it really was, and purposely to avoid finding the key necessary to get the treasure closet open. And how about Geoffroi II, who was certainly complicit in the local rumors and word

games, and was an active player in the *faux* theater of presenting the Lirey devotional cloth as if it were a relic? Had he gone on to Paris by August 15 to prepare for the arrival of Charles VI's queen, Isabel of Bavaria, on August 20? Or was he laying low with key number two in his nearby chateau? In any case, the coconspirators in the 1389 trickery included not just the dean and five canons, but also Geoffroi II, who was up to his ears in the deception. Was there anyone else?

What about Geoffroi II's mother, Jeanne de Vergy? She took possession of the shroud along with the Collegiate Church after her husband's death, as Geoffroi II was still a child. Would she not have been aware of what was afoot? And looking back, is it possible that Jeanne de Vergy took the shroud with her out of the diocese to the Alpine High Savoy when she married again, and later brought it back to Lirey, with her now grown son, Geoffroi II, after her second husband had died? According to Pierre d'Arcis, it was the current dean of the Collegiate Church, Nicole Martin, who persuaded her son, Geoffroi II, to reexhibit the shroud for financial gain. But it was Geoffroi II who took the lead with both the pope and the king—against the strong objections of Pierre d'Arcis—to ensure that the shroud could be shown. It is hard to imagine Geoffroi II taking that bold strategic action without the knowledge and support of his mother.

Tellingly, Jeanne de Vergy is the only major player on stage in both moments of high drama: 1355 and 1389. Geoffroi II was, in 1355, still under the age of ten, the offending dean of the Collegiate Church was to die the next year, and, we may assume, most of the canons of the church when it was founded had died over the next three decades. And consider this: Jeanne de Vergy's second husband, Aymon de Genève, was the uncle of a rising star in the Catholic Church, who would later become Pope Clement VII. Did Jeanne de Vergy have a long-term shroud strategy, born of greed? If not, why that seemingly calculated marriage to Aymon de Genève, and why did she marry off her son, Geoffroi II, to Marguerite de Poitiers, niece of Bishop Henri de Poitiers? My guess is that Jeanne de Vergy was

indeed an accomplice, though probably passive, to the lying in 1389, and that she may have played a similar roll in 1355.

◆

Where, finally, did Bishop Pierre d'Arcis fit into the Holy Shroud puzzle? I believe that in his memorandum the bishop is both telling the truth and lying. He is telling the truth about the major players and their motives as well as the chronology of events. And he is telling the truth about what the dean and canons in Lirey were specifically up to, both in 1355 and in 1389. And he is calling them out. The understanding from the beginning—that I think all the players on both sides of the dispute understood and initially accepted—was that the Lirey Shroud was a manmade copy—a "figure or representation"—of the Sudarium Christi. And thus, in theory at least, this is an innocuous devotional textile. What Henri de Poitiers and Pierre d'Arcis did was to hold the Lirey folks accountable for their greed and audacity, initially, when they used the word "sudarium" and faked miracles, and, thirty-four years later, when they used the word "sanctuarium" and, obstinately, continued to present the cloth as if it were a relic when they were told not to.

But at the same time, I believe that both Henri de Poitiers and Pierre d'Arcis were being less than truthful as to *why* they were taking the actions they took. It was not simply because they were so eager to put an end to idolatry, as they professed, but also, as their detractors claimed, because they wanted to get their hands on the Lirey Shroud and the wealth it represented for themselves. Their cathedral was literally falling apart; on Christmas Day 1389, part of the nave caved in. Recall that day in August 1389 when, on the order of King Charles VI, his bailiff in Troyes was charged to seize the shroud from the Lirey church so that it might be relocated in another church in Troyes. That charismatic cloth meant money, and that's what the bishops desperately needed.

21

Our Delusions

My pummeling by that small army of energized sindonologists after my shroud letter appeared in the *Biblical Archaeology Review* in 1998 was the first, though hardly the last time, that I've felt almost seduced by their shroud-think. As if after watching yet another documentary on the Kennedy assassination, with some "new evidence" for the second gunman on the grassy knoll, I suddenly, after fifty years, believed in the conspiracy theory. The world of shroud-think is a world with a myriad of reputed authorities, a mountain of arcane facts, and an endless supply of contrived theories—all animated by a disturbing, charismatic image of profound mystery. That is a seductive world.

Why can't the Shroud of Turin be as simple as *Our Lady of Guadalupe?* Both are widely believed to be miraculous images "not made by human hands" and each is the object of mass pilgrimage: More than

two million pilgrims came to the Cathedral of St. John in Turin to view the shroud during its six-week showing in 2010, and during that same year, nearly twenty million visited the Basilica of Guadalupe in Mexico City to view the sacred tilma while passing it on an airport-style moving walkway. According to legend, Our Lady of Guadalupe miraculously appeared on Juan Diego's cloak in December 1513; that cloak is part of the historical record beginning just a few decades later and the main texts recounting the miracle date to less than a century after that.

Our Lady of Guadalupe exists around the world in tens of millions of copies, in all media and all sizes, from pendant medallions to tattoos to life-size, crèche-like reconstructions of the miraculous event in suburban backyards. Thousands of miracles have been attributed to Our Lady of Guadalupe, and they can easily be traced through a simple Google search. A famous recent miracle involved Our Lady's spontaneous appearance on July 5, 2012, in the bark of a ginkgo biloba tree on a busy strip of Bergenline Avenue between 60th and 61st Streets in West New York, New Jersey. Within days, the site was flooded with votive flowers, and it rapidly became a destination for throngs of pilgrims, who were seen to kneel, cross themselves, and lean forward to touch the sacred tree.

Juan Diego's sacred tilma has never been scrutinized with anything close to the scientific intensity that the shroud has received. Though it is generally known among those who care that the pigments and technique of the image are consistent with 16th-century painting. Some believers describe its extraordinary state of preservation as miraculous and point to the "fact" that the tilma has twice spontaneously repaired itself. Miracles are miracles, and that seems enough, without such dubious sindonology-like evidence as that recently offered by ophthalmologist Dr. José Aste Tonsmann, who enlarged the Virgin's eyes on the tilma twenty-five hundred times and claimed to see reflected images of all the witnesses present when the Virgin revealed herself on Juan Diego's cloak, plus a family of four, which makes for thirteen people in all.

The Shroud of Turin does not have a comparably vast array of current copies, pendant medallions, or votives—despite enormous pilgrim traffic when it is shown. The historical record of the shroud postdates its reputed miraculous moment of creation by thirteen hundred years, and there is no foundation legend accounting for its travels over those centuries from the Holy Land to France. And as for miracles, a Google search yields as the shroud's main miracle the shroud itself—that its image seems to have anticipated photography by two millennia and that no one can duplicate it. By the time the shroud's carbon-14 tests made headlines in 1988, legions of sindonologists and millions of pilgrims, including the armchair types who visited Turin by way of a television documentary, had long since elevated the Man of the Shroud to the status of a miraculous relic. Such is the charismatic power of that raw image of a dead man, who, unlike that dead John Dillinger photograph of my childhood, happens to look like what most people think Jesus looked like.

Clear thinker though he was, William of Occam was a theist who chose to see science as a matter of discovery and religion as a matter of revelation and faith. This same approach was advocated recently by the late Stephen Jay Gould in the form of his "non-overlapping *magisteria*" dictum, by which science and religion are defined as two separate domains whose authorities do not overlap. Thus, for Gould, "science gets the age of rocks, and religion the rock of ages; science studies how the heavens go, religion how to go to heaven." So how are we to understand the interpenetration of the domains of science and faith when it comes to the shroud? Are sindonologists doing for the shroud no more than what biblical archaeologists are doing for Jerusalem and its monuments; that is, connecting material things of our time with the historical Jesus? If that were all, then their sindonological discoveries would likely have no more meaning for those of faith than would the discovery by archaeologists of the location and configuration of the judgment hall of Pilate, where Jesus was tried—which has its counterpart in the Athenian

agora in the people's court, where Socrates was tried. But the Shroud of Turin certainly carries more significance for Christianity than that. A better parallel might be the Holy Sepulchre, which according to Bishop Eusebius was discovered by Emperor Constantine's mother in a landfill beneath a Roman temple in the northwestern part of Jerusalem. From an archaeologist's point of view, that location and the monument that marks it, which has been a destination for Christian pilgrims and a source of miracles for centuries, may in fact be one and the same with the cave tomb where the body of the historical Jesus was laid after the crucifixion.

But unlike Pilate's judgment hall and the Holy Sepulchre, the shroud is a fragile object that would have survived to our time only through extraordinary, if not miraculous intervention. And while it is pretty easy to understand how the judgment hall and the Holy Sepulchre were constructed and what they originally looked like, the shroud's image has for decades baffled those who study it. Moreover, if the shroud can be shown by authorities within the *magisterium* of science to be certainly or at least plausibly "authentic," to the level, for example, that the Holy Sepulchre is authentic, then the world—believers and nonbelievers—would know nearly for certain, and for the first time, what the historical Jesus looked like. And they would know what his Passion experience was like to a level of detail matching that of Jim Caviezel who played Jesus in Mel Gibson's *The Passion of the Christ*. Had the three carbon-14 labs come back with the dates 60 B.C.E. to 90 C.E., instead of 1260 to 1390, Christianity would have received a huge endorsement, which would have been compounded exponentially had Alan Whanger's theory—that the shroud image was formed by a flash of ionizing radiation as Christ's body disappeared—been somehow scientifically verified. The shroud would be at once Jesus and a miracle, and, more generally, a unique and compelling witness to the scientific reality of a supernatural deity.

But that didn't happen, which hardly means that Christianity in specific or the notion of a supernatural god more generally, was in any

way discredited. Why? In part, because the loss or demotion of relics is commonplace and seems never to have diminished the devotion of the faithful. The abbey church in the tiny French town of Cadouin was a major pilgrimage destination just over a century ago because it possessed a holy shroud that was performing miracles. In the 1930s, the Cadouin shroud was discredited as its decorative border was found to be medieval in manufacture. Nevertheless, the votive plaques attesting to the miracles it performed are still affixed to the church's walls.

But the more basic reason that the carbon-14 test results did not finally resolve the shroud as a creation of the Middle Ages is that the shroud debate, like all debates between the two magisteria, are conducted according to the theist-bias rules of the "God of the Gaps." That is, anything about a phenomenon in the material world—like the big bang—that science has yet not fully explained offers a gap in the scientific, rationalist story line that, by default, is filled in by the hand of the divine. The origin of the image of the Man of the Shroud has not, up to this point, been scientifically explained to the satisfaction of the sindonologists—ergo, it must be evidence of a miracle and authenticity.

Sindonology has introduced science into the realm of religion, which, for me, makes sindonologists modern-day Doubting Thomases, who will be satisfied only when they put their finger in Christ's wounds—that is, see the second, "correct" carbon-14 test results. And at the same time, the sindonologists' teleological bias has put God's design in charge of the story line. But then, of course, God can choose to ignore his design and its rules when he wants to. This is the ultimate complexity wrinkle breaking Occam's law of succinctness: Anything that does not seem to fit the intelligent design of the shroud's story, like the carbon-14 test, can be trumped by the notion that God, at his discretion, has called a time out on the laws of nature in order to test our faith. Our Lady of Guadalupe and the Man of the Shroud are indeed different creatures, at least in part because they have historically been treated differently. From

the beginning, Our Lady has remained comfortably and quietly in the magisterium of religion, whereas for more than a century, the shroud has uncomfortably straddled the two magisteria.

Changing one's opinion in an ideological debate like this one is very difficult. Dante Alighieri, who died just a generation before the shroud appeared in Lirey, was aware of a flaw in our collective power of reason—namely, confirmation bias—that has been explored in depth by contemporary psychologists and sociologists. When they meet in Paradise, Thomas Aquinas cautions Dante that "opinion—hasty—often can incline to the wrong side, and then affection for one's own opinion binds, confines the mind." But I have hope. And yes, pro-shroud thinking can be overturned. The venerable "Mr. Shroud," Father Peter Rinaldi, who had galvanized American Catholics' enthusiasm for the shroud with his 1940 book, *I Saw the Holy Shroud*, fully accepted the carbon-14 test results. On July 5, 1991, not long before he died, Father Rinaldi wrote to a friend:

> It may surprise you to know that since October 13, 1988 I have a completely new relationship with the Shroud. . . . I had began [sic] to feel that I had given the Shroud far too much importance in my spiritual life. Suddenly I understood that what really mattered was the Lord of the Scriptures and the Church and not the Lord of the Shroud. And, too, I saw clearly that falling back on science to bolster one's personal faith in and love for the Lord is only a mirage, a delusion.

22

Members of the Jury

O nce the Mortons had come up with the breakthrough of *how* the image was created, and I was able to piece together the initial "coming out" story of the shroud in the 14th century, I wanted to move on to what for me is the final step: namely, calling the question on my title word "hoax," by putting the Shroud of Turin on trial. But before I could consider the case I wanted to present, I needed to consider my jurors. Finding the right jurors would not be easy, since I imagined my shroud trial to be like the one H. L. Mencken made famous with the label "monkey trial," when William Jennings Bryan and Clarence Darrow squared off over the fate of a small town Tennessee schoolteacher on trial for having taught evolution. Opinions on the Shroud of Turin are intensely felt, and as in the monkey trial, those opinions are borne of deep affection for one of the two divergent magisteria—science and religion.

For my shroud trial, I would certainly settle for a few jurors from among the likes of Father Peter Rinaldi, the archsindonophilc who was, nevertheless, susceptible to a rethink when presented with compelling new evidence. Though at this stage, three decades after the carbon-14 tests, I'm doubtful that many of those exist. This means that I would be looking for agnostics in my jury box. And by that I don't mean those who are agnostic about the existence of God—in fact, I don't care if my jurors are devout Catholics, Protestants, Jews, Muslims, Hindus, animists, or atheists. Rather, as I register my objections to the trial judge during jury selection, I will be looking to reject anyone who cannot honestly say that he or she is agnostic about the possible authenticity of the Shroud of Turin.

Do I have enough evidence to reconstruct a crime more than six hundred years after the fact? And, before I get ahead of myself: What *was* the crime? We know from his papal bulls that Clement VII had no problem with the mere possession of the Lirey Shroud. Geoffroi II was permitted to retain the shroud, to show it to the public, and to make money from that public showing, provided that two conditions were met: that the object was identified as a figure or representation, and that it not be accorded the ritual honors reserved for relics. So if, from the point of view of the papacy, it was permissible to display the Lirey Shroud and take in offerings, it must have been permitted, within the domain of church authority, to create it in the first place. After all, the medieval Catholic Church was not in the business of policing the creation of religious images in the way that the Byzantine Church was a few centuries earlier, during the Iconoclastic Controversy. Pierre d'Arcis tells us that Henri de Poitiers was able to find the artist who created the shroud, but he does not qualify that claim with any implication of wrongdoing on the part of that person. No, the wrongdoing is instead laid at the feet of those who later possessed and displayed the shroud falsely as the Sudarium Christi, the true burial cloth of Jesus.

So let's imagine that my shroud jury box is filled with twelve shroud agnostics. What is at issue in this trial? When I tell people I'm writing a book about the Shroud of Turin, I will often be asked: "Is it real?" Well, of course it's real, insofar as it can be seen and touched. So then, the next version of that question: "Is it fake?" The fake question is more subtle than it might at first appear, given that it involves the intent of the maker and the identification given the work by the person who later possesses it. When Henry Walters bought the Massarenti Collection in Rome in 1902—seventeen hundred works ranging from Etruscan bronzes to an 18th-century canvas by the Italian master Tiepolo—he received a group of seemingly stellar paintings that the collector, a priest in service of the pope, claimed were by Titian, Raphael, and Michelangelo. Unfortunately, these works were early copies of famous works by those masters. The artists who painted the copies did not consider them fakes, nor did the original owners; rather, they understood them for what they are, good copies. Only later, whether through misunderstanding or deceit, were these works labeled as creations by the great masters. At that point, and for the first time, they became fakes, since they were, in effect, then traveling with false IDs.

But what does fakery mean in a world where there are multiple reputed foreskins of Jesus and seemingly enough wood of the True Cross to build Noah's Ark? Despite the fact that the earliest Christians ignored relics, the belief in relics and their power was pervasive during the Middle Ages. The question was not whether relics should exist, nor was there doubt about the miraculous power of relics or the theological ideas that explained that power. Rather, relic questions, when they did arise, revolved almost exclusively around proper identification: Which among the three wooden crosses that Saint Helena is said to have discovered during her excavations in Jerusalem was the "True Cross"?

A rare critique of relics—under the heading of mindless gullibility and irreconcilable claims to the authentic—came in the 12th century

from Guibert, Abbot of Nogent-sous-Coucy, northeast of Paris. In his *Treatise on Relics,* Guibert describes the faking of miracles by monks from Beauvais, "seduced by the gifts" of pilgrims:

> Vulgar, common people are able to be duped in their greedy hearts by feigned deafness, affected madness, fingers pushed back into the palm on purpose, and feet twisted up under thighs.

Guibert was troubled by the corruption that fed on the uncritical acceptance among the naive public of, for example, the sacred milk teeth of Jesus—the Resurrection was, after all, of the whole body of Jesus, including his baby teeth, umbilical cord, and Holy Foreskin. Over the centuries there have been several of the latter, one of which was paraded through the Italian village of Calcata on January 1, 1983, the Feast Day of the Circumcision.

So how could there be any certainty about the authenticity of relics, other than those of saints like Francis of Assisi, who, in 1226, went more or less in public view—much like a dying family member—from being a living holy man to being the relic body of a dead holy man? First, there is external evidence, which might be old documents associated with a reliquary, or descriptions of the burial of the saint's body in his or her life. Should such evidence be found compelling by church authorities, the relics would go through the formal ritual of "elevation," by which they would be made available for public veneration. The point was to come as close to the relics as possible, touch them if permitted, and sleep next to them in a healing ritual called "incubation." Once elevated, the more important, second category of evidence for relic authenticity came into play; namely, miracles—for example, the dramatic and compelling sight of a cripple, having encountered a reliquary, walking away carrying his crutches.

Guibert's Beauvais monks were hardly the first or the last conniving Christians to indulge in relic deception. In 2007, Dr. Philippe Charlier, France's most famous forensic detective, led a team that determined that bone fragments long believed by the Catholic Church to be those of Saint Joan of Arc were fake. These supposed relics turned up in 1867 in the attic of a Paris apothecary with the label: "Remains found under the stake of Joan of Arc, Maid of Orleans." The presumed relics were later found to be a cat femur and bits and pieces of an Egyptian mummy with embalming residue, carbon-14 dated sometime between the 6th and 3rd century B.C.E. Dr. Charlier speculated that these "relics" were fabricated to build enthusiasm for Joan's beatification, which was the first step along the path to making her Saint Joan.

Was the Mandylion of Edessa similarly created to deceive? Or was it an ordinary and innocent image of Jesus imbued with sacred pedigree and miraculous powers through wishful thinking on the part of gullible believers? The story of the Column of the Flagellation in the Church of Holy Sion offers a possible parallel case. In the 5th century, it was simply a column, but by the time the Piacenza pilgrim saw it in the later 6th century, things were different, insofar as he reported that "you can see the marks of both of his hands, his fingers, and his palms." Did someone in the dark of night secretly recarve the column to trick pilgrims and gain additional offerings for the church? Or was it simply the overactive imagination and eager credulity of those pilgrims that enabled them to see things that simply were not there? If so, there need be no more manipulation involved than was involved in what some saw as the face of Satan in the smoke billowing from the Twin Towers on 9/11.

Obviously, though, the Shroud of Turin is not the product of fevered imagination and profound faith. Rather, it is the opposite: It was created through a very calculated act of chemistry and artistry. And though it was clearly created on purpose, that does not necessarily mean that it was, like Saint Joan's pseudorelics, created to deceive.

I believe that those responsible for the creation of the shroud—the artist and the person who found him and gave him his charge—along with all the lead players in the controversy surrounding the shroud's initial display, understood it to be a representation of the burial cloth of Jesus and not the burial cloth itself. Fine, but that's not the issue. The real issue is the object itself, and here the crime of forgery may be inherent, insofar as the shroud *presents* itself not as a representation of the Holy Shroud, like the nearly contemporary Belgrade *Epitaphios*, but rather as the Holy Shroud itself. This is so because the very calculated manner of its creation, through contact with a body, mirrors precisely the specific kind of relic that it purports to be, an *acheiropoieton*—an image "not made by human hands." This makes the Holy Shroud, on its face, a potential deception. I assume that all the insiders at the time that the shroud entered the world in mid-1350s were comfortable with being complicit in this subtle but explosive ambiguity; namely, that the Lirey Shroud was *simultaneously* an acknowledged artifact among the elite and, in the eyes of the simple folk, a miraculous *acheiropoieton*. The only thing that separated the relative culpability of Lirey liars on the one hand and the papacy on the other is that the pope offered tacit endorsement with multiple caveats, whereas the greedy Lirey folks overplayed the moment by giving their charismatic devotional cloth a false ID, inappropriate honors, and faked miracles.

But so what? So what that the "Michelangelo self-portrait" Henry Walters bought in 1902 from Don Marcello Massarenti was not painted by Michelangelo? Two things: First, Henry Walters was cheated out of some money; and second, art historians and those who care about the history of art and culture, were cheated out of a bit of historical truth. In that case, it was hardly a big deal, but if the fake is instead the notorious "Hitler diaries," the sixty volumes of journals written between 1981 and 1983 by Konrad Kujau and sold for nearly $4 million to the magazine *Stern*, which then serialized them, the financial and historical stakes are

much higher. So, yes, fakes are serious, and they should be investigated and called out, since they are not victimless.

As for the shroud, when Robert de Caillac called it the Sudarium Christi and faked the miracles, he was no better than Chaucer's Almoner, who charged the sick a fee to gain access to what they believed were relics, but were actually sheep bones and pig bones. Had these unfortunate victims known that animal remains were in play, they would have known for certain that no miracles were possible. So their money was gone, and their hopes were dashed. In the case of the shroud, money changed hands under that same fraudulent umbrella of false hope, nourished by Robert de Caillac and his canons—and, a generation later, by Geoffroi II along with his dean and his canons. And while the papacy fussed over how the shroud was to be identified and displayed, it turned a blind eye to the inevitable outcome of that display, which was, and is, idolatry.

So where does that leave us? An object perhaps cynically created is falsely presented and mistakenly understood. The victims are those who come to pray before the shroud and make their offerings. They are cheated out of their money as they are paying for false hope, and more significantly, they are drawn into idolatry. Therein lies the answer to the "So what?" question and to the question of what my trial should be about. The medieval bad guys are gone but the idolatry remains, and money continues to change hands, mostly in Turin, under an umbrella of a nurtured misunderstanding, if not outright deceit.

Who, then, should be on trial? It makes no sense to put the shroud itself on trial, and as for those deceitful players of centuries past who created the shroud knowing it would very likely be misunderstood, and then those who upped the ante by lying, they are long since dead. I am hardly going to put on trial the millions of pilgrims who go to Turin to pray before the shroud, believing they are praying before the true image of Jesus. Nor the misguided sindonologists, who endorse the shroud as authentic, or the documentary filmmakers, who exploit its mystery and

thus encourage the faithful to be duped. Are they cynical? Does it make any difference? The actions of the 14th-century shroud conspirators clearly constituted a sin of commission, but now, the workings of the shroud deception are more subtle, insofar as it is a sin of omission, of things not said and not done. And the perpetrator is the Catholic Church itself, which takes its cue on sins of omission from a passage in the Book of James: "So whoever knows the right thing to do and fails to do it, commits a sin." So now I know who should be sitting there in the docket.

◆

Members of the jury, let me offer you a review, in summing up my case, of the preponderance of evidence that I have offered over the duration of this trial in support of labeling the Shroud of Turin a hoax. Let me recall for you that relics were not part of Christian life before the 4th century, and that relics with miraculous contact images appeared for the first time only in the 6th century. Jesus shown dead on the ground is unknown before the 12th century, and it is not until the 14th century that the blood and gore of the Man of the Shroud enters Christian imagery for Jesus. Recall the carbon-14 dating of the linen of the shroud between the years 1260 and 1390, and the headline in the *New York Times* when the results were announced: "Church Says Shroud of Turin Isn't Authentic."

You have become aware of the doubts that lingered after that announcement, nourished by the mystery of how the image of the Man of the Shroud was created. Alan Whanger argued for some atomic event, whereas Robert Morton has demonstrated that such a precise body image with 3-D characteristics could have been printed on the outer fibers of the linen of the shroud with the simple ingredients of iron gall ink. I trust you found Bob's demonstration persuasive. But even if you did not, and even if you reject my ideas on the possible identity of the shroud's artist and donor, the preponderance of remaining evidence against the shroud

that I have brought forward from the history of religion, art history, and science still stands. Provided, of course, that you recognize, as Pierre d'Arcis did and I do, that the Man of the Shroud is the product at once of chemistry and artistry, and not a miracle. And most important, that evidence converges *exactly* with the evidence of medieval documents that place the shroud's first appearance in the historical record in the years just after 1350. Tellingly, this alleged relic of Christ, unlike the others, appears without a legend accounting for its journey from 1st-century Jerusalem to 14th-century Lirey. The shroud had a uniquely inauspicious first act, when it was labeled by a pair of distinguished bishops as a fake, and then the pope went on record insisting that it be called a "figure or representation," and that it be denied the honors of a relic. The Shroud of Turin at its birth was the Shroud of Lirey, and its initial purveyors were liars. Their lies, born of avarice, engendered false hope and inspired idolatry.

What am I asking you to do? Is it enough that the Catholic Church of the 21st century follow the mandate of Pope Clement VII and station a church official near the shroud when it is shown and "say in a loud, intelligible voice, stopping any deception, that the aforementioned figure or representation [is not] the true shroud of our Lord Jesus Christ?" I say no, it is not enough! Not only because that demand was once made by the highest authority and then ignored, but also because the extraordinary charismatic power of the Man of the Shroud, a legacy of its mode of creation, will always overrule such cautionary disclaimers, however emphatic. I suspect that its donor and creator understood that. And I'm pretty sure that the true believers of the Middle Ages, and of today, the simple folk as Pierre d'Arcis labeled them, did not, do not, and will not care.

No, I ask you to take it one step further and follow the sound advice of Pierre d'Arcis. Remember that near the end of his memorandum, the bishop requests that measures be taken by the pope so that "this sort of

error and stumbling block and detestable superstition be utterly rooted out." Why? Because in his view, the purported Sudarium never existed in the first place. But more than that, Pierre d'Arcis wanted nothing to do with his pope's cautionary dictum, since even as a copy of a supposed true shroud, the Lirey cloth would inevitably reach the exalted status in the minds and hearts of the devout of the Sudarium Christi.

Pierre d'Arcis asked the pope to condemn publicly what was going on in Lirey and to declare his legate's letter of permission null and void. Translated into this moment, I ask you, the jurors, to compel the papacy to condemn publicly what is going on in Turin, to declare Pope Clement VII's bull null and void, and to remove the shroud from its Turin shrine and hide it away in the basement of the Vatican forever. Only with this drastic action can shroud idolatry finally be extinguished and the sin of omission by the Catholic Church relieved.

CONCLUSION

M illions of pilgrims come to venerate the shroud today in Turin, believing it to be a relic that once touched the body of Jesus and miraculously retained his image. Why shouldn't they? The Catholic Church voices no objections, plus, there is the seeming proof conjured up by legions of sindonologists and reinforced by television documentaries on the mystery of the shroud. The mistaken notion that the shroud is a relic is so pervasive that it was recently uncritically endorsed by the *Wall Street Journal* in an op-ed piece by Francis X. Rocca, their Vatican correspondent. Rocca unequivocally identified the shroud as a relic, and then went on to note that its 2010 showing was staged in part to draw visitors and their cash to Turin amid the economic downturn. All of this sounds much like Lirey in 1389—with the papacy now playing the entrepreneurial role of Geoffroi II. The church today, like Geoffroi II then, is practicing benign neglect of the truth and, in doing so, willfully opening the door to blatant idolatry. But, in the end, what is good for the Vatican is very good for Turin.

CONCLUSION

◆

I met Pope John Paul II on May 19, 1999. The encounter came at the end of his weekly Wednesday audience, just in front of the great central doors of St. Peter's Basilica. It was a sunny spring day and Bernini's St. Peter's Square was packed with the faithful, who had come to see the pope in person and to his receive his blessing. Just a few hundred special guests had the privilege of sitting to the pope's left in several rows of chairs and, after his blessing of the throng, of meeting him close up and receiving his personal blessing. My Walters board president and I were "guest number 189," which meant that we were received by His Holiness side by side, as if one person. We had the opportunity because Baltimore was the home of Cardinal William Keeler, who was not only a major force within the College of Cardinals, he was very fond of the Walters. Cardinal Keeler spoke at the museum several times on the occasion of exhibitions involving Catholic art, and we became personal friends. I didn't care that my board president and I were considered a single guest; given the huge crowd out there in the square, all looking our way, I felt very special.

I have a fantasy that goes this way. Fast forward twenty years from my 1999 encounter with His Holiness: Cardinal Keeler, who recently died, has been replaced by another Baltimore-based cardinal, and he offers me a papal meeting reprise, this time with Francis I. It is again a sunny day in spring, and this time I bring along my own gift: a copy of this book.

"Your Holiness," I say in this fantasy, "here is a copy of my new book on the Shroud of Turin for the papal library."

"Thank you, my son." Pope Francis replies.

I continue: "Of course you know, Your Holiness, that the shroud is not a relic."

"I do, my son, and that is why I call it an 'icon.'"

Then, emboldened, I continue: "So why do you allow the shroud be worshipped as a relic by millions of Catholics?"

"What am I to do?" replies the pope.

I respond, confidently, thrusting my gift forward: "This book of mine, Your Holiness, has the answers your need."

As I said, this is my fantasy.

How the Shroud Was Created

Robert Morton and Rebecca Hoppe

I n 1994, Dr. Walter McCrone visited Bartlesville, Oklahoma, where we live, and presented a talk about his chemical and microscopic analysis of the Shroud of Turin. We had a chance to talk about his research and discussed the chemistry that may be the basis of the image. My recent research on elemental X-ray imaging (EXI) fascinated him, and we parted wishing that we could collaborate on the shroud, if time permitted. Alas, Walter McCrone passed away in 2002 and did not have the opportunity to see how EXI helped recover Archimedes's writings in the Archimedes Palimpsest and confirm that the Archaeopteryx had been a living animal with real feathers. At the time, we had no idea that EXI would become the key to studying the chemistry of ancient ink and that this would lead back to the Shroud of Turin.

Walter McCrone, a chemist, microscopist, and director of the McCrone Research Institute, made major contributions to shroud research from 1974 to 1994. He documented his forensic work in his 1999 book, *Judgment Day for the Shroud of Turin*. His initial feelings about the shroud are summarized on page 1:

> I began my tests expecting the "Shroud" would be authentic,
> in spite of Bishop Henri claiming it to be a forgery.

Eventually, after rigorous observation and testing of specimens taken from the shroud, Walter McCrone began to see that the shroud was man-made:

> The image is due to two paint pigments in two very dilute collagen tempera paints; there is no blood on the Shroud image . . . the blood stains were added with a second dilute vermillion paint.

As his studies continued, he wondered if there could be a fainter authentic image that had been enhanced.

Could the "fainter authentic image" of the shroud have been embellished with vermillion paint to enhance and create a more dramatic crucifixion image? Walter McCrone felt that the "yellow fibers" of that "fainter authentic image" on the shroud "must be due to a paint medium, originally colorless but yellowed with time." This led to the question of why there was no sign of a thin film layer of paint medium present on the shroud's yellow-area fibers. After many observations and tests, Walter McCrone was left questioning the idea of paint medium and whether the medium was aqueous.

But what if the "fainter authentic image" was formed with *no paint medium at all*? Could that be possible?

◆

Iron gall ink has recorded history for thousands of years; the writings on the Dead Sea Scrolls up to the United States Constitution attest to the durability and longevity of this ink. The chemistry of making the ink's black iron complex with gallotannic acid is one of the most important inventions of Western civilization. Gallotannic acid, also known as tannic acid, is one type of tannin extracted from oak tree galls by boiling them in water. (Gall nuts are outgrowths on oak trees formed where certain insects have bored into the wood.) Tannic acid is an ingredient found in many commercial products; it is formulated into remedies for cold sores, fever blisters, diaper rash, sore throat, et cetera. Tannic acid, an important compound today, is readily available in grocery stores, pharmacies, and even farm supply stores. An example is Blood Stop Powder, which is used by veterinarians, ranchers, and farmers as a disinfectant for minor wounds in animals. Blood Stop Powder is a blend of tannic acid and ferrous sulfate, which are two of the main ingredients in iron gall ink. The powder is white with a bluish tint until exposed to blood (or water). As the blood dissolves the tannic acid and ferrous sulfate, they form a $Fe+2/Fe+3$ organometallic complex with tannic acid (iron tannate) that is jet-black.

Probably the most important role for tannic acid, though, was in archiving history. According to Sylvia Albro and Julie Biggs, conservators at the Library of Congress: "Iron gall ink was the primary writing ink used from the 12th through the 19th centuries in the western world."

General purpose iron gall ink is made from water, ferrous sulfate, tannic acid, and gum arabic. The jet-black complex is a mixture containing both reduced $Fe+2$ and oxidized $Fe+3$, which have combined with the tannic acid. (If made from pure $Fe+2$ sulfate, the ink would not be very dark.) Exposure to sunlight converts some of the $Fe+2$ to $Fe+3$, causing the ink to turn black. This is an early type of photographic

development process where sunlight does not record the image but rather develops it. This is why scribes would set the written pages out in the sunlight to develop after they had ruled their pages and written their texts. If impurities of Fe+3 were present in the ink when prepared, the ink would be initially black and would have a tendency to separate. The addition of gum arabic to a solution of iron tannate helps it stay suspended in water and flow nicely from pen to parchment. The physical properties of iron tannate mixed with water and gum arabic ensured that iron gall ink would become the most common ink up to the 20th century.

◆

On rare occasions, modern science has the opportunity to study seemingly lost works from antiquity. In late 1998, the Archimedes Palimpsest was sold at auction to an anonymous American buyer, who, with Will Noel of the Walters Art Museum, subsequently formed the Archimedes Palimpsest research team. Scientists used some of the most powerful scientific technologies available to recover the ancient texts of the Palimpsest. Archimedes's work dates to approximately 200 B.C.E.; parchment copies were made by hand and stored away for centuries. During the Middle Ages, monks took many manuscripts whose content was thought outdated and repurposed them by erasing them and then assembling their pages into new books. Parchment was hard to come by, after all.

In the 13th century, an Archimedes text in a 10th-century manuscript was separated from its binding, erased, and cleaned. The pages were then added to other scraped and cleaned pages from disparate scholarly manuscripts, and a Christian liturgical text was written over the old and now barely visible texts. The pages of the Palimpsest survived because the book lay hidden away for centuries in a monastery in the Judean desert; the dry climate of that region helped to preserve the texts.

Gum arabic (solidified tree sap) plays a second important role in iron gall ink. A typical page in the Archimedes Palimpsest shows two colors of writing, with the black (later, Christian) text running perpendicular to the light brown (earlier, Archimedes) text. Yet, both texts were written with iron gall ink. Why would one ink be brown and the other black? What chemistry caused the ink to transform to brown? The secret to this mystery is ink corrosion, which occurs when black iron tannate undergoes iron oxidation and acid hydrolysis in the presence of air and moisture. When the ink chemically degrades by oxidation and acid hydrolysis, the color alters from black to a reddish brown, much like the color of rust. When the pages in the original Archimedes text were cleaned, the writing became exposed to air and water; ink corrosion began and eventually turned the text brown. When iron gall ink is prepared with gum arabic, the gum arabic seals the dried ink onto the parchment or paper, keeping air and moisture away, and thus inhibiting iron corrosion. The original writing in the Archimedes Palimpsest is brown because the pages were cleaned, removing most of the gum arabic, and thus allowing the ink to change chemically. The later black text remained unchanged because it was sealed by gum arabic.

The methods employed to mix the chemicals in iron gall ink can lead to some astonishing outcomes unrelated to writing. The most dramatic are contact prints—which returns us to the shroud and Walter McCrone's "fainter authentic image."

◆

Utilizing the chemicals in iron gall ink to make a contact print is not difficult. There are only four main ingredients a medieval monk would have used: oak tree galls, iron sulfate, water, and gum arabic. The preparation is "hands on" and potentially very messy. Anything contaminated with

tannic acid and iron sulfate will turn black, including hands, shirts, pants, wood, leather, rags, et cetera. A basic print can be made with only tannic acid, iron sulfate, and water. Gum arabic can be added if desired to inhibit ink corrosion, but in our experiments, described below, only tannic acid, iron sulfate, and water were utilized.

We employed off-the-shelf materials as stand-ins for the natural ingredients of the medieval monk. Tea, a good source of tannic acid, was hard boiled to extract the tannic acid. Approximately twelve large tea bags boiled with two quarts of water (reduced to one quart) produced enough tannic acid for dozens of contact prints. Plant solids were removed by squeezing the tea bags dry and filtering the solution through a coffee filter. The iron sulfate solution was prepared in a separate container from Blood Stop Powder, which contains about 85 percent iron (ferrous or $Fe+2$) sulfate. Thirty grams of Blood Stop Powder was added to two cups of water. It should be noted that the initial solution was black due to the fact that Blood Stop Powder also contains 1 percent tannic acid, which prematurely turns the solution black. The iron tannate separates and was readily removed by filtering the black solution through two coffee filters. The filtered iron sulfate solution then has a very light bluish tint.

Special note: Coming into contact with solutions of tannic acid and iron sulfate may cause skin and eye irritation. They should never be taken internally. Do not attempt to work with these chemicals without professional assistance. Protective measures were employed to ensure that no people or animals were harmed while making our contact prints.

Our first round of iron tannate contact prints began by applying one of the two solutions (tannic acid) to the surface of the object being copied (a hand), then gently blotting that surface to remove any excess solution. Like printing on paper, too much liquid results in smearing the image. A cloth was then lightly dampened with the second solution (iron sulfate) and carefully applied to the object. The result was a strong black image of the object on the cloth. Rinsing the cloth with water removed excess

tannic acid and iron sulfate, leaving a permanent contact print in place. This iron tannate (iron gall) printing method produces a dark image, but lacks fine detail. This is because the solution diffuses deeply into the cloth. Nevertheless, the negative of the image shows some very surprising details, such as palm lines and fingerprints. Interesting as these features may be, though, they lack the image fidelity observed on the shroud.

The shroud has a faint brown image of a person *on the surface threads* of just one side of the cloth, with no diffusion. The photographic negative of the face reveals, as Secondo Pia discovered in 1898, many hidden details, some of which are quite startling. The Man of the Shroud seems to be sleeping, with his hair, beard, mustache, eyebrows, eyelids, nose, and closed lips all clearly visible. When the shroud's color levels are automatically adjusted using Photoshop 6, one sees features otherwise not visible. (This is not a negative image, but rather one resulting from a technique that brings out highlights and shadows.) Eyes and seeming "teeth" stand out as if the person were staring directly at the viewer and smiling. The eerie presence of what look like teeth (in fact, they're likely folds in the fabric) coupled with faint, forward looking eyes (these in multiple, from multiple contact exposures) make the picture appear like an early, soft X-ray radiograph.

Applying tannic acid to an object and then making a transfer print with an iron sulfate impregnated cloth isn't very sophisticated. In this situation, the ink/image is chemically formed when the iron-sulfate-containing cloth comes into contact with the tannic acid on the object being printed.

It might seem more logical simply to apply iron gall ink to the object to be printed and then pressing it against a clean cloth—a technique familiar in woodcuts, lithographs, and the printing press. Once again, though, the image would be diffused into the fabric and blur, whereas the image on the shroud is on its outer surface fibers and is incredibly crisp and detailed. An image only on the surface threads of the shroud rules out any means of formation that would result in diffusion, whether it be

the convergent components of iron gall ink in the single-cloth method, direct printing with iron gall ink onto clean fabric, or, following some of the more exotic shroud image theories, a blast of powerful light or any high energy radiation like medical X-rays. For even if the X-rays were low energy and did not pass through the cloth, they would still follow the Beer-Lambert law, which states that light (X-rays) is logarithmically absorbed as it passes through materials. In other words, an image formed by radiation or light would cast a shaded gradient into the cloth. This is a perplexing problem about the mechanism for making a highly detailed, surface-only image on cloth, and lies at the very heart of the mystery of the shroud.

Achieving a nondiffused transfer print on cloth having the highly detailed qualities of the shroud would seem to be a truly daunting task, especially with only a few chemicals from medieval times at one's disposal. Ultimately, though, we discovered the solution—the same solution, we believe, that was discovered by those in 14th-century France who created the shroud.

From the previous experiment, we knew that a single-cloth contact print does not produce a surface image. Yet, the photograph taken from a single-cloth contact print does reveal a negative that has similarities to the negatives prepared from photographs of the Shroud of Turin. What would happen, we wondered, if the tannic acid and the iron sulfate only came into contact between two pieces of cloth? A small modification to the previous procedure can do just that. Keeping the chemicals separate except where the two cloths are in contact might, we thought, prevent the image from forming diffusely into the cloth and would yield prints with greater detail. We have outlined the five steps we used to make a two-cloth contact print in a drawing. The hands are shown palm side up and down, as if the cloth were placed below the hands and folded over the top. Tannic acid and ferrous sulfate are applied to two separate cloths. The cloth with the tannic acid contains the latent image of the

object, and a lightly iron sulfate dampened cloth is used to develop the final image.

First, the tannic acid solution is applied to the object (the hands), and excess solution is gently blotted away. Next, a slightly dampened cloth is stretched over the object so that it is in direct contact with the tannic-acid-covered surface. Gentle pressure is applied to the cloth and the object to help move some of the tannic acid to the cloth. The pressure applied to the cloth controls the amount of tannic acid transferred, and thus the density and optical quality of the final image. The cloth with the latent image is then removed from the object and spread out flat, image side up, on a flat work surface. The cloth impregnated with the iron sulfate is laid over the latent image cloth so that both are in contact and flat against each other. The image is fixed and developed by firmly pressing both cloths together with a warm iron. Separating the two cloths reveals a black image of the object where the two cloths came into contact. The image is permanent because the iron tannate (iron gall) has formed a physical bond to the outer layer of the fibers in the cloth. Rinsing the cloth with water washes away excess tannic acid and iron sulfate leaving a final indelible black image.

Contact prints made with the two-cloth method show remarkable detail. The delicate nature of the wrists, hands, and fingers is remarkable. The hand on top seems to cast a shadow on the hand below. Visible are fingernails, knuckles, skin texture, blood vessels (back of the hand), and creases in the palm. Amazingly, folds in the cloth by the wrist below the palm seem to retain the fluidity of the cloth. Clearly, the two-cloth contact print method is a highly sensitive one. In addition, bringing tannic acid and iron sulfate together only at the interface between two cloths restricts the depth of the tannic acid print to the cloth surface. Prints made with this technique have similar properties to the positive and negative photographs taken of the shroud. The almost self-illuminating quality of the negative hands is similar to the ethereal quality of the

shroud negative. The details in the hands and wrists juxtaposed with the ghostly illumination of the negatives made from the shroud strongly indicate the shroud was made as a two-cloth contact print using medieval chemistry that originated from the preparation of iron gall ink.

◆

People view the world in binocular perspective. Contact prints reproduce only a flat surface, and if the model object is flat the two easily match. Preparing a contact print from a three-dimensional object, on the other hand, can be tricky. Prints made from a face are difficult to translate to a flat surface because perspective is easily lost by the thickness of the head. (Mapmakers have the same trouble reproducing a round globe and projecting it onto a piece of flat paper.) The manner in which tannic acid is applied to the face must align with the expected perspective of the viewer. For example, when the tannic acid is applied along the side of the face all the way to the ears and the two-cloth method applied one creates a very distorted image. Since the cloth is laid over and around the face down past the ears, the print gives the human face an elliptical shape.

If the intention is to create a face in perspective, then the tannic acid must be applied only to surfaces from the viewpoint of the observer. (Closing one eye during application helps.) A little artistic finesse is needed to keep the tannic acid exposure in perspective. The negative almost glows with a face that appears to be sleeping. The face is forward looking compared to the example where the tannic acid covered the head all the way back to the ears. Tannic acid applied in perspective combined with the two-cloth contact print method results in a great improvement in image quality and a sense of powerful physical reality.

Restricting tannic acid only to familiar regions of the face produces a contact print with familiar details like the nose, eyes, eyelashes, hair, and lips. Interestingly, the nose easily becomes distorted due to the

pliable nature of the tissue. Too much tannic acid builds up along the sides of the nose and is transferred by compression when the cloth was pulled tight over the face. Limiting compression of flexible parts like the nose is important; care must be taken to not press too firmly when laying the cloth down. The quality of the final print depends on the application of just enough pressure to transfer the tannic acid to the cloth, but not too much as to distort important features. A two-cloth contact print is pressure sensitive. Pressure applied in step three affects the amount of tannic acid picked up by the cloth. There are a number of factors involved. The porous nature of skin acts like a sponge; thus, when pressure is applied more tannic acid is released from the skin into the cloth. Porous materials can thus appear darker due to the amount of tannic acid absorbed. Also, tannic acid can flow from high pressure areas and accumulate where pressure is lower. In this case, the low pressure areas appear darker than their surroundings. The pressure-sensitive nature of a contact print gives rise to the details seen in the negative images. The brow ridge, nose, cheeks, lips, and chin are enhanced due to a gradient of shading from high- to low-pressure areas.

Adjusting the colors in a photograph taken from a contact print with Photoshop 6 results in an image that is strikingly three-dimensional. Unusual effects caused by changes in pressure become visible, such as teeth. Essentially, the color adjustment created in Photoshop 6 brings out highlights and shadows in areas where tannic acid wasn't absorbed well by the cloth. The teeth, being hard, compress the lips, allowing tannic acid to be absorbed in low-pressure areas. An example of a low pressure area is the spaces between the teeth, which leads to more tannic acid penetrating the cloth fibers. This gives the effect of an X-ray-like image due the pressure sensitive technique. Photographs, in turn, highlight these regions where tannic acid is concentrated and not in the shadows.

The two-cloth tannic acid/iron sulfate method is capable of recording subtle details. The method is pressure sensitive, reproducing surface

features that other methods would omit. Photographic film only records light emanating from the surroundings; by contrast, a contact print is the result of both physical and chemical interactions with a surface. Texture influenced by porosity and pliability is recorded because of the direct contact with the subject. For example, the folds of cloth on the left wrist. Ultimately, selecting a subject with good physical properties will enhance the quality of the final image.

It should also be noted that no paint is required to make the iron tannate transfer images. This supports Walter McCrone's opinion that a "fainter authentic image" had been enhanced with a dilute pigmented paint to create the iconographic details of the Man of the Shroud. But instead of being colorless and turning over time to sepia, as Walter thought, the base ("yellow fiber") image was initially black, turning over time to pale yellow-brown. In addition, photographic negatives taken from the two-cloth contact print method highlight details otherwise invisible. These negatives have similar qualities to the photographic negatives from the shroud.

In conclusion, the lips, teeth, and multiple eyes shown in Photoshop 6 adjusted images of the shroud are a strong indication that the image on the Man of the Shroud was created as a multiple-exposure contact print using the chemistry of iron gall ink. We have to be careful with our interpretations of what we see. In this case what we see as teeth because of the proximity to the mouth is really lines in the image that pass from the mouth area to the eyebrows as seen in the next pair of images. The left image is the enhanced image of the face where four white lines have been added covering up the linear features in the face. Moving these four lines to the side, as shown in the right image, reveals the lines in the face are not teeth but a series of linear features. Perhaps they are wrinkles in the cloth itself when the image was formed.

◆

Creating multiple-exposure prints required further examination of the minor details of the two-cloth method. Although the two-cloth contact images were on the outer most fibers of the cloth, there were sections of the image that seemed to be darker than others, causing a "blotchy" look. This was due to the tannic acid solution accumulating in patches across the face and not being absorbed evenly across the skin. The key to solving this was the addition of a wetting agent that was readily available in medieval times: honey. Once the honey was added to the tannic acid solution the images became less "blotchy" and more photograph-like.

The next issue to resolve was the registry and perspective of the eyes. When looking at the shroud image, the eyes are in perspective to the viewer; compare these to the eyes in our initial two-cloth contact print, which are off-center slightly to the left and right. This is due to the bridge of the nose creating distance between the eyes that is viewed as "abnormal." This is much like the issues of facial distortion and getting the image into perspective. The rectification of the registry of the eyes requires multiple exposures. Each eye was created separately, which involved moving the latent image cloth to the left or right to create proper alignment between the eyes and the nose. For example, the tannic acid-honey solution was added to the left eye lid and brow region, then the cloth was moved to the left ½ inch to 1 inch, depending on the subject's facial features and size of the nose bridge, to correct for the registry of the left eye. The same was done for the right eye, but the cloth was moved towards the right to correct of the right eye registry.

Once the procedure was set up to correct for eye registry, the multiple-exposure technique was ready to be employed. First, the tannic acid-honey solution was added to the subject's forehead, cheeks, mouth, and hair. The lightly dampened cloth was applied to the subject for the base image. Next, the tannic acid-honey solution was added to the left eye and then the right eye, to create the proper perspective. Lastly, the nose and brow ridge were added to the latent image because, as the

nose is very pliable, it is easily distorted. Adding the nose and brow ridge last resulted in the image having little to no distortion, as seen in the final multiple-exposure image.

◆

The Shroud of Turin has survived from the Middle Ages because generations of the faithful have devoted great efforts to ensuring that it would be preserved, and that its story would be told to future generations. The shroud has many mysterious properties. An image of a man has formed only on the surface of one side of the cloth; when first viewed in the 14th century, the image was dark, crisp, and black, and, over time, it turned light brown and vague. Photographic negatives of the shroud have otherworldly qualities that enhance ghostly details of a man seemingly scourged and crucified, yet lying in a peaceful repose. A mouth with apparently well-defined teeth is seen by adjusting the color channels in a photograph of the face to bring out highlights and shadows.

Many explanations for these powerful photographic features of the shroud have been advanced over the years. Through multiple procedures, setups, and experiments, we believe we finally have the answer: the multiple-exposure tannic acid/iron sulfate contact print method. It is capable of producing highly detailed, anatomically "real" contact prints of a human body that are confined to the outer surface of a cloth—just like the shroud. These contact prints were made without gum arabic or any other sealant, and thus turned from black to light brown over time as the iron tannate corroded to a brown mixture of iron oxides. Negatives prepared from these photographs are remarkably similar to the negatives from the shroud; skin texture, wrinkles, lips, hair, and even eyelashes are clearly visible. The multiple-exposure method is a pressure sensitive method that provides the illusion that the image is three-dimensional.

Even though the evidence from our experiments powerfully supports the proposition that the Shroud of Turin is man-made, that conclusion does not imply that it should have any less value for those who have long loved and cherished it. The shroud is an amazing object that needs to be preserved and respected for future generations.

By any standards of any age, the creator of the Shroud of Turin was a genius.

ACKNOWLEDGMENTS

I would never have written this book if it weren't for the brilliant chemist from near Bartlesville, Oklahoma, Robert Morton, and his daughter Rebecca, who I'm convinced figured out the "how" of the Shroud of Turin body image. Their shroud discovery opened, for me, the door to the questions of when, why, and by whom. By extension, I probably should thank the late Leonard Nimoy, that intrepid space traveler, whose *In Search of . . .* television series, which featured every imaginable mystery from Big Foot to Killer Bees, fanned the flames of popular enthusiasm for the shroud and eventually ignited the imagination of the Mortons.

Those of us who care about the early history of the shroud owe much to two great Catholic scholars of a century ago, Canon Ulysse Chevalier, responsible for the monumental *Répertoire des sources historiques du moyen âge,* and Herbert H. C. Thurston, S. J., author of more than 150 articles in the *Catholic Encyclopedia.* In their publications of 1900 and 1903, Chevalier and Thurston gathered, translated, and interpreted the primary sources relating to the shroud's appearance, around 1350, in the historical record, its surreptitious fabrication, and its disingenuous

display—with Father Thurston concluding: "The probability of an error in the (condemning) verdict of history . . . (is) almost infinitesimal." That could have been the end of it.

But since then, ever increasing throngs of shroud amateurs have generated a vast library of authentication literature. Among the few published skeptics who have preceded me, I acknowledge with thanks Joe Nickell (1998), Hugh Farey (2019), and Andrea Nicoletti (2020) who collectively have shredded the sindonologists cherished arguments, and the father of modern microscopy, Walter McCrone, whose *Judgment Day for the Shroud of Turin* (1999) came tantalizingly close to the "how" answer. Moreover, it was McCrone, by way of an encounter with Bob Morton after his 1994 lecture on the shroud in Bartlesville, who gave Bob the point of departure for his work. Had McCrone not died in 2002, the two would likely have collaborated.

And I should thank the scientists in Oxford, Zurich, and Tucson who, in 1988, carbon-14 dated the linen of the shroud between the years 1260 and 1390. That certainly should have put the authenticity question to rest. But it did not.

More than a century would pass before another serious scholar, historian Andrea Nicolotti of the University of Turin, tackled those critical medieval documents relating to the shroud's early history, along with scores of other shroud related sources that Chevalier and Thurston left untouched, going back to biblical times and extending up to the present. Nicolotti's two exhaustive, heavily footnoted books, *From the Mandylion of Edessa to the Shroud of Turin* (2014) and *The Shroud of Turin: The History and Legends of the World's Most Famous Relic* (2020), are models of meticulous academic rigor and have taught me much. These two volumes will, I'm certain, long remain the standard publications on the Shroud of Turin—complemented, I hope, by what this book has to offer. Gentleman and scholar that he is, Andrea allowed me to read the second volume in page proofs before publication.

Thanks to Andrea Nicolotti, I have the privilege not only of passing over in this book vast stretches of shroud source material and argumentation that he so expertly has covered, but also of using a general audience voice and foregoing footnotes. Further, I have the luxury of roaming freely in more speculative "who done it" territory forbidden by an academic's caution.

There were two 14th-century bishops of the Diocese of Troyes, Henri de Poitiers and Pierre d'Arcis, who risked their careers in an ultimately futile quest to convince the papacy that the shroud, then in a small Collegiate Church in nearby Lirey, was being fraudulently displayed, as an incitement to idolatry with the aim of wheedling money out of gullible pilgrims. That church was built by the illustrious knight—and first owner of the Holy Shroud—Geoffroi de Charny, who died in 1356 at the Battle of Poitiers heroically defending King John II. I admire all three and thank them, in retrospect.

And I thank Geoffroi de Charny redux, also known as Alain Hourseau, a part-time author, amateur historian, and irrepressible tour guide to the Troyes region, who, in September 2017, introduced me and my wife, Elana, to what's left of Lirey. But much more than that, Alain led us on a hunt for medieval terra-cotta roof fragments in the moat of Geoffroi de Charny's long vanished chateau, and showed us what survives of the Roman road leading south from Troyes, that the shroud pilgrims must once have walked. And then took us to a medieval festival, where Alain dressed in a jousting outfit with Geoffroi's coat of arms and his wife, Monique, dressed as Geoffroi's wife, Jeanne de Vergy. Together they quite literally brought the 14th century and the age of the shroud back to life.

And finally, I owe a great debt to my two editors, Tracy Gold and Jessica Case, who struggled mightily to guide me away from my academic's hubris and to keep me ever attentive to Occam's (keep it simple!) razor and an audience of nonspecialists. And to my agent, Laura Strachan, without whom this book might never have found a home.

BIBLIOGRAPHY

Aberth, John, *The Black Death: The Great Mortality of 1348–1350: A Brief History with Documents*, The Bedford Series in History and Culture (Boston and New York, Bedford/St. Martins, 2005).

Albro, Sylvia, and Julia Biggs, "Conservation Corner: Solutions for Treating Iron-Gall Ink Artifacts," Library of Congress Information Bulletin, June 2008 (www.loc.gov/loc/lcib/0806/conservation.html).

Angenendt, Arnold, "Relics and Their Veneration," *Treasures of Heaven: Saints, Relics, and Devotion in Medieval Europe*, Martina Bagnoli, Holger A. Klein, C. Griffith Mann, and James Robinson, eds. (New Haven, CT and London, Yale University Press, 2010), 19–28.

Angold, Michael, *The Fourth Crusade: Event and Context* (New York, Routledge, 2003).

Autrand, Françoise, *Charles V* (Paris, Fayard, 1994).

Bagnoli, Martina, "A Crucifixion by Naddo Ceccarelli," *The Journal of the Walters Art Museum*, 70–71 (2012–13): 15–25.

Bahat, Dan, "Does the Holy Sepulchre Church Mark the Burial of Jesus?" *Biblical Archaeology Review*, 12/3 (1986).

Barbet, Pierre, *Doctor at Calvary: The Passion of Our Lord Jesus Christ as Described by a Surgeon* (Forest Grove, OR, Allegro Editions, 2014).

Belting, Hans, *The Image and Its Public in the Middle Ages: Form and Function of Early Paintings of the Passion*, Mark Bartusis and Raymond Meyers, trans. (New Rochelle, NY, Aristide Caratzas, 1990).

Belting, Hans, *Likeness and Presence: A History of the Image Before the Era of Art* (Chicago, University of Chicago Press, 1994).

Belting, Hans, "In Search of Christ's Body: Image or Imprint?," *The Holy Face and the Paradox of Representation: Papers from a Colloquium Held at the Bibliotheca Hertziana, Rome and Villa Spelman, Florence, 1996*, Herbert Kessler and Gerhard Wolf, eds. (Bologna, Nuova Alfa Editoriale, 1998): 1–11.

Bergmann, U., R. W. Morton, et al., "*Archaeopteryx* Feathers and Bone Chemistry Fully Revealed via Synchrotron Imaging," *Proceedings of the National Academy of Sciences*, 107/20 (June 2010): 9060–65.

Boeckl, Christine M., *Images of Plague and Pestilence: Iconography and Iconology*, Sixteen Century Essays and Studies, VIII (Kirksville, MO, Truman State University, 2000).

Boeckl, Christine M., "The Legend of Saint Luke the Painter: Eastern and Western Iconography," *Wiener Jahrbuch für Kunstgeschichte*, 54/1 (Kirksville, MO, Truman State University, 2005): 7–37.

Brading, David A., *Mexican Phoenix: Our Lady of Guadalupe, Image and Tradition across Five Centuries* (Cambridge, UK, Cambridge University Press, 2003).

Brock, Sebastian, "Transformations of the Edessa Portrait of Christ," *Journal of Assyrian Academic Studies,* 18/1 (2004): 46–56.

Brown, Peter, *The Cult of the Saints: Its Rise and Function in Latin Christianity* (Chicago, University of Chicago Press, 1982).

Brubaker, Leslie, and John Haldon, *Byzantium in the Iconoclast Era, c. 680–850: A History* (Cambridge, UK, Cambridge University Press, 2015).

Bucklin, Robert, "The Medical Aspects of the Crucifixion of Christ," *Sindon* (December 1961): 5–11.

Bynum, Caroline Walker, *Wonderful Blood: Theology and Practice in Late Medieval Northern Germany and Beyond,* The Middle Ages Series, (Philadelphia, University of Pennsylvania Press, 2007).

Bynum, Caroline Walker, *Christian Materiality: An Essay on Religion in Late Medieval Europe* (New York, Zone Books, 2015).

Byrne, Joseph P., *Daily Life During the Black Death* (Westport, CT, and London, Greenwood, 2006).

Byzantium: Faith and Power (1261–1557), Helen C. Evans, ed. (New Haven, CT, and London, Yale University Press, 2004).

Byzantium at Princeton: Byzantine Art and Archaeology at Princeton University, Slobodan Ćurčić and Archer St. Clair, eds. (Princeton, NJ, Princeton University Press, 1986).

Cameron, Averil, "Images of Authority: Elites, Icons, and Cultural Change in Late Sixth-Century Byzantium," *Past and Present*, 84 (1979): 3–35.

Cameron, Averil, "The Sceptic and the Shroud: An Inaugural Lecture in the Departments of Classics and History Delivered at King's College, London on 19 April 1980," (London, 1980).

Cameron, Averil, "The History of the Image of Edessa: The Telling of a Story," *Okeanos: Essays Presented to Ihor Ševčenko on His Sixtieth Birthday*, Cyril Mango and Omeljan Pritsak, eds., Harvard Ukrainian Studies 7 (Cambridge, MA, 1983), 80–94.

Cameron, Averil, "The Mandylion and Byzantine Iconoclasm," *The Holy Face and the Paradox of Representation: Papers from a Colloquium Held at the Bibliotheca Hertziana, Rome and Villa Spelman, Florence, 1996*, Herbert Kessler and Gerhard Wolf, eds. (Bologna, Nuova Alfa Editoriale, 1998), 33–54.

Carrillo, Jenny Cooney, "The Passion of Mel," Interview with Mel Gibson, *Urbancinefile* (February 26, 2004).

Chevalier, Ulysse, *Étude critique sur l'origine de Saint Suaire de Lirey-Chambery-Turin* (Berkeley, University of California Libraries, 1900).

Chevalier, Ulysse, "Autour des origins du Suaire de Lirey," *Bibliothèque liturgique*, 5 (Berkeley, University of California Libraries, 1900): parts 2 and 4, 9–21, 129–50.

Contamine, Philippe, "Geoffroy de Charnay (début du XIVe siècle-1356), 'Le plus prudhomme et le plus vaillant de tous les autres'," *Histoire et société: Mélanges offerts à George Duby, Textes réunis par les médiévalistes de l'Université de Provence* (Aix-en-Provence, Université de Provence, 1992): II, 107–21.

Cormack, Robin, *Painting the Soul: Icons, Death Masks and Shrouds* (London, Reaktion Books, 1997).

Dale, Arthur, "New Evidence: Holy Shroud NOT a Fake," *Sun,* December 19, 1989.

Dale, William S. A., "The Shroud of Turin: Relic or Icon?" *Nuclear Instruments and Methods in Physics Research,* B29 (1987): 187–92.

Damon, P. E., et al., "Radiocarbon Dating of the Shroud of Turin," *Nature,* 337 (1989): 611–15.

Dawkins, Richard, *The God Delusion* (Boston and New York, Mariner Books, 2008).

De Mely, François, *Le St-Suaire de Turin: est-il authentique?* (Paris, 1902).

Delluc, B. and G., *Vister l'abbaye de Cadouin* (Luçon, FR, 1992).

DesOrmeaux, Anna L., *The Black Death and Its Effect on Fourteenth- and Fifteenth-Century Art* (MA Thesis, Louisiana State University, 2007).

Devoisse, Jean, *Jean le Bon* (Paris, Fayard, 1985).

De Wesselow, Thomas, *The Sign: The Shroud of Turin and the Birth of Christianity* (New York, Plume, 2012).

Dini, Giulietta Chelazzi, et al., *Five Centuries of Sienese Painting: From Duccio to the Birth of the Baroque* (New York, Thames & Hudson Ltd., 1998).

Drijvers, J. W., *Helena Augusta: The Mother of Constantine the Great and Her Finding of the True Cross* (Leiden, Jan Willem Drivers Brill, 1992).

Drijvers, H. J. W., "The Image of Edessa in the Syriac Tradition," *The Holy Face and the Paradox of Representation: Papers from a Colloquium Held at the Bibliotheca Hertziana, Rome and the Villa Spelman, Florence, 1996,* Herbert Kessler and Gerhard Wolf, eds. (Bologna, Nuova Alfa Editoriale, 1998): 13–31.

Ekroth, Gunnel, "The Cult of Heroes," *Heroes: Mortals and Myths in Ancient Greece,* Sabine Albersmeier, ed. (Baltimore, The Walters Art Museum, 2009): 120–43.

Enseignes de pèlerinage et enseignes profane, Musée National du Moyen Age—Thermes de Cluny (Paris, 1998).

Eldredge, Charles C., Julie Schimmel, and William H. Truettner, *Art In New Mexico, 1900-1945: Paths to Taos and Santa Fe* (Washington, DC, and New York, Abbeville Press, 1986).

Eusebius, Life of Constantine, Clarendon Ancient Hisotry Series, Averil Cameron and Stuart G. Hall, intro., trans., and commentary (Oxford, Oxford University Press, 1999).

Fanti, Giulio, and Roberto Maggiolo, "The Double Superficiality of the Frontal Image of the Turin Shroud," *Journal of Optics A: Pure and Applied Optics,* 6 (2004): 491–503.

Farey, Hugh, *The Medieval Shroud*, I, II (academia.edu, 2018, 2019) (academia.edu/35960624/THE_MEDIEVAL_SHROUD; academia.edu/35960624/THE_MEDIEVAL_SHROUD_2).

Farley, David, *An Irreverent Curiosity: In Search of the Church's Strangest Relic in Italy's Oddest Town* (Los Angeles, Avery, 2009).

Fiey, J. M., "Image d'Édcssc ou Linceul de Turin. Qu'est-ce qui a été transféré à Constantinople en 944?," *Revue d'histoire ecclésiastique,* 82 (1987): 271–77.

Finney, Paul Corbey, *The Invisible God: The First Christians on Art* (New York and Oxford, Oxford University Press, 1994).

Fossati, Luigi, *La Santa Sindone: Nuova luce su antichi documenti* (Turin, Borla Editore, 1961).

Fossati, Luigi, "The Lirey Controversy," *Shroud Spectrum International,* 8 (Turin, Borla Editore, 1983): 24–34.

Fossati, Luigi, "Copies of the Holy Shroud," *Shroud Spectrum International,* 12, 13 (Turin, Borla Editore, 1984): 7-13, 23–29.

Freeman, Charles, *Holy Bones, Holy Dust: How Relics Shaped the History of Medieval Europe* (New Haven, CT, and London, Yale University Press, 2011).

Freeman, Charles, "The Pseudo-history of the Shroud of Turin," *Yale Books Blog: Yale University Press*, May 25, 2012 (http://yalebooks.wordpress.com/2012/05/25/the-pseudo-history-of-the-shroud-of-turin-author-article-by-charles-freeman/).

Freeman, Charles, "The Origins of the Shroud of Turin," *History Today,* 64/11 (New Haven, CT, and London, Yale University Press, 2014).

Friedlander, Alan, "On the Provenance of the Holy Shroud of Lirey/Turin: A Minor Suggestion," *The Journal of Ecclesiastical History,* 57/3 (2006): 457–77.

Geary, Patrick J., *Furta Sacra: Thefts of Relics in the Central Middle Ages,* rev. ed. (Princeton, NJ, Princeton University Press, 1990).

Geary, Patrick J., *Living with the Dead in the Middle Ages* (Ithaca, NY, and London, Cornell University Press, 1994).

Geoffrey Chaucer, The Canterbury Tales, Penguin Classics, Nevill Coghill, trans. (London and New York, Penguin Classics, 1951).

Ghiberti, Giuseppe, *Sindone, le imagine 2002* (Turin, Editrice ODPF, 2002).

Gibson, David, "What Did Jesus Really Look Like," *The New York Times,* February 21, 2004.

Glatz, Carol, "Pope Confirms Visit to Shroud of Turin; New Evidence on Shroud Emerges," *Catholic News Service,* July 27, 2009.

Gould, Stephen Jay, *Rocks of Ages: Science and Religion in the Fullness of Life* (New York, Ballentine Books, 2002).

Grabar, André, *La Sainte Face de Laon: Le Mandylion dans l'art orthodoxe* (Prague, 1931).

Grabar, André, *Christian Iconography: A Study of its Origins,* Bollingen Series, 35.10 (Princeton, NJ, Princeton University Press, 1968).

Gregory of Tours: Glory of the Martyrs, Translated Texts for Historians, Latin Series, III, Raymond Van Dam. trans. (Liverpool, Liverpool University Press, 1988).

Guscin, Marc, *The Image of Edessa* (Leiden, Brill, 2009).

Haldon, John, "The Works of Anastasius of Sinai: A Key Source for the History of Seventh-Century East Mediterranean Society and Belief," *The Byzantine and Early Islamic Near East, I: Problems in the Early Source Material,* Averil Cameron and Lawrence Condon, eds. (Princeton, NJ, Darwin Pr, 1992), 107–47.

Heller, John, *Report on the Shroud of Turin* (Boston, Houghton Mifflin Harcourt, 1983).

Henderson, John, "The Flagellant Movement and Flagellant Confraternities in Center Italy, 1260–1400," *Religious Motivation: Biographical and Sociological Problems for the Church Historian,* Studies in Church History, 15, Derek Baker, ed. (Oxford, Blackwell Pub, 1978): 147–60.

Histoire du roi Abgar et de Jésus, Alain Desreumax, ed. (Turnhout, Belgium, Brepols, 1993).

Holum, Kenneth G., and Gary Vikan, "The Trier Ivory, Adventus Ceremonial, and the Relics of St. Stephen," *Dumbarton Oaks Papers,* 33 (1979): 114–33.

Holy Image, Holy Space: Icons and Frescoes from Greece. Myrtali Acheimastou-Potamianou, ed. (Athens, The Greek Ministry of Culture—The Byzantine Museum of Athens, 1988).

Hourseau, Alain, *Autour du Saint Suaire et de la Collégiale de Lirey (Aube)* (Books on Demand).

Innemée, K. C., "Some Notes on Icons and Relics," *Byzantine East, Latin West: Art-Historical Studies in Honor of Kurt Weitzmann*, Christopher Moss and Katherine Kiefer, eds. (Princeton, NJ, Princeton University Press, 1995): 519–21.

Jacobson, Mark, "Satan's Face: In the Smoke, a Sign," *New York Magazine*, August 2011.

Jacobus de Voragine, The Golden Legend: Readings on the Saints, William Granger Ryan, trans., Eamon Duffy, intro. (Princeton, NJ, Princeton University Press, 2012).

Janin, Raymond, *La géograhie ecclésiastique de l'empire byzantin*, I. *Le siège de Constantinople et le patriarcat oecuménique*, III. *Les églises et les monastèries*, 2nd ed. (Paris, Inst. Franc. et Byzantine, 1969).

Jean Froissart, Chronicles, Geoffrey Brereton, trans. (London et al., Penguin Classics, 1978).

John of Damascus, Orthodox Faith, The Fathers of the Church, 37, F. H. Chase, trans. (Washington, DC, The Catholic University of America, 1958).

Kaeuper, Richard W., and Elspeth Kennedy, *The Book of Chivalry of Geoffroi de Charny: Text, Context, and Translation* (State College, PA, University of Pennsylvania Press, 1996).

Kessler, Herbert L., "Medieval Art as Argument," *Iconography at the Crossroads*, Brendan Cassidy, ed. (Princeton, NJ, Princeton University Press, 1993): 59–70.

Kessler, Herbert L., "Configuring the Invisible by Copying the Holy Face," *The Holy Face and the Paradox of Representation: Papers from a Colloquium Held at the Bibliotheca Hertziana, Rome and the Villa Spelman, Florence, 1996*, Herbert Kessler and Gerhard Wolf, eds. (Bologna, Nuova Alfa Editoriale, 1998): 129–51.

Kessler, Herbert L., *Spiritual Seeing: Picturing God's Invisibility in Medieval Art* (State College, PA, University of Pennsylvania Press, 2000).

Kessler, Herbert L., "Christ's Dazzling Dark Face," *Intorno al Sacro Volto: Genoa, Bisanzio e il Mediterraneo (secoli XI–XIV)*, A. R. Calderoni Masetti, C. Dufour Bozzo, and Gerhard Wolf, eds. (Venice, Marsilio, 2007): 231–46.

Kieckhefer, Richard, "Radical Tendencies in the Flagellant Movement of the Mid-Fourteenth Century," *Journal of Medieval and Renaissance Studies,* 4 (1974): 157–76.

Kitzinger, Ernst, "The Cult of Images in the Age Before Iconoclasm," *Dumbarton Oaks Papers,* 8 (1954): 83–150.

Klein, Holger A., "Sacred Relics and Imperial Ceremonies at the Great Palace of Constantinople," *Visualisierungen von Herrschaft: Frühmittelalterliche Residenzen Gestalt und Zeremoniell,* Internationales Kolloquium, 3./4. Juni 2004 in Istanbul, Franz Alto Bauer, ed., *BYZAS,* 5 (2006): 79–99.

Kloner, Amos, and Boaz Zissu, *The Necropolis of Jerusalem in the Second Temple Period,* Interdisciplinary Studies in Ancient Culture and Religion, 8 (Leuven and Dudley, MA, Peeters Publishers, 2007).

Krueger, Derek, "The Religion of Relics in Late Antiquity and Byzantium," *Treasures of Heaven: Saints, Relics, and Devotion in Medieval Europe,* Martina Bagnoli, Holger A. Klein, C. Griffith Mann, and James Robinson, eds. (New Haven, CT, and London, Yale University Press, 2010): 5–17.

Kuryluk, Ewa, *Veronica and her Cloth: History, Symbolism and Structure of a "True" Image* (Oxford, Blackwell Pub, 1991).

La vie ancienne de S. Symeon Stylite le Jeune (521–592), Paul Van den Ven, Subsidia Hagiogaphica, 32, vols. 1 and 2 (Brussels, Societe des Bollandistes, 1962/1970).

Laclotte, Michel, and Elisabeth Mognetti, *Avignon, Musée du Petit Palais: Peinture italienne,* Inventaire des collections publiques françaises, 21 (Paris, RMN, 2005).

Lidov, Alexi, "Holy Face, Holy Script, Holy Gate: Revealing the Edessa Paradigma in Christian Imagery," *Intorno al Sacro Volto: Genova, Bisanzio et il Mediterraneo (secoli XI–XIV),* A. R. Calderoni, D. Dufour Bozzo, and Gerhard Wolf, eds. (Venice, Marsilio, 2007): 195ff.

Lidov, Alexi, "The Mandylion over the Gate: A Mental Pilgrimage to the Holy City of Edessa," *Routes of Faith in the Medieval Mediterranean: History, Monuments, People, Pilgrimage Perspectives,* Proceedings of an International Symposium, Thessalonike, 7–10 November, 2007 (Thessalonike, 2008).

Long, John, "The Shroud of Turin's Earlier History: Part Three: The Shroud of Constantinople," *Associates for Biblical Research,* March 28, 2013 (www.biblearchaeology.org/post/2013/3/28/the-Shroud-of-Turins-Earleir-History-Part-Three-The-Shroud-of-Constatninople.aspx).

Mango, Cyril, *Art of the Byzantine Empire: 312–1453,* Sources and Documents in the History of Art Series (Englewood Cliffs, NJ, Prentice-Hall, 1972).

Marinelli, Emanuela, and Maurizio Marinelli, "The Copies of the Shroud," *Proceedings of the International Workshop on the Scientific approach to the Acheiropoietos Images, ENEA Frascati, Italy, 4–6 May 2010* (www.acheiropoietos.info/proceedings/MarinelliWeb.pdf).

Marino, Joseph G., and M. Sue Bedford, "Evidence for the Skewing of the C-14 Dating of the Shroud of Turin Due to Repairs," *Worldwide Congress "Sindone 2000"* (Orvieto, August 28, 2000).

Martiniani-Reber, M., "La Sainte Face de Laon," *Byzance. L'art byzantin dans les collections publique françaises* (Paris, 1997): 475.

Massaro, Lucandrea, "This 3D 'Carbon Copy' of Jesus was Created using the Shroud of Turin," *Aleteia,* March 28, 2018.

Mazaroff, Stanley, *Henry Walters and Bernard Berenson: Collector and Connoisseur* (Baltimore, Johns Hopkins University Press, 2010).

McCrone, Walter, *Judgement Day for the Shroud of Turin* (Amherst, NY, Prometheus Books, 1999).

Medieval Art from Private Collections: A Special Exhibition at the Cloisters, Carmen Gomez-Moreno (New York, The Metropolitan Museum of Art, 1968).

Medieval English Verse, Brian Stone, trans. and intro. (Baltimore, Johns Hopkins University Press, 1964).

Miller, Guillaume, "Clément VII et le Suaire de Lirey," *Le Correspondant,* 210 (1903): 254–59.

Miller, Patricia Cox, "Relics, Rhetoric and Mental Spectacles in Late Ancient Christianity," *Seeing the Invisible in Late Antiquity and the Early Middle Ages*, Papers from "Verbal and Pictorial Imaging: Representing and Accessing Experience of the Invisible, 400–1000" (11–13 December 2003), Utrecht Studies in Medieval Literacy, 14 Giselle de Nie, Karl F. Morrison, and Marco Mostert, eds. (Turnhout, Belgium, Brepols, 2005): 25–52.

Morello, Giovanni and Gerhard Wolf, *Il volto di Cristo* (Milan, Electa, 2000).

Netz, Reviel and William Noel, *The Archimedes Codex: How a Medieval Prayer Book is Revealing the True Genius of Antiquity's Greatest Scientist* (New York, Da Capo Press, 2007).

Nickell, Joe, *Inquest on the Shroud of Turin* (Amherst, NY, Prometheus Press, 1998).

Nickell, Joe, "Rorschach Icons," *Skepitcal Inquirer*, 28/6 (2004): 15–17.

Nickell, Joe, "Pope Francis and the Turin Shroud: Making Sense of a Mystery," *The Economist*, May 31, 2013.

Nickell, Joe, "Crucifixion Evidence Debunks Turin Shroud," *cfi* (centerforinquirery.org), June 18, 2018.

Nickerson, Raymond S., "Confirmation Bias: A Ubiquitous Phenomenon in Many Guises," *Review of General Psychology*, 2 (1998): 175–220.

Nicolle, David, *Poitiers, 1396: The Capture of a King* (Oxford, Osprey Publishing, 2004).

Nicolotti, Andrea, "Una reliquia constantinopolitana dei panni sepolcrali di Gesù secondo la Cronaca del crociato Robert de Clari," *Medioevo greco*, 11 (2011): 151–96.

Nicolotti, Andrea, "Su alcune testimonianze del Chartularium Culisanense, sulle false origini dell'Ordine Costantiniano Algelico di Santa Sofia e su taluni suaoi documenti conservati presso l'Archivio di Stato di Napoli," *Giornale di storia*, 8 (2012).

Nicolotti, Andrea, *Rivista storica italiana*, 125/3 (2013): 890–99.

Nicolotti, Andrea, *From the Mandylion of Edessa to the Shroud of Turin* (Art and Material Culture in Medieval and Renaissance Europe) (Leiden, Brill Academic Pub, 2014).

Nicolotti, Andrea, *Sindone: Storia e leggende di una reliquia controversa* (Turin, Einaudi, 2015).

Nicolotti, Andrea, *The Shroud of Turin: The History and Legends of the World's Most Famous Relic* (Waco, TX, Baylor University Press, 2020).

Nir-el, Y., and M. Broshi, "The Black Ink of the Dead Sea Scrolls," *Dead Sea Scrolls Discoveries*, March (1996): 157–67.

Paradisio: The Divine Comedy of Dante Alighieri, Allen Mandelbaum, trans. (New York, Bantam Classics, 1986).

Perret, M., "Essai sure l'histoire du Saint Suaire du XIVe au XVIe siècle," *Académie des Sciences, Belles Lettres et Arts de Savoie, Mémoires,* ser. 6, IV (1960): 49–121.

Picturing the Bible: The Earliest Christian Art, Jeffrey Spier, ed. (New Haven, CT, and London, Yale University Press, 2007).

Pliny the Elder, The Natural History, Bohn's Classical Library, John Bostock and Henry Thomas Riley, eds. (London, BiblioBazaar, 1872).

Provoledo, Elisabeth, "Turin Shroud Going on TV, with Video from Pope," *The New York Times,* March 29, 2013.

Queller, Donald E., and Thomas F. Madden, *The Fourth Crusade: The Conquest of Constantinople,* 2nd ed. (Philadelphia, University of Pennsylvania Press, 1997).

Questions of Authenticity Among the Arts of Byzantium, Susan Boyd and Gary Vikan (Washington, DC, Dumbarton Oaks, 1981).

Rinaudo, Jean-Baptiste, "Shroud of Turin: Shroud Experts and Origina STURP Team Members Gather at Shreveport's Cathedral of St. John Berchmans for a Special Panel," *Catholic Connection,* September 28, 2018 (thecatholicconnection.org/?p=8407).

Robert de Clari, The Conquest of Constantinople, Translated from the Old French, Columbia Records of Civilization, 23, Edgar Holmes McNeal, trans. (New York, Columbia University Press, 2005).

Roux, Brigitte, *Les Dialogues de Salmon et Charles VI* (Geneva, Droz, 1998).

Saxer, Victor, "Le Suaire de Turin aux prises avec l'histoire," *Révue d'histoire de l'Église de France,* 76 (1990): 21–55.

Scavio, P., "Ricerche sopra la Santa Sindone," *Pontificium Athenaeum Salesianum,* I (1955): 120–55.

Scavone, Daniel C., "The Shroud of Turin in Constantinople: The Documentary Evidence," *Diadalikon: Studies in Memory of Raymond V. Schroder, S. J.,* Raymond F. Sutton Jr. ed. (Wauconda, IL, Bolchazy Carducci Pub, 1988).

Scavone, Daniel C., "The Turin Shroud from 1200 to 1400," *Alpha to Omega: Studies in Honor of George John Szemler on his Sixty-Fifth Birthday,* W. J. Cherf, ed. (Chicago, Ares Pub, 1993): 187–225.

Scavone, Daniel C., et al., "Deconstructing the 'Debunking' of the Shroud" (www.shroud.com/bar.htm#scavone).

Schmitt, Jean-Claude, *Ghosts in the Middle Ages: The Living and the Dead in Medieval Society*, English ed. (Chicago and London, University of Chicago Press, 1999).

Schweber, Nate, "In New Jersey, a Knot in a Tree Trunk Draws the Faithful and the Skeptical," *The New York Times,* July 22, 2012.

"Science Sees What Mary Saw From Juan Diego's Tilma" (catholiceducation .org) (http://www.catholiceducation.org/articles/religion/re0447.html).

Sciolino, Elaine, "After Liberté and Égalité, Its Autopsie," *The New York Times,* July 7, 2012.

Shamir, Orit, "A burial textile from the first century CE in Jerusalem compared to Roman textiles in the land of Israel and the Turin Shroud," *SHS Web of Conferences,* 15/10 (2015): 1–14.

Shroud.com = all current news about the Shroud of Turin, including publications and conferences.

Shroud 2.0 = first official App for iPad and iPhone with high-resolution images of the Shroud of Turin.

shroudphotos.com = digital copies of the photographs taken by Vernon Miller of the 1978.

Sox, David, "The Cult of the Shroud," *The Tablet,* no. 6602, February 28, 1998 (http://www.thetablet.co.uk).

Spade, Paul Vincent, "William of Occam," *Stanford Encyclopedia of Philosophy* (Stanford, 2006–10).

Splendor of the Word: Medieval and Renaissance Illuminated Manuscripts at the New York Public Library, Studies in Medieval and Early Renaissance History, Jonathan J. G. Alexander, James Marrow, and Lucy Freeman Sandler (New York, Harvey Miller Publishers, 2006).

Squires, Nick, "Pope Benedict Says Shroud of Turin Authentic Burial Robe of Jesus," *The Christian Science Monitor,* May 3, 2010.

Sterling, Charles, *La peinture médiévale à Paris,* I–II, I: 1300–1500 (Paris, Bibliothèque des arts, 1987).

Stones, Alison, John Williams, Quitterie Cazies, and Klaus Herbers, *Compostela and Europe: The Story of Diego Gelmirez* (New York, Skira, 2010).

Sulpicius Severus, Sacred History, The Nicene and Post-Nicene Fathers, P. Schaff and H. Wace, eds., second series, vol. II, A. Roberts, trans. (Grand Rapids, MI, 1955).

Suro, Roberto, "Church Says Shroud of Turin Isn't Authentic," *The New York Times*, October 14, 1988.

Taburet-Delahaye, Elisabeth, and François Avril, et al., *Paris 1400: Les arts sous Charles VI* (Paris, Fayard/RMN, 2004).

The Ecclesiastical History of Evagrius, Christian Roman Empire Series, 5, Edward Walford, trans. (n.p., Evolution Pub & Manufacturing, 2008).

The Glory of Byzantium: Art and Culture of the Middle Byzantine Era, A.D. 843–1264, Helen C. Evans and William D. Wixom, eds. (New York, The Metropolitan Museum of Art, 1997).

The Passion: Photography from the Movie The Passion of the Christ, Mel Gibson, forward (n.p., Tyndale House Publishers, Inc., 2004).

Thurston, Herbert, "The Holy Shroud and the Verdict of History," *The Month*, CI (1903): 17–29.

Thurston, Herbert, "The Holy Shroud (of Turin)," *The Catholic Encyclopedia* (New York, 1912).

Treasures of Heaven: Saints, Relic, and Devotion in Medieval Europe, Martina Bagnoli, Holger A. Klein, C. Griffith Mann, and James Robinson, eds. (Baltimore, New Haven, and London, Yale University Press, 2010).

Trilling, James, "The Image Not Made by Human Hands and the Byzantine Way of Seeing," *The Holy Face and the Paradox of Representation: Papers from a Colloquium Held at the Bibliotheca Hertziana, Rome and the Villa Spelman, Florence , 1996,* Herbert Kessler and Gerhard Wolf, eds. (Bologna, Nuova Alfa Editoriale, 1998): 109–27.

Turner, Victor and Edith, *Image and Pilgrimage in Christian Culture: Anthropological Perspectives* (New York, Columbia University Press, 1978).

Van Biema, David, "Science and the Shroud," *TIME*, April 20, 1998.

Vikan, Gary, "Why the Shroud of Turin Can't Be Real," Q&A with Tom Weisser, Baltimore *City Paper*, 11/32, August 1987.

Vikan, Gary, "Sacred Image, Sacred Power," *Icon: Four Essays,* Gary Vikan, ed. (Washington, DC, Trust for Museum Exhibitions, 1988): 6–19.

Vikan, Gary, "Ruminations on Edible Icons," *Studies in the History of Art*, 20 (1989): 47–59.

Vikan, Gary, "Icons and Icon Piety in Early Byzantium," *Byzantine East, Latin West: Art-Historical Studies in Honor of Kurt Weitzmann,*

Christopher Moss and Katherine Kiefer, eds. (Princeton, NJ, Princeton University Press, 1995): 569–76.

Vikan, Gary, "Debunking the Shroud: Made by Human Hands," *Biblical Archaeology Review*, 24/6 (1998): 27–29 (responses in *BAR*'s March/April 1999 issue).

Vikan, Gary, *Sacred Images and Sacred Power in Byzantium*, Variorum Collected Studies Series (Aldershot, UK, and Burlington, VT, 2003).

Vikan, Gary, *Early Byzantine Pilgrimage Art* (Washington, DC, Dumbarton Oaks/HUP, 2010).

Vikan, Gary, *From the Holy Land to Graceland: Sacred People, Places, and Things in Our Lives* (Washington, DC, AAM Press, 2012).

Vikan, Gary, *Sacred and Stolen: Confessions of a Museum Director* (New York, SelectBooks, 2016).

Walker, Peter W. L., *Holy City, Holy Places? Christian Attitudes to Jerusalem and the Holy Land in the Fourth Century* (Oxford, Oxford University Press, 1990).

Weber, Max, *Economy and Society*, I–III (Berkeley, University of California Press, 1978).

Weitzmann, Kurt, "The Origin of the Threnos," *De Artibus Opuscula, XL, Essays in Honor of Erwin Panofsky* (New York, 1961): 476–90.

Weitzmann, Kurt, *The Monastery of Saint Catherine at Mount Sinai: The Icons, I, From the Sixth to the Tenth Century* (Princeton, NJ, Princeton University Press, 1976).

Whanger, Alan, "A Letter to Hershel Shanks, Editor of BAR," November 30, 1998, (www.shroud.com/bar.htm#shanks).

Whanger, Mary and Alan, *The Shroud of Turin: An Adventure of Discovery* (Franklin, TN, Providence House Pub, 1998).

White, Maureen, and Suzan Clarke, "The Face of Christ Revealed?," *ABC News*, April 1, 2010.

Wild, Robert A., "The Shroud of Turin: Probably the Work of a 14th-Century Artist or Forger," *Biblical Archaeology Review*, 10/2 (1984): 30–46.

Wilkinson, John, intro. and trans., *Jerusalem Pilgrimage, 1099–1185*, John Wilkinson, intro. and trans. (London, Routledge, 1988).

Wilkinson, John, intro. and trans., *Egeria's Travels*, 3rd ed., John Wilkinson, intro. and trans. (Jerusalem and Warminster, UK, Liverpool University Press, 1999).

Wilkinson, John, intro. and trans., *Jerusalem and Pilgrims Before the Crusades*, rev. ed., John Wilkinson, intro and trans. (Warminster, UK, Aris & Phillips, 2002).

Wilson, Ian, *The Shroud of Turin: The Burial Shroud of Jesus Christ?* (Garden City, NY, Doubleday, 1978).

Wilson, Ian, *The Shroud: Fresh Light on the 2000-Year-Old Mystery* (London et al., Bantam, 2010).

Wolf, Gerhard, "Picturing the 'Disembodied' Face and Disseminating the True Image of Christ in the Latin West," *The Holy Face and the Paradox of Representation: Papers from a Colloquium Held at the Bibliotheca Hertziana, Rome and the Villa Spelman, Florence, 1996,* Herbert Kessler and Gerhard Wolf, eds. (Bologna, Nuova Alfa Editoriale, 1998): 153–79.

Woodfin, Warren, "Liturgical Textiles," *Byzantium: Faith and Power (1261–1557)*, Helen C. Evans, ed. (New Haven and London, Yale University Press, 2004).

Wortley, John, "Iconoclasm and *Leipsanoclasm*: Leo III, Constantine V and the Relics," *Byzantinische Forschungen*, 8 (1982): 253–79.

Wortley, John, "Relics and the Great Church," *Byzantinische Zeitschrift*, 99/2 (2007): 631–47.

Wroth, William, *Images of Penance, Images of Mercy: Southwestern Santos in the Late Nineteenth Century* (Norman, OK, and London, University of Oklahoma Press, 1991).

Zeri, Federico, *Italian Paintings in the Walters Art Gallery*, I, II (Baltimore, The Walters Art Gallery, 1976).

Zugibe, Frederick, *The Cross and the Shroud: A Medical Examiner Investigates the Crucifixion* (New York, Distributed by Exposition Press, 1982).

SOURCES FOR QUOTED PASSAGES

INTRODUCTION

p.ix Squires, 2010

CHAPTER 2

p. 12 Wilkinson, 2002, Travels, 44
p. 15 Nicolotti, 2020, 39
p. 16 Nicolotti, 2020, 44
p. 18 Nicolotti, 2020, 90
p. 19 Nicolotti, 2020, 91

CHAPTER 5

p. 39 *Sulpicius Severus*, 1955, 2.33

CHAPTER 8

pp. 57–58 Wroth, 1991, 58–59

CHAPTER 12

p. 80 Carrillo, 2004

CHAPTER 15

p. 98 Henderson, 1978
p. 98 Aberth, 2005, 123
p. 100 Aberth, 2005, 72

SOURCES FOR QUOTED PASSAGES

CHAPTER 17

pp. 113–118 Nicolotti, 2020, 90-96 (Memorandum d'Arcis)
p. 115 Nicolotti, 2020, 85

CHAPTER 18

pp. 121–122 Nicolotti, 2020, 106-107
p. 124 Nicolotti, 2020, 94
p. 124 Nicolotti, 2020, 95
p. 125 Nicolotti, 2020, 91
p. 127 Rinaudo, 2018

CHAPTER 19

p. 132 Nicolotti, 2020, 84

CHAPTER 20

pp. 138–139 Nicolotti, 2020, 90-96 (Memorandum d'Arcis)
pp. 139–142 Nicolotti, 2020, 85–88

CHAPTER 21

p. 147 Gould, 1999
p. 150 *Paradisio*, canto XIII
p. 150 Sox, 1998 (with permission)

CHAPTER 22

p. 154 Freeman, 2011, 118

INDEX

INDEX

120–121; blood imagery of, 16–17, 80; books about, 28; carbon-14 dating of, 46–47, 61, 64–71, 75, 120, 129, 147, 149, 158; Catholic Church on, 120–123; charismatic power of, 123–128, 147, 159; controversy over, 18–20, 31–32, 72–77, 149; creation of, 83–90, 129–137, 155–156, 165–179; current thinking on, 30; dating of, 16, 17, 20–21; display of, ix, xi, xiii, 8, 69–70, 146, 161; *Epitaphios* and, 34–35; as fake, 20–21; false representation of, 138–144; first appearance of, 72–73; frenzy over, 8; history of, 17–20, 147; as hoax, xiii, 151–160; opinions on, 151; origin of, xii, 132–137, 149; origins of story of, 113–119; pilgrim badges, 105, 111–115; preservation of, 178–179; questions about, 21; reasons for creation of, 130; as relic-icon, 10–11, 14; replicas of, 2; significance of, 148–149; skepticism about, x, 18, 32; TV interview on, 22–26; as work of art, 14–17; *see also* Man of the Shroud
Shroud of Turin Research Project (STURP), 8, 40, 43–44, 45–47, 66, 70, 85
The Shroud of Turin: The Burial Cloth of Jesus Christ? (Wilson), 8, 27–31

The Shroud of Turin: The History and Legends of the World's Most Famous Relic (Nicolotti), 17
Simeon Stylites (saint), 38–39
sindonoclasts, 32
sindonologists, 30, 31, 44, 71, 74–77, 93, 97, 147, 149, 157, 161
skepticism, 32
Socrates, 10, 148
Stanley, Bill, 52
Stephen (Saint), 20
Stevens, George, 82
Stone of the Anointment, 15
St. Peter's Basilica, 102
St. Sernin basilica, 4–5
STURP. *See* Shroud of Turin Research Project (STURP)
Sudarium Christi, 35–36, 102, 115, 117–118, 123, 125, 130, 142, 144, 152, 157, 160
"sweat cloths," 130

T

tannic acid, 89, 167, 170–175, 177, 178
Taylor Museum, 59
teleological reasoning, 31
television interview, 22–26, 76
Theodosian Dynasty, 7
Thurston, Herbert H. C., 17
Time magazine, 70, 72–73, 77
Toledo, Spain, 35
Tonsmann, José Aste, 146